EXHIBITING CONTRADICTION

Essays on the Art Museum in the United States

Alan Wallach

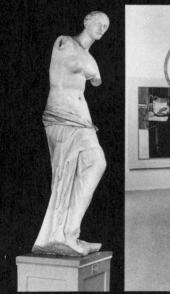

Copyright © 1998 by The University of Massachusetts Press
All rights reserved
Printed in the United States of America
Set in Garamond. Printed and bound by Thomson Shore, Inc.

Library of Congress Cataloging-in-Publication Data
Wallach, Alan.
Exhibiting contradiction : essays on the art museum in the
United States / Alan Wallach.
p. cm.
Includes bibliographical references and index.
ISBN 1-55849-117-1 (cloth : alk. paper). — ISBN 1-55849-118-X
(pbk. : alk. paper)
1. Art museums—Educational aspects—United States.
2. Art—Exhibition techniques. I. Title.
N510.W35 1998 708.13—dc21 97-28371 CIP

Several chapters of this book were previously published
in slightly different forms. Their earlier appearances are listed
with the notes to those chapters.
This book is published with the support and cooperation
of the University of Massachusetts, Boston, and the
College of William and Mary.
British Library Cataloguing in Publication data are available.

To the memory of Israel Wallach (1903–1971)

CONTENTS

ILLUSTRATIONS

ACKNOWLEDGMENTS

I am grateful to numerous friends, colleagues, students, librarians, archivists, and curators who have interested themselves in these essays. Especially helpful have been Alejandro Anreus, Christopher Bailey, Jo-Anne Berelowitz, Casey Blake, David Brigham, Liza Broudy, Lisa Graziose Corrin, Joe and Wanda Corn, Barbara Dawson, Donna De Salvo, Colleen Doyle, Jeannine Falino, Joseph Gualtieri, Robert Gross, Grey Gundaker, Andrew Hemingway, Patricia Hills, Pat Lynagh, Andrew McClellan, Emily Mieras, Rodney Olsen, Deborah Owen, Alexandra Peña, Clive Phillpot, Marcia Pointon, Anjeanette Rose, Jean Rosenblatt, Robert Schumann, Katherine A. Schwab, Juliet Steyn, Ellen Williams, Karen J. Winkler, and Gwendolyn Wright.

I am deeply indebted to Paul Wright, my editor at the University of Massachusetts Press, whose enthusiasm made this book possible. William H. Truettner of the National Museum of American Art has been an exemplary colleague and friend who not only shared, unstintingly, materials from the "West as America" archive but also, with characteristic selflessness, urged me to be as critical of the exhibition as I was of its neoconservative detractors. My heartfelt thanks to Paul Mattick who has been, for years, my most demanding critic and therefore the rarest of friends. I am grateful beyond measure to Phyllis Rosenzweig for inspiration, criticism, and the life we share.

This book is dedicated to the memory of my father, Israel Wallach. A difficult man living in a difficult time, he nonetheless taught me an unforgettable lesson in courage and intellectual integrity.

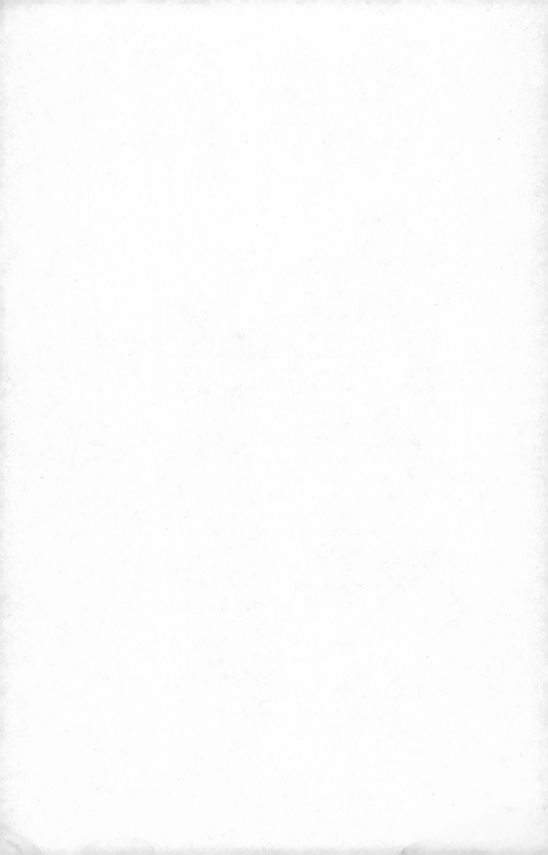

Exhibiting Contradiction

INTRODUCTION

My interest in the art museum as a subject of scholarly inquiry dates to the fall of 1976 when Max Kozloff, then editor of *Artforum,* asked me to review "The Natural Paradise," the Museum of Modern Art's bicentennial exhibition.[1] Although I had been visiting art museums since childhood, while reviewing "The Natural Paradise," I found myself for the first time considering not only the paintings on exhibit but the manner in which the curator—in this case Kynaston McShine—had organized them. In "The Natural Paradise," McShine posited an art historical connection between sublime landscapes by mid-nineteenth-century American painters such as Albert Bierstadt, Frederic Church, and Thomas Moran, and the work of such moderns as Jackson Pollock, Mark Rothko, and Clyfford Still. Perhaps anticipating the public's reluctance to accept a thesis that ran counter to received art historical wisdom, McShine dramatized his argument by installing the exhibition in reverse chronological order. Studying McShine's atypical arrangement, I began to consider how a visit to an art museum involved far more than simply an opportunity to come into contact with original works of art. It became evident to me that, by walking through a gallery space hung with pictures, museum visitors acted out, and thus in some sense internalized, a version of art history.

Working with Carol Duncan, I developed these ideas further in "The Museum of Modern Art as Late Capitalist Ritual: An Iconographic Analysis," which we published in 1978.[2] In this article Professor Duncan and I studied the museum's permanent collection using concepts derived from anthropology (especially Victor Turner's work on ritual), Panofskyan iconography, and Marx-

ist theory. Two years later, in "The Universal Survey Museum," we employed the same analytical tools to examine the historical importance of the museum type first exemplified by the Louvre.[3] These articles represented an early attempt, within the discipline of art history, to think critically about museums.[4] As interventions in what had been, up to that point, pretty much a celebratory discourse, they provoked intense interest and, on occasion, profound disquiet.

The field of critical museum studies has grown enormously since then. Today anthropologists, art critics, art historians, historians, philosophers, political scientists, sociologists, and artists—e.g., Hans Haacke, Louise Lawler, and Fred Wilson—explore a wide range of museum-related issues. In place of a trickle of publications, there is now an endless stream of books, articles, and catalogs as well as greatly increased opportunities for exchanges between scholars, artists, and museum professionals.[5] The growing scholarly curiosity about the history and function of the art museum results not only from the rise of critical theory and the partial breakdown of barriers separating academic disciplines but also from the spectacular growth of the art museum itself during the last two decades. The ever-increasing number of institutions involved in the definition of art, the interpretation of the history of art, and the presentation of cultures from around the world, as well as the unprecedented expansion of official taste—exemplified in collections of "primitive" and contemporary art at mainstream institutions such as the Metropolitan Museum of Art and the National Gallery—pose an inescapable challenge to anyone concerned with the current state of American culture.

Stimulated by the work of colleagues in the field of critical museum studies, and simultaneously fascinated and appalled by the ongoing Disneyfication of much of American cultural life, I have in recent years focused my efforts on two areas: the history of art institutions in the United States, and the way in which art museums depict or represent American society and the American past. As the essays that comprise this volume attest, these two areas connect. Understanding how art museums currently organize themselves, put on exhibitions, and display works of art requires a grasp not only of the histories of individual museums but of the history of the art museum as an institution within American society.

A critical history of the art museum in the United States has yet to be written. What I offer in part I of this book represents an outline or schematic history up to World War I. Although I do not deal with the founding of such powerhouses as the Metropolitan Museum of Art, the Boston Museum of

Fine Arts, and the Art Institute of Chicago, taken together the four essays in part I sketch the rise of the art museum as a crucial feature of American culture. Chapter 1, "Long-term Visions, Short-term Failures," considers why, before the Civil War, there was no institution in the United States that could properly be called an art museum despite the existence of art academies, athenaeums, multipurpose exhibition spaces like the Peale Museum in Philadelphia, and public galleries like the very popular Düsseldorf Gallery in New York. In this chapter, I draw upon the work of sociologist Paul DiMaggio to argue that pre–Civil War elites were too fragmented to collaborate in the founding of permanent institutions dedicated solely to the display of works of art. Chapter 2, "William Wilson Corcoran's Failed National Gallery," deals with a similar problem, the creation of a national art museum in the period immediately following the Civil War. The United States' leading financier during the 1840s and 1850s, Corcoran built the nation's first art museum. The museum building, located in Washington, D.C., diagonally across the street from the White House, was almost complete before the outbreak of hostilities between North and South in 1861, but because of political complications could not be opened until 1874. Corcoran hoped that the institution he had created would serve as a national gallery but his hopes were sadly disappointed. After the Civil War, factions of the "national upper class" proved capable of creating lavish municipal art museums, but they remained too divided to establish a national gallery of art.

Art museums sacralize their contents: the art object, shown in an appropriately formal setting, becomes high art, the repository of society's loftiest ideals. Indeed, without art museums, the category high art is practically unthinkable. As I point out in chapter 1, before the Civil War the distinction between high art and low, or popular, art existed only in the minds of the tiny number of American collectors and connoisseurs familiar with European art collections and museums such as the Louvre. The public, by contrast, tended to regard art exhibitions as little more than a form of entertainment or spectacle. After the Civil War, museums in Boston, New York, Washington, D.C., and elsewhere in effect institutionalized high art as a category. Yet the contents of these museums—what then constituted high art—would in some respects surprise today's museum-goers. When the Corcoran Gallery opened in 1874, it was primarily a museum of casts and replicas of Greek, Roman, and Renaissance art, and what was true for the Corcoran was also true for most other art museums of the period. Thus, in chapter 3, "The American Cast Museum: An

Episode in the Institutional Definition of Art," I explore the implications of this type of early museum collection and display. Through the study of replicas, the museum-going public became familiar with such canonical works as the *Apollo Belvedere,* the *Laocoön,* and the *Venus de Milo.* When, in the early 1900s, leading art museums began to relegate cast collections to basement warehouses and hence to oblivion, the change represented a crucial shift in the definition of art and the goals of the museum. In this chapter, I argue that the elimination of cast collections marks the historical moment when the experience of high art became wholly identified with seeing original works of art in museums. Art museums thus shifted their emphasis from traditional forms of artistic education to spectacular displays of cultural property, a move entirely consonant with a new age of conspicuous consumption.

Yet if after 1900 American art museums increasingly focused on collecting costly originals, they never abandoned what they took to be their civilizing mission. What that mission initially involved is underscored in chapter 4, "Samuel Parrish's Civilization." Parrish, who opened his Southampton Gallery of Art (today the Parrish Art Museum) during the Spanish-American War, was a well-connected corporate lawyer and Republican Party activist who numbered among his friends Henry Gurdon Marquand, a millionaire Wall Street banker and, between 1889 and his death in 1902, president of the Metropolitan Museum of Art's board of trustees. Parrish could not afford to collect first-rate European paintings and sculptures, and in any case, along with many of his contemporaries, he believed that a museum of casts and replicas would better serve the purpose of education and civic uplift. Parrish's plan for his Southampton Gallery of Art reveals the extent to which his political and artistic aspirations overlapped. For Parrish, the ideals of western civilization, symbolized by his museum's architecture and collections, were inextricably bound up with belief in a national policy of imperial conquest and colonial domination.

Part I examines the opposing and contradictory ideologies that drove the development of the American art museum in the nineteenth century. Part II focuses on tensions and contradictions characteristic of the more recent history of art museums in the United States. In chapter 5, "The Museum of Modern Art: The Past's Future," I explore the implications of MOMA's 1980–84 renovation and expansion. MOMA's history divides into phases in which the idea of the modern undergoes significant alteration. Initially, in the 1930s and 1940s, the museum building, as much as its collections, symbolized an equation between modernity and a vision of a corporate-utopian future of ra-

tionality and technological progress. Beginning in the 1950s modernity, as projected by the museum, increasingly turned into nostalgia for the lost utopianism of the 1930s and 1940s. MOMA's 1980–84 renovation and expansion dramatized the disjunction between nostalgia for the museum's long ago utopian-modernist hopes and the banality of a futureless, postmodern present.

Chapter 5 considers MOMA's depiction of the future of American society; chapter 6, "Regionalism Redux" deals with the portrayal of the American past in recent exhibitions of the work of George Caleb Bingham and Thomas Hart Benton, painters who, in their different historical periods, were each celebrated as "the Missouri artist." Here a close examination of curatorial techniques— the sequences in which works are hung, the use of lighting, color, gallery furniture, and the selection of wall texts, as well as the accompanying exhibition catalogs—reveals a host of art historical and museological problems. Because both exhibitions bought into populist-conservative myths of regionalist painting, they ended up obscuring or glossing over the complexities of their historical materials. As I argue, in this and the remaining three chapters, neither scholars nor curators can base their work on myth, or take as their intellectual foundation the very ideologies they propose to study.

Unlike the curators of the Bingham and Benton exhibitions, the organizers of "The West as America," an exhibition mounted at the National Museum of American Art in 1991, attempted a critical-historical approach to representations of the American past. Earlier exhibitions of western art tended to celebrate the work of such painters as Frederic Remington and Charles Russell for its "realism" and hence its putative documentary or historical value. As I assert in chapter 7, "The West as America" demonstrated the possibility of exploring, in an exhibition format, depictions of such inherently problematic subjects as westward expansion and Native American life. Unfortunately, the response to the exhibition also demonstrated the high price an institution might have to pay for daring to subject cherished nationalist myths to critical scrutiny. Coming immediately in the wake of the victory of the United States and its allies in the Gulf War, "The West as America" drew down upon itself and the federally funded National Museum of American Art the wrath of senators, neoconservative pundits, and the head of the National Endowment for the Humanities who reproached the exhibition's organizers for their "aggressive lack of objectivity."[6]

"The West as America" exemplified some of the problems curators may encounter organizing revisionist exhibitions. Chapters 8 and 9, originally pub-

lished as opinion pieces in *The Chronicle of Higher Education,* explore the gap between the revisionism which now dominates academic art history and the more traditional approaches that remain characteristic of museums. In chapter 8, "Revisionism Has Transformed Art History, but Not Museums," I argue for the importance of mounting revisionist exhibitions despite the built-in opposition of institutions dependent upon corporate and government support. In chapter 9, "Museums and the Resistance to History," I evaluate the response to a revisionist exhibition for which I was responsible. In 1994, as cocurator with William H. Truettner of "Thomas Cole: Landscape into History," I had an opportunity to present the work of a major artist of the Hudson River School in relation to its social, historical, and political contexts. Critics lauded "Thomas Cole: Landscape into History" for demonstrating that "Cole's art was rooted in his own historical moment."[7] Robert Hughes, writing in *Time,* found the exhibition "highly engaging, not least because the curators—without imposing a modern agenda on Cole's work—have done such an intelligent job of ferreting out what ideas of American identity [Cole] satisfied, including political ideas."[8] Yet reactions to the exhibition were at best ambivalent, with some critics expressing hostility to the idea that Cole was motivated by philosophical and political beliefs, and relatively few visitors grasping the exhibition's underlying purpose. The difficulty, I maintain, resulted in part from the widespread resistance by art museums and their publics to the historical—as opposed to the transhistorical or transcendental—understanding of art.

From the beginning the sacralization of art was the art museum's chief function. Demystification requires the thoroughgoing critique of its transcendental status, of the idea that art is somehow exempt from the mundane realities of history and contemporary life. Such a critique necessarily implies a historical critique of the museum as an institution. Demystification will not ruin art, as some critics now fear, but will result instead in new dimensions of historical and aesthetic understanding. Indeed, if there is any lesson to be learned from recent museum history, it is that we will not achieve a new comprehension of art without the art museum's wholesale transformation. Such a transformation will be extremely difficult: art museums are profoundly conservative institutions and although some have in recent years made concessions to, or even encouraged, revisionist approaches, the majority continue to resist the implications of revisionist scholarship and critical theory. Those who would change museums are thus obliged to struggle against the odds. This book is intended as a contribution to that struggle.

PART I

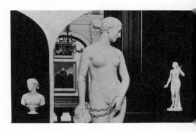

CHAPTER ONE

Long-Term Visions, Short-Term Failures:
Art Institutions in the United States, 1800–1860

Because my space is limited and my topic large, what I am about to present can be no more than a rough sketch. I will attempt to analyze the historical limitations of art institutions in the United States during the six decades preceding the Civil War. I begin with a reflection on the differences between pre- and post-Civil War art institutions; I then argue that the history of art institutions during the antebellum period can be read as a history of relatively weak elite factions attempting, but almost invariably failing, to establish permanent institutions of high art.

High art is of course a central feature of bourgeois society, a necessary component of bourgeois hegemony. William C. Dowling, commenting on the work of Frederic Jameson, has observed that "it is a spiritual death for the bourgeois intellectual to imagine a Brueghel or a Rembrandt being thrown on the bonfire, a world in which no one will ever view a Raphael again."[1] Yet to produce such a mind-set, to construct a "Rembrandt" or a "Raphael" adequate to the demands of bourgeois hegemony is no easy thing. It cannot occur without at least minimal cooperation between elite factions capable of taking control of, or establishing power over, the state—either locally or nationally.

This was precisely *not* the case in the United States during the six decades preceding the Civil War. Upper class Americans may have dreamt of an American Louvre but elites were, for the most part, far too weak and divided to cooperate in the creation of national cultural institutions.[2] Even on the local level elite groupings generally lacked the power to achieve cultural hegemony. Studies of elites in Boston, New York, Philadelphia, and Charleston suggest

that factionalism and a concomitant political weakness were commonplace.[3] For example, in an analysis of the early years of the Boston Athenaeum, Ronald Story distinguishes the Boston elite of the period 1800–1850 from the "upper class" of the 1850s and 1860s, noting "the [latter's] greater cohesion of occupational, familial and generational components . . . and its greater consciousness of its interests vis-à-vis antagonistic social elements." By the 1860s, the Boston elite "seems to have achieved a unique cohesiveness and a singular cultural complexion."[4]

The history of the Boston Brahmins is in many respects unique; yet consolidation and increasing cultural awareness also characterized urban elites throughout the United States during the closing decades of the nineteenth century. With the formation of what historians have described as a "national upper class" in the post-Civil War period, the bourgeoisie finally arrived at a point where it could achieve cultural hegemony.[5] Yet, for the most part, hegemony developed through a network of local institutions. Thus a United States national gallery was out of the question until well into the twentieth century. (Of course it might be argued that New York's Metropolitan Museum, a monument to the New York industrialists and financiers who had emerged triumphant from the Civil War, had in the interim taken the place of a national gallery.) My point is that the bourgeoisie's inability, during the postwar period, to create a national art institution comparable to the Louvre or the London National Gallery reveals the extent to which elite factionalism remained a persistent feature of American political and cultural life, and it points to the far greater intensity of those divisions, the more or less fragmented character of American elites, during the years preceding the Civil War.

The historical problem might be stated (as it has been so far) in terms of a history of institutions. It is of course noteworthy that before the Civil War there was not one institution in the United States that, properly speaking, could be called a museum of art. By contrast, after the Civil War, art museums rapidly began to appear. In 1870, just five years after the war's end, museums were incorporated in Boston, New York, and Washington, D.C. But the historical issues should not be understood purely in institutional terms. There are also key questions that have to do with the sacralization of art, the definition of high art and its opposite, popular or low art, and the institutionalization of these categories. In a study of the founding of the Boston Museum of Fine Arts and the Boston Symphony Orchestra, the sociologist Paul DiMaggio suggests that three interlocking factors had to be present in order to establish

institutions of high culture in Boston (and, by implication, elsewhere in the United States). There had to be, first, *elite entrepreneurship:* the creation of organizational forms that the elite group or faction could totally control (these organizational forms were invariably corporate and nonprofit, thus insulating them from the market and to an extent from the state); second, *classification:* the erection of strong and clearly defined boundaries between art and entertainment with the former appropriated by the elite as its own cultural property, and, crucially, "the acknowledgment of that classification's legitimacy by other classes and the state"; and third, *framing:* creation of "a new etiquette of appropriation, a new relationship between the audience and the work of art."[6]

In a venerable scholarly tradition stretching from William Dunlap in 1834 to Lillian Miller and Neal Harris in the 1960s and on down to the present, commentators on the history of pre-Civil War patrons and art institutions have celebrated the creation of art collections, galleries, athenaeums, and academies as patriotic endeavors that contributed to the rise and progress of the arts in the United States.[7] Yet in light of DiMaggio's analysis we can begin to read this history in a different manner: indeed we can begin to read it in terms of a recurring impulse to establish institutional bases for high art.

This is not to say that before the Civil War the bourgeoisie in the United States lacked art or what today we would readily identify as high art. In the North American colonies and later, in the United States, there was a specifically bourgeois art: how else, after all, should we characterize John Singleton Copley's portraits of Boston's pre-Revolutionary merchant oligarchs or the productions of such mid-nineteenth-century genre painters as William Sidney Mount, George Caleb Bingham, or Francis Edmonds?[8] Yet it is one thing to possess an art in this sense and another to lay down general aesthetic criteria or an aesthetic regime for society as a whole. Before the Civil War, notions of high art abounded: for example aristocratic connoisseur-collectors like Philip Hone of New York and Robert Gilmor of Baltimore upheld a set of aesthetic criteria derived from British writings on aesthetics and from the study of European collections. (Gilmor, in a famous series of letters, disputed aesthetic theory with the artist Thomas Cole; elsewhere in his correspondence we find him complaining that Luman Reed, the nouveau-riche New York collector who, in the early 1830s, commissioned work from Cole, Asher B. Durand, and William Sidney Mount, "knew nothing about the art" of painting.)[9] Or we might consider the case of John Vanderlyn who returned to the United States in 1815 after almost two decades in Paris where he had studied with François

1.1 John Vanderlyn, *Ariadne Asleep on the Isle of Naxos,* 1809–14. Oil on canvas, 68 1/2 x 87 in. (174.0 x 221.0 cm.). Courtesy of the Museum of American Art of the Pennsylvania Academy of the Fine Arts, Philadelphia. Gift of Mrs. Sarah Harrison (Joseph Harrison, Jr., Collection).

André Vincent and exhibited at the salon. Vanderlyn had been a protégé of Aaron Burr and, with the help of Burr's old political connections, obtained aid from the New York City Common Council in building a rotunda in which to exhibit panoramas. But his real purpose, he claimed, was to raise American standards of taste by acquainting the New York public with the results of his years of work in France, Davidian paintings which he also exhibited in the rotunda building—*The Death of Jane McCrea* (1804, Wadsworth Atheneum, Hartford), *Marius Amid the Ruins of Carthage* (1807, Fine Arts Museums of San Francisco), and *Ariadne* (1809, Pennsylvania Academy of the Fine Arts, Philadelphia) (fig. 1.1).[10] Or to take yet another example: in the 1840s the American Art-Union, concerned that its nationalist program might be criticized for lowering artistic standards, promoted what it explicitly called "high art"—although

in this instance high art probably meant simply art with elevated religious or moralizing subject matter rather than art defined in terms of the academic system of history painting. In 1847 it distributed to its members a mezzotint reproduction of George Caleb Bingham's *The Jolly Flatboatmen* (1846, private collection, on loan to the National Gallery of Art, Washington, D.C.), and then issued a second membership print after Daniel Huntington's *A Sibyl* (fig. 1.2),

1.2 John Casilear after Daniel Huntington, *A Sibyl,* 1847. Engraving, 9 3/16 x 7 13/16 in. (23.3 x 19.8 cm.). Courtesy of the Museum of Art of the Pennsylvania Academy of the Fine Arts, Philadelphia. John S. Phillips Collection.

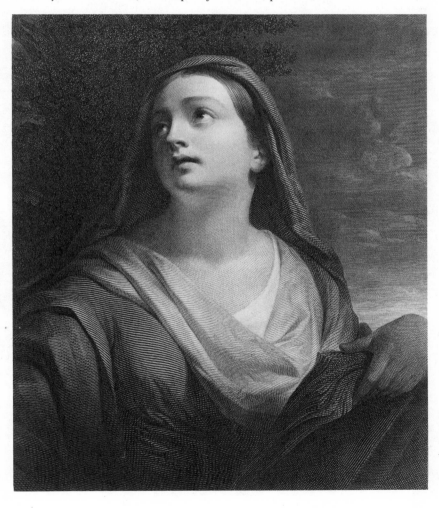

one of the artist's classical allegories. William J. Hoppin, the editor of the Art-Union's *Bulletin,* presented a resolution to the Art-Union's annual meeting which proclaimed "it is the duty of this Association to use its influence to elevate and purify public taste, and to extend among the people, the knowledge and admiration of the productions of 'HIGH ART.' "[11] In support of his motion, Hoppin asserted that while "the very name [*Jolly Flatboatmen*] . . . gives a death blow to all one's preconceived notions of 'HIGH ART' . . . the engraving of 'SIBYL' . . . will amply atone for all that the other may lack."[12]

Yet high art was at best an ideal, not an institution, and this was precisely the problem during the antebellum period. Lawrence Levine and others have emphasized that before the Civil War what we have come to regard as high art was no such thing, that "highbrow" and "lowbrow," as Levine calls them, were both popular.[13] Shakespeare appealed to lower class audiences; and the same can be said of most stage literature, of music (including grand opera), and of the visual arts. Norms now taken for granted did not exist; audiences were not demurely appreciative but highly demonstrative; there was an endless indiscriminate mixing of genres, of (from a later viewpoint) high art and kitsch. Relatively little was sacred—or rather sacralized. Levine exaggerates the extent to which pre–Civil War culture might be considered democratic (the antebellum period is, in his treatment, often a cultural-populist's utopia) and neglects the ways in which elites exerted a good deal of control over artistic production and consumption.[14] But he is surely right to emphasize the relative absence of hierarchical cultural categories. Almost every major painter of the period aspired to produce works for the edification of a mass audience. And although these aspirations were often deeply rooted in traditional artistic culture (Joshua Reynolds's *Discourses* and Benjamin West's example as a history painter loomed very large until at least the mid-1830s), in practice they usually resulted in forms of artistic entrepreneurship with a deliberate appeal to popular audiences, especially since patrons did not very often want works executed on a grand scale. Not only respectable artists, but the leaders of the profession—men who were themselves members of, or identified with, elites and who often harbored a deep hostility to political democracy and popular rule, men such as John Vanderlyn, John Trumbull, Washington Allston, Rembrandt Peale, Thomas Cole, and Frederic Church—produced paintings that might be called spectacle pictures: large-scale works often with sensational but also edifying and moral subject matter calculated to excite popular approval and enthusiasm.

The art institutions that did exist—athenaeums, academies, galleries, art unions—attempted to establish norms but without much success. Although often begun with high hopes, they frequently led a precarious existence and usually failed to influence the public's wide-ranging and eclectic tastes. Or to put the matter somewhat differently, they were incapable of enforcing any sort of real distinction between (high) art and (popular) entertainment. Their history is complex and often tortuous: a history, as my title indicates, of long-term visions and short-term failures; of institutions futilely competing with one another and with other forms of entertainment and display; of academies and athenaeums, such as New York's aristocratic American Academy of Fine Arts, lapsing into somnolent clubbiness as a result of a lack of resources and a lack of public interest; of institutional breakdowns as members or supporters tired of making up annual deficits; of hostility or indifference on the part of local and state governments, and total indifference on the part of the federal government.

It should be noted, however, that New York's National Academy of Design, Philadelphia's Pennsylvania Academy of the Fine Arts, and the Boston Athenaeum did not fit the overall pattern of failure and defeat. An artist-run organization modeled on the Royal Academy and primarily concerned with exhibition and education, the National Academy of Design managed to survive due in large measure to its artist members' professional stake in its success. The Pennsylvania Academy, in contrast, was organized by members of the Philadelphia elite; however, unlike the American Academy (see below), it guaranteed its survival by accommodating the needs of the Philadelphia artistic community. The Boston Athenaeum, like the academies in New York and Philadelphia, held annual exhibitions and collected works of art, but after 1850, as its library grew, space for exhibitions diminished, and in 1873 it turned over most of its collection to the newly opened Boston Museum of Fine Arts. Among antebellum art organizations these three institutions did the most to uphold artistic standards for elite patrons and collectors, and for the public that attended their exhibitions. They thus helped to lay the groundwork for post-Civil War institutions, but their influence on the culture as a whole was not very great and, as we have seen, their own artist members rarely drew hard distinctions between high and popular art forms.[15]

Despite failures, over time the number of attempts to create art institutions increased. If we consider the history of art institutions in New York City, the increase is in some respects dramatic (it goes hand in hand with New York's

astonishing growth as a center of finance, trade, and manufacturing beginning in the 1820s) and it reveals something, I believe, about the persistence of attempts to formulate and promote a high art aesthetic. Before 1840 New York had only two art organizations of any significance: the American Academy of Fine Arts, founded in 1802, and the National Academy of Design, created in 1825 by artists who were fed up with the American Academy's habitual indifference to their needs, and who intended to exert greater control over their market. The American Academy, essentially a patronage organization run by the remnants of New York's old federalist elite (its last president · was the ultra-federalist and highly aristocratic John Trumbull), did not long survive the competition with the National Academy, and by the early 1830s it existed pretty much in name only, its failure symbolic of the decline of the old aristocratic order.[16]

The American Academy's demise coincided with a growing interest on the part of New York's new elites—nouveau-riche businessmen, bankers, and financiers—in acquiring something of the aura of aristocratic distinction that accompanied the possession of works of art. In the early 1830s Luman Reed, a self-made businessman who had acquired a fortune in the wholesale grocery and dry goods business, built a mansion on Greenwich Street in lower Manhattan, which included a large gallery where he exhibited a collection of mediocre old masters and works he had commissioned from contemporary artists, including Thomas Cole's *Course of Empire* series.[17] Reed opened his gallery to a polite public once a week, perhaps in imitation of established European practice.[18] Although Reed died in 1836 his collection was not dispersed. In 1844 a group led by Jonathan Sturges—Reed's former business partner—and made up primarily of wholesale grocers, founded the New-York Gallery of Fine Arts, which purchased Reed's collection.[19] The Gallery's "object," according to its organizational document, was "to establish in the city of New York a permanent Gallery of Paintings, Statuary, and other Works of Art."[20] Justification for the Gallery took the form of what would soon become a familiar lament:

> A permanent Gallery of Paintings, Sculpture and Engravings, is the ornament of almost every city of the world that equals in population the city of New-York. That New-York, with her wealth, enterprise and general intelligence should be destitute of one of the features which indicate, in other cities, a liberal and refined people, has been a source of regret and mortification for all who feel a just pride in her character and pros-

perity. . . . may we not hope that the friends of the Fine Arts here will do as the friends of the Fine Arts have done in London?[21]

The Gallery was to be housed in Vanderlyn's old rotunda which was owned by the City. The mayor and some members of the city government saw the proposal as a money-losing proposition and opposed turning over the rotunda to the Gallery. The dispute engendered wide public interest. About three hundred merchants manifested their support by signing a petition which asserted (among other things) that public art galleries were a prominent feature of European cities and that Americans would do well to emulate European precedent. About fifty bank presidents and Wall Street brokers opposed the Gallery. The conflicts between bankers and brokers on the one hand, merchants and city government on the other, were symptomatic of deeper tensions and divisions within relatively weak elite factions.[22] (James Gordon Bennett, publisher of the *New York Herald,* sneered at the Gallery's merchant founders who, in his opinion, "know more about pork and molasses than they do about art.")[23] The Gallery finally opened. Yet despite early interest in its exhibitions, it ran a deficit throughout its history. Surviving less than a decade, its collection was finally turned over to the New-York Historical Society.

Something similar occurred with the American Art-Union, an art lottery whose subscribers enrolled for a chance to win paintings, and who received steel engravings as yearly premiums for membership. This organization was set up in New York in 1839 and took as its mission the goal of awakening national interest in contemporary American art.[24] At its height it attracted almost nineteen thousand subscribers nationwide, and its annual drawings were social events of note. As Rachel Klein has argued, "promoters of the Art-Union believed that art could exert its educative mission only if selection and distribution were removed from the popular market in culture."[25] The Art-Union's program, based upon eighteenth-century republican assumptions, aimed at diminishing class antagonisms and excluding from the realm of art anything that smacked of "selfish" or "interested" motives while creating "an uplifted, unified sense of national identity."[26] The Art-Union thus represented an attempt by an elite faction to create an organization it could totally control (elite entrepreneurship) by defining a uniquely American high art aesthetic, and by prompting a broad public to distinguish between high art and popular entertainment. Some commentators, including the writer Nathaniel Parker Willis, complained that the Art-Union's standards were not high enough. In addition,

artists protested what they saw as the Art-Union's attempt to monopolize patronage. Finally, the penny press, led by Bennett's *New York Herald*, joined with Willis in both attacking the Art-Union as a promoter of mediocrity, and condemning its annual lottery as a "swindle." The *Herald* played a central role in an escalating legal attack which ended in 1851 with the State Supreme Court declaring the Art-Union an illegal lottery.[27]

What we have then is, on the one hand, a growing demand for institutions of high art, either public art galleries like those in Europe supported by the state, or, like the lottery, adhering to innovative, entrepreneurial forms. On the other hand we have bourgeois factions too weak and divided to sustain such institutions, economically or politically, especially since at this point these factions could conceive of establishing art institutions only on a profit-making or break-even basis. There was thus a powerful impulse toward what DiMaggio would call classification and framing, but, ironically, the class's entrepreneurship (DiMaggio's third factor) was insufficient: it had yet to develop the corporate organizational forms necessary to sustain high art institutionally or the strength to dictate state policy.

Accordingly the history of art institutions during the period 1800–1860 can be read as a series of contradictory and thwarted impulses toward the institutionalization of high art. This history is, in my view, crucial to understanding artistic production and aesthetic thought during the period. In conclusion I would like to examine an attempt to formulate a high art aesthetic. This examination involves a rereading of fairly well known historical evidence.

Between 1855 and 1861, an art journal called *The Crayon* was published in New York. Edited by William Stillman and John Durand (the painter Asher B. Durand's son), *The Crayon* is usually, if somewhat mistakenly, remembered as an American vehicle for Ruskin's ideas (the journal eventually evolved a Unitarian-Transcendentalist critique of Ruskin).[28] Although *The Crayon* has been understood primarily in terms of the history of American aesthetic thought, it can also be studied as an institution within the New York art world of the 1850s. The aesthetic theories it promoted were never entirely disinterested but were connected with the needs and concerns of a particular group of artists and patrons based primarily in the Century Club. There are many ways to interpret *The Crayon,* but if we read it with regard to contemporary artistic practice we quickly discover a tendency to favor what are sometimes called "Luminist" or, as Janice Simon has put it, "Crayonist" landscape painters, and to disparage artists pursuing what now appear to be more popu-

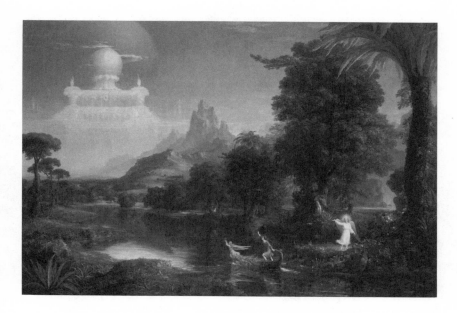

1.3 Thomas Cole, *The Voyage of Life: Youth,* 1842. Oil on canvas, 52 7/8 x 76 3/4 in. (134.3 x 194.9 cm.). National Gallery of Art, Washington, D.C., Ailsa Mellon Bruce Fund. © 1997 Board of Trustees, National Gallery of Art, Washington.

lar forms. An example of the latter is Frederic Church, probably the most popular artist in the United States during the six years *The Crayon* was published, and author of such crowd-pleasers as *Niagara* (1857) and *Heart of the Andes* (1859).[29] Moreover, if *The Crayon* was mildly disparaging toward Church, it was positively hostile to Church's teacher, Thomas Cole, especially to his *Voyage of Life* series which had, during the late 1840s and 1850s, enjoyed critical acclaim and great popular esteem (fig. 1.3). (The American Art-Union offered the series as a prize—and James Smillie's steel engraving of *Youth* as a premium for membership—in 1849, the year it attracted its largest number of subscribers.) For most of his working life Cole was considered the United States' leading landscape painter, and his untimely death in 1848 was represented in the press as a national calamity. Yet eight years later *The Crayon* did not hesitate to condemn Cole's *Voyage of Life* and his art in general in the harshest terms imaginable:

> Cole, in his "Voyage of Life," has grounded on both rock and quicksand, and the success of his allegories, generally, has been as injurious to the

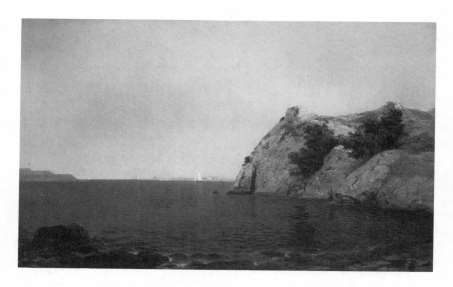

1.4 John F. Kensett, *Beacon Rock, Newport Harbor,* 1857. Oil on canvas, 22 1/4 x 35 3/16 in. (56.6 x 90.9 cm.). National Gallery of Art, Washington, D.C. Gift of Frederick Sturges, Jr. © 1997 Board of Trustees, National Gallery of Art, Washington.

ideal of Art, as instrumental to his own success in life. The popularity of these semi-religious stories he told on canvas, was not based at all on his Art, but on his morality or his theology—a significant token of his weakness. . . . As landscapes, the pictures of the "Voyage of Life" are false, artificial, and conventional, and far below the standard he aimed at in his pure landscape-painting. There is not, we believe, in the whole series, one earnest, faithful study from Nature, one object in which we can find that Cole was reverent towards those truths which it is made the duty of the landscape-painter to tell us (which, in fact, he never was, even when he professed only to paint a landscape); rocks, trees, and shrubs, fall alike under the censure of the student of Nature.[30]

What explains the vehemence of *The Crayon*'s assault upon Cole's reputation? In my view, it resulted from an ongoing effort to distinguish between a presumably debased popular art and an elite or high art that conformed to Ruskinian (or later Luminist or Crayonist) ideals. In this respect, it is significant that the fully evolved Luminist or Crayonist aesthetic promoted relatively small paintings (as against Church's or Albert Bierstadt's outsize extrava-

ganzas) which could be enjoyed by only one or two viewers at a time, thereby addressing viewers in more private and subjective terms, and that these smaller pictures were generally devoid of the sort of sensational subject matter often chosen by Church and Bierstadt. Instead they tended to emphasize subtleties of individual perception and the artist's unique sensibility, qualities that appealed only to those few who possessed the abilities necessary to appreciate them (fig. 1.4).

Luminism or Crayonism attests to the way in which bourgeois elites almost reflexively attempt to formulate a high art aesthetic. Yet an aesthetic is one thing, an aesthetic institution another. As a high art institution, Crayonism was doomed to failure. Like the work of such artists as Albert Pinkham Ryder and James Abbott McNeill Whistler, it represented a form of aesthetic exclusivity, a way of defining an unbridgeable distance between classes.[31] Paul DiMaggio has noted that

> a secret or thoroughly esoteric culture could not have served to legitimate the status of American elites; it would be necessary to share it at least partially. The tension between monopolization and hegemony, between exclusivity and legitimation was a constant counterpoint to the efforts at classification of American urban elites.[32]

Sharing required that institutions be insulated from the marketplace and from the political vagaries of the state. But it also required that institutions, like the American Art-Union, make education and uplift their primary rationale. Thus, during the post-Civil War period, as a national upper class emerged, the public art museum—with its promise of canonical histories of art and a relatively uniform set of aesthetic criteria—became not only an urgent necessity but also, given the class's new strength, a real possibility.

CHAPTER TWO
William Wilson Corcoran's Failed
National Gallery

How are national collections constituted? What are the general historical pre-conditions for establishing national museums and national galleries of art? There are, I believe, two such preconditions. They are fairly obvious, although they become perhaps somewhat less obvious when we begin to examine them in relation to historical examples.

The first precondition is that there be a centralized state power with the ability to create and sustain national institutions. It follows that when such a power exists, particular institutions and groups may claim national status and in some situations be capable of designating themselves "national," though their claims will, in the long run, be of relatively little consequence without the state's imprimatur. Second, the state must experience a need for a national gallery and a national collection. Needs of this sort vary, but they fall into two broad categories: the need to address a national audience—to represent the nation to itself in a particular form and thereby play a role in shaping it as, what Benedict Anderson calls, an "imagined community."[1] And, the need to address an international audience and thus represent the nation in relation to other nations.

I

Turning to the United States in the nineteenth century we encounter a situa-tion in which neither precondition fully applies. In the period before the Civil War the country was, as Bertram Wyatt-Brown has put it, "held together

largely by common memories of Revolutionary triumph and the making of the Constitution—and mutual indifference."[2] While it was possible with the Smithsonian for the state to create a national scientific institution, the Smithsonian was to a large degree an exception, an anomaly precipitated upon a federal government torn by sectional rivalries and notable for its general absence from cultural affairs.

Union victory in the Civil War produced the modern American state, a state whose "inheritance from the antebellum period was," in Richard Bensel's words, "nil."[3] This new, centralized state, invented during the 1860s by a Republican Party juggernaut intent upon institutionalizing its program of industrial development and territorial expansion, possessed the ability to create national institutions pretty much at will. And yet, while Gilded Age capitalists amassed great collections in their palatial townhouses, and while, between 1870 and 1900, municipal art museums multiplied at a dizzying rate, there was hardly any interest on the part of the federal government in the formation of a national art collection or national gallery. As Richard Rathbun, an assistant secretary of the Smithsonian and a highly interested observer of these matters, noted in 1909, "the cultivation of art, even in directions promising practical benefits to the people, has never received encouragement from the national Government, except in the privilege of copyright and patent."[4]

Why was this the case? By the time Rathbun wrote, the idea of a national gallery and art collection had, in one form or another, been mooted for more than a century. In 1806 Jefferson had campaigned for a national university which, as he envisioned it, would incorporate Charles Willson Peale's Philadelphia Museum. Although known primarily for natural history collections organized in accord with the Linnaean system of classification, Peale's Museum also featured portraits of heroes of the Revolution and of figures such as the naturalists Baron Cuvier and Alexander von Humboldt, who presided over the glass cases, which displayed American mammals, birds, and fish.[5] Peale conceived of his museum as part scientific institute, part patriotic shrine, but his concept was not limiting; in 1789 he exhibited a collection of Italian paintings. Later American museums, conceived along similar Enlightenment lines, often also combined natural history displays with exhibitions of works of art. This was true of efforts in Washington, D.C., such as the Columbian Institute (1816–1838), John Varden's Museum (1829–1841), and the federally sponsored National Institution for the Promotion of Science. The latter, founded in 1840, exhibited a collection of government-owned paintings in the

great hall of the Patent Office Building during the 1850s. (The collection was known to some contemporaries as the "National Gallery.")[6] The National Institution took over Varden's Museum in 1841, and was in turn absorbed by the fledgling Smithsonian in 1862. Joseph Henry, the Smithsonian's first secretary, had no interest in running either a natural history museum or an art museum (he thought the Smithsonian should dedicate itself exclusively to scientific research), but he dutifully carried out the terms of James Smithson's will, which called for the creation of an art gallery. Thus in 1858 he set up an exhibition of paintings in the Smithsonian's west wing, only to abandon it in 1865 after a fire destroyed much of its contents.[7] This put an end to the Smithsonian's "National Gallery" for the remainder of the century.

The temples of art that began to appear in the large cities of the Northeast and Middle West after the Civil War bore little resemblance to what had earlier passed (in the United States) for a museum. Although Peale's Philadelphia Museum and the Washington, D.C., predecessors of the Smithsonian were primarily devoted to educational scientific displays, to most of the antebellum public the word "museum" signified a form of popular entertainment—a collection of freaks and curiosities, which could, by no stretch of the imagination, be described as scientific or enlightening. For example, Gardiner Baker's American, or Tammany Museum, which opened in New York in 1789, featured, among other things, a haphazard assortment of natural history specimens; a waxworks; Indian, African, and Chinese artifacts; a menagerie; a steamjack; a Scottish threshing machine; and a Gilbert Stuart portrait of George Washington.[8] Baker's museum later passed into the hands of George Scudder and was eventually sold to P. T. Barnum, who also bought a number of Peale family museums.[9]

The elites that built big city art museums in the years between 1870 and 1900 were at pains to distance themselves from Barnum-like enterprises. Boston Brahmins, parvenu New York merchants, and Chicago industrialists labored for the institutionalization of high culture. Their efforts, as sociologist Paul DiMaggio has argued, involved the sacralization of certain cultural forms via definitions that rigorously distinguished between high art and its opposite, low or popular entertainment.[10] Although the definition of high art proved capacious enough to accommodate such elite preoccupations as collections of arms and armor and accumulations of antique musical instruments, it nonetheless served the purpose of delimiting cultural property. High art belonged to the elite and to a segment of the middle class. The institutionalization of

high art meant "the acknowledgment of that classification's legitimacy by other classes and the state."[11]

The great magnates of the Gilded Age purchased culture by the carload. Matthew Josephson has described unforgettably how the robber barons "ransacked the art treasures of Europe, stripped medieval castles of their carvings and tapestries, ripped whole staircases and ceilings from their place of repose through the centuries to lay them anew amid settings of a synthetic age and a simulated feudal grandeur."[12] Yet their acquisition of cultural property played across the divide between monopolization and hegemony, exclusivity and legitimation. As individuals, these men practiced conspicuous consumption, vying to outdo one another in the richness and value of their holdings; as members of a class, they cooperated in creating civic institutions over which they exercised exclusive control. Torn between building monuments to their personal fortunes and monuments to their civic-mindedness, they found themselves caught up in local politics and local society.

The history of the art museum in the United States in the late nineteenth century was thus intertwined with the peculiar histories of urban elites, the rise and fall of different groups within them, and their efforts to achieve cultural hegemony at the local level.[13] Consequently, while robber barons and captains of industry boldly hijacked the national economy, they displayed an uncharacteristic reticence when it came to the question of a national art museum or gallery.

2

There was one exception: William Wilson Corcoran, financier, political operator, and founder of the Washington art museum that bears his name (fig. 2.1). For a brief historical moment, the Corcoran Gallery was the nation's premier art museum—and, as I shall argue, a would-be national gallery.

Although he lived until 1888, Corcoran was no robber baron but belonged instead to an earlier generation of bankers and financial speculators.[14] Born in 1798 into a well-to-do Georgetown family (his father was both businessman and local politician), he went to work, when he was a teenager, for a Georgetown dry goods merchant and, at the age of nineteen, founded his own firm with help from his brothers. Although the company failed in the Panic of 1823, Corcoran had by then cemented lifelong ties to two other Georgetown dry goods merchants, Elisha Riggs, who went on to become a leading Wall Street

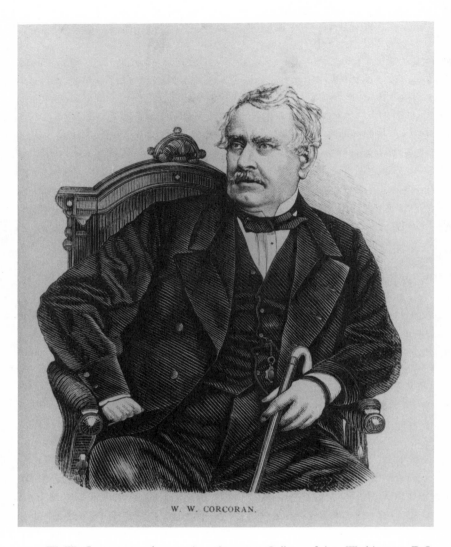

W. W. CORCORAN.

2.1 *W. W. Corcoran,* wood engraving, Corcoran Gallery of Art, Washington, D.C. From M. E. P. Bouligny, *A Tribute to W. W. Corcoran of Washington City* (Philadelphia, 1874), frontispiece.

banker, and George Peabody, Riggs's partner, who later made a fortune working in London with the financier Junius Morgan. Corcoran's career languished until 1837 when he opened a brokerage firm in Washington; two years later, with capital supplied by Elisha Riggs, he formed a banking partnership with Riggs's son George.

In the next few years, the firm of Corcoran and Riggs assumed the role of the defunct Bank of the United States as a repository of government funds. (With fitting symbolism, Corcoran and Riggs, in 1845, also took over the bank's building, located diagonally across the street from the White House.) In addition, the firm played a profitable role as chief intermediary between the United States Treasury and the Wall Street money markets. In 1846 Corcoran arranged the financing of the Mexican War, taking on, over a period of two years, close to $24 million in government bonds. When in 1848 the United States securities market declined, Corcoran successfully sold United States bonds in London and Paris. This was risky business, causing Corcoran's more conservative partner to withdraw from the firm, but in the end it brought Corcoran a bonanza.

At this point Corcoran could have retired, but he stayed on until Franklin Pierce's reform-minded Treasury secretary, James Guthrie, removed the federal deposits from the firm, thus depriving it of its favored position as the nation's leading "pet" bank. Yet even after leaving Corcoran and Riggs early in 1854, Corcoran remained in business as a large-scale investor and private banker, which meant that, more or less as a matter of course, he continued his deep involvement in politics. (He was, for example, part of the cabal that secured James Buchanan's election to the presidency in 1856.)[15]

Corcoran became known as the "American Rothschild," but he was not remembered as being especially brilliant or quick-witted. His outstanding traits as a businessman were "a keen opportunism" and a knack for diplomacy.[16] A Democrat at a time when the banking community tended to be Whig, Corcoran made the most of his connections with the dominant party. But he also knew how to get along with the opposition, and his bank maintained the same special relationship with the Whig administrations of Zachary Taylor and Millard Fillmore as had brought it prosperity with the Democrats. As a successful banker Corcoran "relished the authority, the prestige, and above all the sense of being in the center of things."[17] In 1849 he bought Daniel Webster's former residence at 1 Lafayette Square, directly across from the White House. He was, as Henry Cohen has written,

the Capital's outstanding host. His annual ball for the Congress and his weekly gourmet dinners were practically institutions, as well as useful instruments of goodwill. When Jenny Lind, the famous singer (and shrewd businesswoman), appeared in Washington, it was natural that he was chosen to entertain her, and so with other eminent visitors.[18]

In 1854, when Corcoran was on the verge of retirement, George Peabody wrote from London urging him to reconsider: "It is true you don't want more money; but if you retire, I think you will sigh for that particular occupation and excitement which both you and myself have been accustomed to all our business lives."[19]

Yet if Corcoran gave up "that particular occupation," he did not want for excitement. Politics and private investing provided it in abundance, as did the creation of an art gallery which in effect was, for Corcoran, politics by other means.

Corcoran pursued his interest in art with the same combination of diplomacy and opportunism that had marked his business career. Taking a cue from his European associates, he began, in the late 1840s, to seriously collect European landscape and portrait paintings. In 1850 he expanded operations, buying the work of American artists and, as one contemporary observed, was always on the lookout for "conspicuous examples."[20] Among his early purchases were David Huntington's *Mercy's Dream* of 1850, a fashionable work at the time; Thomas Cole's 1837 series the *Departure and Return,* which Corcoran obtained for $6,000 from William Van Rensselaer, scion of an ancient, aristocratic New York family; and Hiram Powers's *Greek Slave* (fig. 2.2), antebellum America's most popular sculpture (Powers made five replicas; Corcoran's was the first), a work that many at the time interpreted as a representation of the quintessential woman, and some saw as the quintessential slave.[21] More than any other acquisition, *The Greek Slave* secured Corcoran's reputation among his contemporaries as "a righteous man and a true critic of art, who would never purchase a work of art that was of inferior quality or in poor taste."[22] (Beyond the issue of "taste," one wonders what Powers's *Greek Slave* actually signified for Corcoran and his circle of financiers and politicians, especially since he was, like so many who were close to him, a slaveholder.)

As his collection of American art grew, so did his reputation as patron and benefactor. He bought not only "name" works but works by unknown American artists as well. He was also, in 1856, a founding member of the Washington

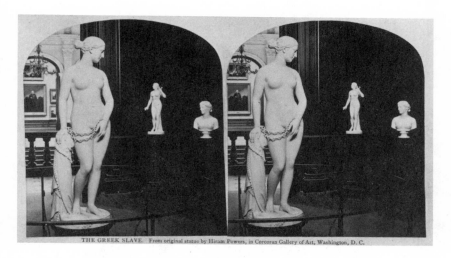

2.2 *The Greek Slave.* From the original statue by Hiram Powers, c. 1877, stereoscopic photograph, Corcoran Gallery of Art, Washington, D.C.

Art Association, which he supported by buying works from its artist members, providing exhibition space, and paying exhibition expenses. William MacLeod, a landscape painter and, later, curator of the Corcoran Gallery, vividly recalled the "sumptuous dinner" Corcoran held at his house for members of the association at the close of their 1859 exhibition, where Corcoran, with "his fine personal appearance . . . [and] with the dignity of years struck his friends as the ideal of a courteous, wealthy friend of art."[23]

There was in all these activities an almost inexorable expansionist logic. Corcoran's growing art collection required a gallery of its own, and in the early 1850s he hired James Renwick, the architect who had designed the Smithsonian Institution Building, to remodel his house on Lafayette Square to accommodate a gallery, which he then opened to the public two days a week.

There was nothing particularly unusual in this development: earlier American collectors and patrons, for example Luman Reed, had set up galleries of European and contemporary American works and, as a matter of *noblesse oblige,* opened them to a polite audience. But by the mid-1850s, Corcoran's ambition had enlarged even further. He visited Paris in 1855 and was deeply impressed with the additions to the Louvre being built under the direction of Louis Bonaparte's architect, Hector Lefuel. (Renwick was in Paris at the same time and may well have viewed the "new" Louvre with Corcoran.) Back in Wash-

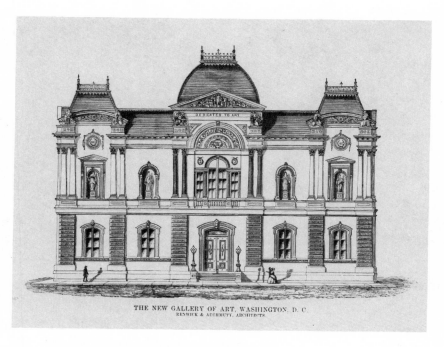

THE NEW GALLERY OF ART, WASHINGTON, D. C.
RENWICK & AUCHMUTY, ARCHITECTS.

2.3 Corcoran Gallery, exterior, 1870s, wood engraving,
Corcoran Gallery of Art, Washington, D.C.

ington, Corcoran became, as we have seen, the *éminence grise* of the Washington
Art Association. The association was not only dedicated to exhibiting local
artists; it also embodied a larger aim described by a writer in 1859 as establish-
ing "a 'National Gallery of the Fine Arts' in the metropolis of the nation, to
call the attention of the government to the neglects, the narrowness, and the
caprices of national patronage; to ask protection for genius; to excite our
public men to constitute themselves the true patrons of the living genius of
the land."[24]

Corcoran committed to paper almost none of his thoughts on art; conse-
quently, this description is probably the closest approximation available of his
ideas on the subject of a national gallery and a national program for the arts.
Having seen the Louvre in Paris—and in all likelihood having been impressed
by the French tradition of government patronage—Corcoran now contem-
plated an "American Louvre," a national institution dedicated to the history of
art and to the promotion of national "genius." Such a vision required prompt

action. Skilled at operating behind the scenes, Corcoran probably at first intended that a national gallery be the work of the Washington Art Association; but if that was the case, he evidently changed his mind. Impatient, accustomed to having his way, in the end he bypassed the association and set out on his own. Renwick was engaged, land was acquired at the corner of Seventeenth Street and Pennsylvania Avenue (diagonally across from the White House and directly across from the War Department), and in 1859 work was begun. By 1861 Renwick had almost completed the exterior of the Louvre-like Renaissance revival building, and the words "Dedicated to Art" had been inscribed over the entrance. In the process, the national gallery became the Corcoran Gallery of Art (fig. 2.3).[25]

3

At this point things began to go seriously awry. Corcoran opposed the Civil War, but when it came, his loyalties, like those of many Washingtonians, were with the South.[26] Resentment against him grew. It was known that he handled financial matters for several Confederate leaders including Jefferson Davis, and that he entertained Southern sympathizers in his home. He began to take precautions. In the fall of 1861 he shipped his fortune abroad. A year later he went into exile in Europe. Many never forgave him this desertion.[27] He returned to Washington in 1865 to find his gallery turned into a Union Army clothing depot, and the Republicans out for revenge. Secretary of State Edwin Stanton spent a year harassing him with tax evasion proceedings. Corcoran worked to rebuild his position but did not attempt to conceal his sympathies. He gave money to Virginia colleges damaged by the war. He built a home in Washington for genteel Confederate widows down on their luck. In 1870 he presided over a memorial meeting for Robert E. Lee. In 1873 he helped found the Southern Historical Society, an organization dedicated to promoting the Confederacy's version of the Civil War.

Yet if Corcoran publicly supported the defeated South, he also exhibited a zealous patriotism as part of his effort to reconstitute his position as a national figure. He became an "extremely active member," as Davira Taragin notes, of the Washington Memorial Society. He also involved himself in the building of a monument to Thomas Jefferson and gave generous support to the restoration of Mount Vernon.[28]

But it was his art gallery that was to be the main vehicle for his national

aspirations, and it presented difficult problems. Having confiscated it during the Civil War, the federal government at first refused to restore it to him. There was, first, a wrangle over rent. Eventually agreements were reached. The sequence of events can be summarized as follows: in May 1869 Corcoran deeded the Gallery to a board of trustees consisting mainly of business allies and associates, including his old banking partner George W. Riggs.[29] In September the government returned the gallery, and in May 1870 Congress granted the trustees a charter of incorporation. Work on the building resumed a month later, and in February 1871 Corcoran celebrated its completion with a ball that was, according to a contemporary newspaper account, "the most magnificent . . . ever held in Washington."[30] The ball took place on Washington's Birthday and was meant to raise funds for the Washington Monument Society. It also marked the reconciliation between Washington's indigenous elite, which had sided with the South during the Civil War, and Republican officialdom, which on this occasion included, not only President Ulysses S. Grant and Vice President Schuyler Colfax, but also General William Tecumseh Sherman who stood shoulder-to-shoulder with Corcoran at the head of the receiving line. Three years later the Corcoran Gallery opened its first exhibition with the president and other high officials once again in attendance.

In his 1869 letter to the gallery's future trustees, Corcoran stated his intention of creating an institution "to be 'Dedicated to Art,' and used solely for the purpose of encouraging American genius in the production and presentation of works pertaining to the 'Fine Arts,' and kindred objects."[31] Corcoran's language is reminiscent of the Washington Art Association's call more than a decade earlier for "the protection of [American] genius." In other words, Corcoran continued to adhere to a belief, characteristic of the period 1825–1860, that a truly patriotic art collector would be primarily concerned with fostering the development of contemporary American art. This idea determined, for the most part, the Corcoran Gallery's organization and collecting policies during the first decade of its existence.

The gallery projected a version of the history of art in which American art was seen as a continuation of a Western fine arts tradition stretching back to the ancient Greeks.[32] Visitors to the gallery in 1877, three years after it opened, encountered on the ground floor a stupendous collection of plaster casts, electrotype reproductions, and original works in marble, bronze, and ceramic.[33] The sculpture hall (fig. 2.4) at the back included full-sized casts of

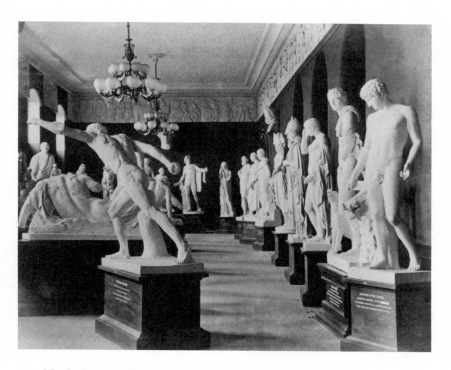

2.4 The Sculpture Hall, c. 1885, photograph, Corcoran Gallery of Art, Washington, D.C.

the Elgin marbles, the *Discobolus,* the *Venus de Milo,* the Medici and Capitoline Venuses, the *Laocoön,* the *Apoxyomenos,* the *Apollo Belvedere,* and dozens of other replicas of works belonging to the Louvre, the British Museum, the Vatican Museums, and so on. Other rooms contained copies of Renaissance sculpture, including casts of Ghiberti's *Gates of Paradise* and Michelangelo's *Slaves* (from the Louvre); electrotype reproductions of ninety objects from the South Kensington Museum as well as armor from various collections; and a number of original works including 114 bronzes by Antoine Louis Barye, majolica vases, and Japanese vases. Ascending the impressive main staircase, visitors found themselves moving along a north-south axis (fig. 2.5) running from the Octagon Room, specially designed to display the *Greek Slave,* to the Main Picture Gallery, the Corcoran's own Salon Carré, where eighty-eight European and American paintings were exhibited in the closely-packed manner characteristic

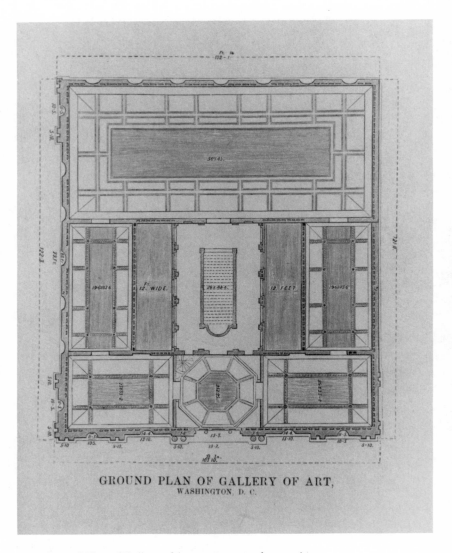

GROUND PLAN OF GALLERY OF ART,
WASHINGTON, D. C.

2.5 Ground Plan of Gallery of Art, c. 1877, wood engraving,
Corcoran Gallery of Art, Washington, D.C.

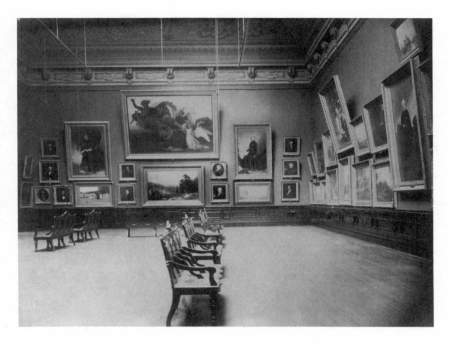

2.6 View of the Main Gallery, c. 1880, photograph, Corcoran
Gallery of Art, Washington, D.C.

of the period (fig. 2.6). This gallery was the heart of the collection, the culmina-
tion of the canonical history set forth on the lower level, and it displayed an
indiscriminate mix of European and American paintings (almost all by con-
temporary artists) as if to demonstrate that American art could hold its own in
international company—an important point for middle-class Americans in the
nineteenth century, who tended to a prickly defensiveness when it came to the
products of American culture.

To a degree Corcoran succeeded in his aims. As Taragin observes, "the role
of the Corcoran Gallery of Art as a repository in the nation's capital of Ameri-
can masterpieces caused artists to believe it was a great honor to have their
works included in the collection."[34] Indeed, the Hudson River School painter
Albert Bierstadt went so far as to offer for sale a painting of an entirely ficti-
tious "Mount Corcoran" in an effort to have his work included in the gallery.

But success in creating a gallery of American art was one thing, achieving

national gallery status another. Although the Smithsonian made a loan during the 1870s of most of the paintings that had survived the fire of 1865, the loan did nothing to advance the gallery toward official status. Corcoran persisted. He began assembling a collection of portraits of presidents and other American notables, and in 1879 curator MacLeod made known Corcoran's idea that the gallery's "main objective was to collect portraits of national heroes."[35] But this was a move more appropriate to the age of Luman Reed and Charles Willson Peale than to that of Carnegie and Frick.

4

Corcoran's initial plan for a national gallery may have seemed grandiose at the time, but he was probably the only person in the United States who in the 1850s could have reasonably entertained such an idea. Like the robber barons of a later generation, Corcoran achieved national influence while working his way up a local social ladder. However, because Corcoran was a Washingtonian, he faced two distinct although sometimes overlapping social hierarchies, one consisting of old Washington families, the other a government hierarchy extending from senators and representatives to cabinet members and the president. As part of a quasi-permanent shadow government, Corcoran identified with federal power and was capable of seeing that power in an international context. The plan for his gallery was thus a perfect symbolic vehicle for his position as the "American Rothschild." Not that the situation evolved as simply or as unambiguously as the previous sentence implies. Still, Corcoran's ambition—never directly articulated, although steadily pursued—took an entirely conventional form. As Pierre Bourdieu reminds us, a love of art, while it may mean many things, signifies above all else the quest for the only type of "distinction" bourgeois society allows.[36] That Corcoran sought such distinction is beyond doubt: not for nothing was his gallery "Dedicated to Art." Yet his project was premature since its success required achieving on a national level a form of cultural hegemony that barely existed anywhere on a local level.

Perhaps Corcoran sensed as much. The particular type of national gallery he envisioned would have, in the words of the Washington Art Association's program, "excite[d] our public men to constitute themselves the true patrons of the living genius of the land." But such "true patrons" were not available before the Civil War—or after. By then, Corcoran's ideas for a national gallery were rapidly becoming anachronistic. Despite his continuing efforts to win

federal support, his gallery, like other big city museums of the period, functioned primarily as a monument to the cultural aspirations of a local, not a national, elite. When, almost a decade after his death, the gallery moved to its present location, it relinquished in symbol as well as in fact any lingering claim to national gallery status.

CHAPTER THREE

The American Cast Museum: An Episode in the
History of the Institutional Definition of Art

Introduction

Historians have long been aware that a visit to an art museum in the United States during the years between 1874 and 1914 often involved the perusal of a collection of casts and reproductions, but they have made very little of this remarkable fact.[1] During this period, sculptural replicas were the order of the day, the means by which the museum-going public was to acquire the benefits of a higher civilization. Casts were admired, studied, judged in terms of their quality as casts, and only rarely criticized. In 1898 Samuel Parrish, proprietor of the Southampton Art Gallery (today the Parrish Art Museum), argued that cast collections were "the real treasures" of the great museums of New York, Boston, Chicago, and Washington. In Parrish's view, collections of "modern pictures," although "interesting and valuable," did not compare in educational worth with "plaster reproductions of the antique and Renaissance sculpture, those masterpieces of the genius of man at its highest period of development in the world of art."[2] Parrish's comments echoed a commonplace opinion of the time. If we take his comments seriously—and I believe we should—they pose a historical problem. Because we are now so accustomed to equating museum art with notions of originality and authenticity, the collections of plaster casts that once filled American art museums may seem to have been at best stopgaps, simulacra of "real" or "authentic" museum collections. In other words we may be too ready to understand them only in comparison with what eventually replaced them, thus missing the aesthetic and social imperatives that

prompted early museum proprietors, directors, and boards of trustees to fill elaborate and expensive museum buildings with relatively inexpensive collections of copies and reproductions. Yet the history of the creation and subsequent obliteration of cast collections in American art museums forms an important part of the history of the concept of art itself: for it was only through the institutionalization of the polarity between original and copy, authentic and fake, that art became irrevocably associated with notions of originality and authenticity.

The Art Museum in the Age of Mechanical Reproduction

The history of American art museums before 1900 is, with one or two exceptions, a history of collections of casts and reproductions. Although museums may have possessed extensive holdings of other works—often examples of modern (i.e., nineteenth-century) painting and sculpture—the heart and soul of the public art museum, the works that provided it with its raison d'être, were assemblages of casts of famous antique sculptures: the Parthenon frieze, figures from the Parthenon pediments, the *Discobolus,* the *Belvedere Torso,* the *Apollo Belvedere,* the *Dancing Faun,* the *Laocoön* (fig. 3.1), the *Borghese Warrior,* the *Dying Gladiator,* the *Seated Boxer,* the *Uffizi Wrestlers,* the *Apoxyomenos,* Praxiteles' *Hermes* and *Dionysos,* the *Niobe Group,* the *Spinario,* the *Capitoline Venus,* the *Venus de Medici,* the *Venus de Milo* (fig. 3.2), the *Winged Victory* (fig. 3.3). These works were almost invariably supplemented with casts of Italian Renaissance sculpture: Ghiberti's *Gates of Paradise;* Donatello's *St. George,* bronze *David,* and reliefs from the Cantoria in Florence's Duomo; Luca della Robbia's Cantoria reliefs; Andrea della Robbia's *Visitation;* Verrocchio's *David;* Michelangelo's *David, Pietà, Moses, Slaves,* and Medici Tombs (fig. 3.4). Moreover, in addition to casts of antique and Renaissance sculpture, museums frequently exhibited architectural casts, casts of Assyrian, Egyptian, and medieval sculpture, electrotype reproductions of coins and metal work, and photographs of paintings and other works of art.

That American art museums would be museums of casts and reproductions was, from the beginning, taken for granted. For example, when the Corcoran Gallery of Art opened in Washington, D.C., in 1874, it featured casts and electrotype reproductions, and original works in marble, bronze, and ceramic.[3] Predictably, the Corcoran's sculpture hall, at the back of its ground floor, included full-sized replicas of the Elgin marbles, the *Discobolus,* the *Venus de*

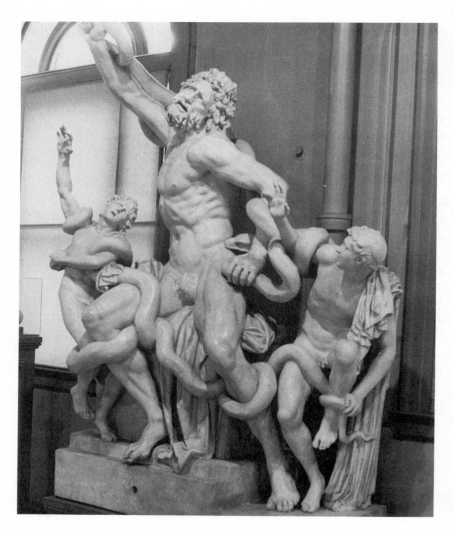

3.1 *Laocoön,* cast, George Walter Vincent Smith Art Museum, Springfield, Massachusetts. Photo: author.

Milo, the Medici and Capitoline Venuses, the *Laocoön,* the *Apoxyomenos,* the *Apollo Belvedere,* and dozens of other works belonging to the Louvre, the British Museum, and the Vatican Museums (see fig. 2.4). Other rooms contained copies of Renaissance sculpture, including casts of Ghiberti's *Gates of Paradise* and Michelangelo's *Slaves.* There were, in addition, electrotype repro-

ductions of ninety objects from the South Kensington Museum (mainly Renaissance goblets, beakers, ewers, and candlesticks), copies of arms and armor from the Louvre, as well as a miniature replica of the recently rebuilt Column Vendôme.[4]

Given the often dramatic disappearance of cast collections from major museums beginning shortly after 1900, we might assume that interest in cast collections declined or tapered off during the 1880s and 1890s; however, precisely the reverse is the case. For example, the Boston Museum of Fine Arts opened its doors two years after the Corcoran with twenty-five casts on loan from the Boston Athenaeum and another fifty purchased with proceeds from the sale of a large collection of original oil paintings willed to the museum by Charles Sumner.[5] By 1879 the museum owned 614 sculptural and architectural casts and by 1890 the number had risen to 777 (fig. 3.5). Indeed, the museum boasted that its collection was the third largest in the world, surpassed only by the Royal Museum in Berlin, which possessed 2,271 casts, and the University Museum at Strasbourg, which owned 819.[6] Moreover, like the Corcoran Gallery, the Museum of Fine Arts made sculptural casts a central feature of what might be called its iconographic program.[7] Occupying most of the rooms on the first floor of the building at Copley Square, the cast collection provided the canonical basis, the root in classical antiquity and the Italian Renaissance, for the collection of oil paintings (mainly Italian, Dutch, modern French, and American works), prints, drawings, watercolors, coins, and crafts that visitors encountered on the second floor.[8]

Edward Robinson, the Museum of Fine Arts' curator of classical antiquities and a cast expert, played a key role in the formation and expansion of other cast collections during the closing years of the century. Robinson was responsible for the selection, purchase, and installation of a collection of casts at the Slater Memorial Museum, a part of the Norwich (Connecticut) Free Academy (figs. 3.6, 3.7). According to Henry Watson Kent, the Slater's first curator and, later, director of education at the Metropolitan Museum of Art, the Slater "was to be entirely a museum of reproductions, but of reproductions treated with the gravity and respect due their great originals."[9] The collection at the Slater Memorial Museum, which is still intact, exerted an influence far out of proportion to its size. Charles Eliot Norton, professor of art history at Harvard, and America's leading disciple of Ruskin, gave the keynote address at the museum's opening on 22 November 1888, which was attended by a host of luminaries from the New England worlds of art, education, and philanthropy.[10] In

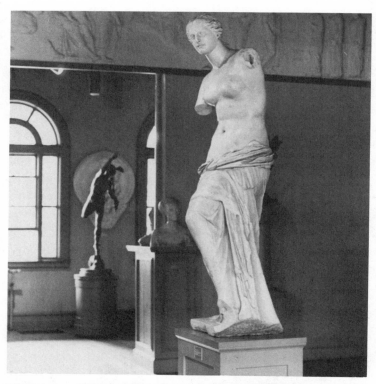

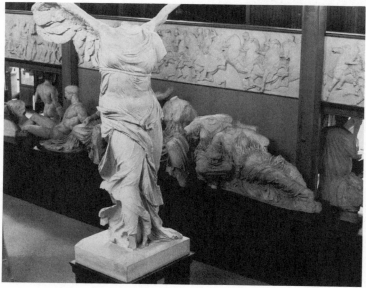

42 THE AMERICAN CAST MUSEUM

3.2 *Venus de Milo,* cast, George Walter Vincent Smith Art Museum, Springfield, Massachusetts. Photo: author.

3.3 *Winged Victory,* Parthenon Pediment Figures (*The Three Graces*) and Section of the Parthenon Frieze, casts, Slater Memorial Museum, Norwich, Connecticut. Photo: author.

3.4 Michelangelo, Lorenzo de' Medici tomb, cast, George Walter Vincent Smith Art Museum, Springfield, Massachusetts. Photo: author.

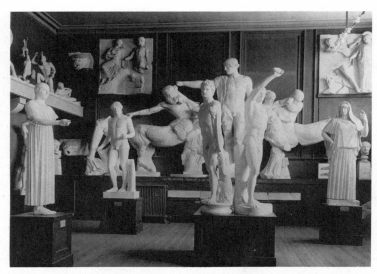

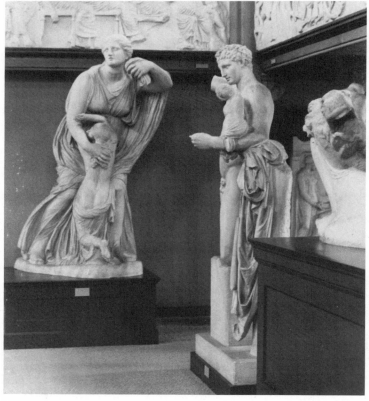

44 THE AMERICAN CAST MUSEUM

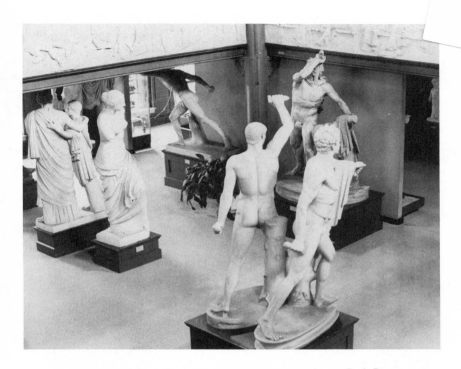

3.5 T. E. Moss, Copywork, *Old Boston Museum Interior as Seen in Back Bay,* ca. 1895. Museum of Fine Arts, Boston. Courtesy, Museum of Fine Arts, Boston.

3.6 View, Slater Memorial Museum, Norwich, Connecticut. Photo: author.

3.7 View, Slater Memorial Museum, Norwich, Connecticut. Photo: author.

1891 William A. Slater, the museum's benefactor, arranged for a special drawing room car to convey members of the Metropolitan Museum's special committee on casts, and a number of other guests—Andrew Carnegie was one—to Norwich where they spent the afternoon inspecting the museum's collection.[11] The Metropolitan's special committee included Augustus Saint-Gaudens, Stanford White, and Professor Allan Marquand (later an expert on the art of the della Robbias). Appointed in 1890 by the museum's board of trustees, it had within a few years raised almost $80,000 toward the expansion of the museum's hitherto relatively modest collection of casts. With Edward Robinson guiding the committee and acting as its special agent, the Metropolitan purchased two thousand casts including, in Calvin Tompkins's words, "the principal masterworks of Egyptian, Greek, Roman, and Renaissance sculpture, together with scale models of the Hypostyle Hall at Karnak, the Parthenon,

the Pantheon, the Cathedral of Notre Dame, and other architectural monuments."[12] Kent, working in consultation with Robinson, installed the collection in 1894 in the Metropolitan's recently completed Wing C, which was entirely given over to the exhibition of casts.[13]

Having enjoyed Robinson's expert tutelage, Kent oversaw, between 1894 and 1906, the purchase and installation of cast collections at the Buffalo Fine Arts Academy (later the Albright Art Gallery); the Fine Arts Building of the Springfield (Massachusetts) Public Library (the installation was re-created in the late 1970s and is still in place); the Rhode Island School of Design; and, at the behest of Andrew Carnegie, who hadn't forgotten his visit in 1891 to the Slater Memorial Museum, the Carnegie Institute in Pittsburgh.[14] Kent's activities underscore the popularity of cast collections at the turn of the century. I could perhaps endlessly cite examples—collections at colleges and universities of the period (Brown, Columbia, Cornell, Dartmouth, Harvard, Mount Holyoke, Ohio State, Princeton, Yale, etc.); at institutions such as the Valentine Museum in Richmond, Virginia (which put a large collection of casts on display in 1898); and at Samuel Parrish's Southampton Gallery of Art (which also opened in 1898)—but by now the point has been sufficiently demonstrated.[15] Cast collections were not an oddity or a transient fashion but *the* central attraction of American art museums during the years between 1874 and 1905.

Cast Culture

Because of the ubiquity of cast collections, we should not be surprised that nineteenth-century commentators sometimes claimed that casts could provide an aesthetic experience equivalent or even superior to that afforded by originals. Yet the crucial historical question is not whether casts were considered comparable to originals but how critics and museums justified the exhibition of cast collections in the first place. Here we encounter not only arguments but also tacit assumptions about the importance of casts and the works of art they reproduced or represented. We encounter, in other words, an evolving art ideology in which collections of reproductions of antique art both defined and supported the larger purposes of a developing American culture. That culture now saw itself competing with the high cultures of France, England, Italy, and Germany, thereby staking its claim to the heritage of western civilization, symbolized above all by the sculpture and architecture of Greco-Roman antiquity and the Italian Renaissance.

The literature of the period overflows with appeals to the civilizing potential of the masterpieces of antique and Renaissance art. For example, in January 1870, perhaps in anticipation of the opening that year of major museums in Washington, New York, and Boston, a writer for *Appleton's Journal* set forth an argument for art museums and, implicitly, collections of casts:

> A museum of art would afford us adequate instruction in the vestiges of the ancient civilizations—a solemn and beautiful teaching—it would foster *reverence*, without which man is barbarian, and obnoxious to every fine and noble sense of the difference of things. We are a raw and noisy and obtrusive people; but place one generation of us under the influence of the past, let us see something grand and beautiful, *not* made by our hands . . . and perhaps we shall feel the sweet flower of humility break through our pride, and diffuse its gracious influence over us.[16]

Or consider the words of Edward Robinson, reflecting in *The Nation* (1889) upon the significance of the recently opened Slater Memorial Museum:

> More than once we have endeavored to impress upon our readers the importance of collections of casts and other art reproductions as factors in popular education. It is only through these that the body of our people can ever hope to become familiar with the great masterpieces of European galleries, which have had so much effect upon the taste of people among whom they exist, and might do a similar good work in this country were they only brought within reach. Doubtless there are many who join us in the wish that not only every large, but every small city might have its gallery of reproductions as well as its public library—a gallery in which children could grow up familiar with the noblest productions of Greece and Italy, in which the laborer could pass some of his holiday hours, and in which the mechanic could find the stimulus to make his own work beautiful as well as good.[17]

These rationales have a familiar ring: museums with their collections of casts would civilize and refine a "raw" American public, would tame "the barbarian" and enhance the lives of not only the educated middle class but also "the laborer" and "the mechanic," who would directly apply, to their work, lessons in ideal beauty learned at the museum.

The arguments put forth by Robinson and others were unabashed and relatively straightforward. Yet questions remain: why the particular focus on

Greek, Roman, and, to a somewhat lesser degree, Renaissance sculpture? What special powers did plaster replicas of such works as the *Laocoön* or the *Medici Venus* possess? Why did commentators, almost without exception, simply assume their civilizing value, their necessary contribution to what was so often denominated "popular education"?

The answer to these questions forms the basis of what I call "cast culture." In the introduction to their study of the taste for the antique, Francis Haskell and Nicholas Penny remark that "for many centuries it was accepted by everyone with a claim to taste that the height of artistic creation had been reached in a limited number of antique sculptures." These works constituted the canon of ancient art and served "as the only bulwark of absolute values in a world governed by capricious and frequently changing tastes."[18] As a cultural form the art museum was predicated upon European tradition. Consequently, when art museums made their appearance in Boston, New York, and Washington, D.C., there was no question that they would be temples to the same muses that presided over the Louvre and the British Museum. Cast culture arose in the United States in a society in which education remained identified, as in Europe, with the study of Greek and Latin, and classical literature and classical art were generally viewed as the unshakable foundations of learning and taste. Popular education—to which American museums at first enthusiastically dedicated themselves—did not mean a different type of education, rather it meant making available to a broader audience, on terms that can be easily imagined, not only representations or simulacra of antique and Renaissance art, but also the values and beliefs associated with it.

For these didactic purposes, then, casts were as good as, and in some respects better than, originals. With casts a museum could present the entire canon of antique sculpture. Indeed, as the architect Pierre LeBrun emphasized in 1885 in *The American Architect and Building News,* collections of casts had "a completeness and a unity not found possible in museums of originals."[19] Casts were celebrated in terms that made them virtually indistinguishable from originals. In a few instances, catalogs of cast collections brought together philological and archaeological data with a precision and sophistication that matched anything written about the originals. Edward Robinson's catalog of Greek and Roman sculpture at the Museum of Fine Arts—first published in 1891, and extensively revised in 1896 to take into account recent archaeological findings—was a model of its kind.[20] Even small art museums, like the Valen-

tine, made strenuous efforts to furnish visitors with information and extensive commentaries.

Thus American art museums, at the turn of the century, stood as monuments to traditional learning and traditional concepts of civilization. The buildings' facades, frequently adorned with replicas of canonical works and the names of canonical artists, served as fitting preambles to all that visitors would encounter within. The cast collections that filled museum galleries were neither anomalies nor stopgaps but integral to their purpose and highly compatible with their designs, providing an entirely fitting visual complement to their often elaborate Beaux Arts settings.

The Cult of the Original

As we have observed, between 1890 and 1894, the Metropolitan Museum's special committee on casts raised almost $80,000 to obtain, in its words, "a complete collection of casts, historically arranged, so as to illustrate the progress and development of plastic art in all epochs, and mainly in those that have influenced our civilization."[21] Indeed, the Metropolitan's Hall of Casts functioned as "the very center" of the original museum building, and for a time during the 1890s the museum operated a "moulding department" in emulation of the Louvre's Atelier de Moulage. Yet in 1906 the museum abolished the office of curator of casts, and over the next three decades the cast collection slowly disappeared from public view.[22]

At about the same time that the Metropolitan was abolishing its cast department, Boston's Museum of Fine Arts witnessed a dramatic "battle of the casts," pitting Edward Robinson, now the museum's director and curator of classical antiquities, against Matthew Prichard, a British student of classical art and the museum's assistant director.[23] This rather murky "battle" resulted in Prichard's demotion and eventual departure from the museum, and in Robinson's resignation (he went on to become assistant director and then director of the Metropolitan). Once the smoke—or rather plaster dust—had cleared, the museum's extensive cast collection began to fade from its galleries. In the 1910 edition of the museum's *Handbook,* published one year after the museum's move from Copley Square to more spacious quarters on Huntington Avenue, the description of the cast collection occupies only three of the book's 348 pages, and it commences with the following *caveat:*

In looking at [the cast collection], it must be remembered that the final perfection of style in the work of great masters cannot be reproduced in plaster. The effect of this material in color, quality of surface, and response to light and shadow is very different from that of the original marble or bronze. The impression that the casts produce should be constantly corrected by reference to the collection of original ancient sculptures in the classical galleries.[24]

What accounts for this sudden turnaround by the United States' two leading art museums? How was it that cast collections, deemed so essential to taste, to popular education, and to the study of a canonical history of art, became, almost overnight, expendable, or worse—as the passage from the Museum of Fine Arts' *Handbook* hinted—an aesthetic embarrassment?

In the United States, the cult of the original had its immediate origins in the 1880s and 1890s. As robber baron collectors began to discover their fortunes equal to the prices charged for old master paintings, Renaissance sculpture, and Greek and Roman antiquities, and as the European art market expanded, the distinction between original and fake became all-important. Connoisseurship was increasingly professionalized, in the person of either the art dealer or the freelance expert. It was at this point that such figures as Joseph Duveen and Bernard Berenson began to make their appearance on the international art scene. Not surprisingly, those most involved in the marginalization of cast collections were often directly concerned with the collecting of originals. Consider, for example, the case of Matthew Prichard. Before coming to Boston, Prichard had lived at Lewes House in Sussex, England, an establishment presided over by the eccentric antiquarian Perry Warren, scion of a wealthy Boston family and brother of Samuel Warren, president of the museum's board of trustees. Between 1894 and 1902, Prichard collaborated with Perry Warren who, during the 1890s and early 1900s, virtually took control of the European market in Greek and Roman antiquities, purchasing works for the Museum of Fine Arts' rapidly growing collection of original antique sculpture.[25] Upon arriving in Boston, Prichard became a close friend of the collector Isabella Stewart Gardner and took an interest in the work of her protégé, Bernard Berenson.[26] Immersed in a world in which artistic originality and historical authenticity counted for everything in a work of art, Prichard became the museum's most outspoken advocate for the abolition of the cast collection.

At the Metropolitan Museum, the shift to collecting only original works of art was associated with the regime ushered in by J. P. Morgan in 1904.[27] A collector with a gargantuan appetite, and the financial resources to match it, Morgan not only brought to the museum Roger Fry with his needed expertise in Renaissance painting; he also oversaw the museum's adoption of a new policy on collecting, spelled out in the annual report for 1905. Although in the past the museum had accepted gifts "hardly worthy of permanent display," it would in the future "rigorously exclude all which do not attain to acknowledged standards." According to the report, the museum would endeavor "to group together the masterpieces of different countries and times in such relation and sequence as to illustrate the history of art in the broadest sense, to make plain its teaching and to inspire and direct its national development."[28] The museum would, in other words, better perform its traditional functions through the exhibition of originals that met the highest aesthetic standards. In the brave new museum world created by Morgan and his fellow millionaires on the board of trustees, there was no room for inexpensive replicas or copies. Collecting originals may have required unprecedented sums of money—it was Morgan who told his son-in-law that the three most expensive words he knew were "unique au monde"[29]—but money was after all simply cold cash. What it would buy was what mattered and, as Henry James noticed, at the Metropolitan, money would now purchase nothing less than greatness. At the conclusion of his unparalleled analysis of the Metropolitan's new order, James contemplated the museum's future—a future that would be secured by discarding all that was bogus and second rate: "in the geniality of the life to come [the master wrote, with his usual touch of irony] such sacrifices, though resembling those of the funeral pile of Sardanapalus, [would dwindle] to nothing."[30]

"The Pianola of the Arts"

No one better articulated the argument against casts than the extraordinary Matthew Prichard. Concerned that the Museum of Fine Arts would continue to feature cast collections in its new building, Prichard maintained that the decision the museum made about the disposition of the casts would, in the most fundamental way, determine its future as an institution. In an essay written in December 1903, and intended to be read by the museum's board of trustees, he argued that

A museum of art, ultimately and in its widest possible activity, illustrates one attitude toward life. It contains only objects which reflect, clearly or dimly, the beauty and magnificence to which life has attained in past times. The fruits of this exalted and transcendent life are gathered within its walls, and it is the standard of this life with the noble intellectual activity it presupposes that a museum of art offers for acceptance by its visitors. In a narrower sense, yet in part performance of its wider obligation, the aim of a museum of art is to establish and maintain in the community a high standard of aesthetic taste. In performing this task it is its function to collect objects important for their aesthetic quality and to exhibit them in a way most fitted to affect the mind of the beholder.[31]

For Prichard, a cast was no match for the original work of art as a representative of the "exalted and transcendent life" of past cultures. As he later wrote Samuel Warren, president of the museum's board of trustees, a cast could not communicate the emotion produced by an original. "So true is this that the one thing possible to predicate of every cast, which might indeed be inscribed under each in a museum, is THE ORIGINAL DOES NOT LOOK LIKE THIS."[32] A genuine fin de siècle aesthete, his thinking often shading into something resembling religious mysticism, Prichard put forth arguments for the aesthetic value of originals that in many instances remain current today.[33] According to Prichard, original art exhibited in the museum had no purpose other than to give pleasure:

> The Museum is for the public and not for any caste or section of it, whether student, teacher, artist or artisan, but is dedicated chiefly to those who come, not to be educated, but to make its treasures their friends for life and their standards of beauty. Joy, not knowledge, is the aim of contemplating a painting by Turner or Dupré's *On the Cliff*, nor need we look at a statue or a coin for aught else than inspiration and the pleasure of exercising our faculties of perception. It is in this sense, furthermore, that they are accepted by those who visit our galleries, in accordance with the teaching of Aristotle, who recognized that the direct aim of art is the pleasure derived from a contemplation of the perfect.[34]

Casts were, by contrast, "the pianola of the arts," "trite reproductions such as is the stock in trade of every ready-made museum of art," nothing but "data mechanically produced"; only "our originals are works of art." To exhibit casts

"would be to put them frankly on a level with works of art" and thus degrade originals. For the museum to succeed in its purpose—and it should be noted that in Prichard's writings its purpose was being substantially revised—its new "galleries should be freed of casts." Only then would it be "a gem in a fair setting—a museum of works of art."[35]

Boston's "battle of the casts" thus carried implications that went far beyond the question of the relative value of originals and copies. Would the museum be devoted to education or to aesthetic pleasure? Would it serve the needs of students and artists, or would it appeal to a public capable of deriving enjoyment from contemplation of "the perfect"? As Eileen Hooper-Greenhill has observed, the art museum was, from the beginning, "an apparatus with two deeply contradictory functions: that of the elite temple of the arts, and that of a utilitarian instrument for democratic education."[36] Any institution with a sufficient number of casts, any "ready-made museum" in Prichard's scathing formulation, could convey knowledge, could educate the public in a canonical history of art. Thus, for example, John Cotton Dana attracted popular audiences to the newly acquired cast collection at the Springfield Public Library with an ambitious educational program of lectures and drawing classes, and on one occasion even issued "a special invitation to street railway men [which] brought out 150."[37] But education, particularly of this sort, was hardly what Prichard and others had in mind for the Museum of Fine Arts or the Metropolitan Museum. Indeed, only a very few museums—the largest, the best endowed—were capable of upholding the highest standards of taste, which were now increasingly identified with the display of originals.

Of course, awareness of the difference between original and copy had been present all along. Beginning in the sixteenth century casts, replicas, and prints had whetted the appetites of travelers to Italy who, according to Haskell and Penny, "agreed that the reality [of the originals] far surpassed the copies on which they had been brought up."[38] Unsurprisingly, nineteenth-century artists frequently insisted on the superiority of originals over copies. Thomas Eakins, writing home from Paris in 1866, described how on his initial visit to the Louvre he went first to see the statues: "they are made of real marble and I can't begin to tell you how much better they are than the miserable plaster imitations at Philadelphia."[39] During the period under consideration, trustees, curators, and administrators may have, perhaps somewhat self-servingly, bought into the notion that casts were, for the purposes of an American art museum, equal or superior to originals, but there were others who remained unconvinced or, as

no doubt they would have seen it, undeluded. No less a personage than General Luigi Palma di Cesnola, director of the Metropolitan Museum from 1879 until his death in 1904, thought casts utterly unworthy of a world-class institution and strenuously, if unsuccessfully, resisted attempts to enlarge the museum's collection. In a letter of 24 March 1885 to William E. Dodge, a member of the museum's board of trustees, Cesnola wrote with characteristic pugnacity:

> What are *casts*? Copies made in plaster—of what are the casts in the Boston Museum? Copies made in plaster *of archaeological objects,* and existing in European museums, and nothing more. . . . Now the fact is, that our Museum possesses archaeological objects and paintings in *originals* instead of being inferior *casts* and *copies*. . . . The Boston Museum fulfills its duty as a Lyceum; and for a provincial city without a future prospect as our city has, its museum does very well; but what is sufficient for Boston would be utterly absurd and inefficient for a great city like New York. The Boston Museum is destined to remain what it is at present. A *Pygmy*.[40]

Despite his vehement opposition, Cesnola could not avert the formation at the Metropolitan of a special committee on casts or block the acquisition during the 1890s of a large collection. (The special committee, holding views diametrically opposed to those of the director, quickly metamorphosed into a powerful cabal seeking his ouster.)[41] Cesnola's opposition to cast collections turned out to be premature but his arguments were prophetic. Cesnola had not forgotten that the Metropolitan had, from its inception, aspired to equal or surpass the Louvre. Thus for Cesnola and, as time went on, for a growing number of American museum trustees and administrators, one of the most basic considerations involved in deciding the value of cast collections was whether a museum could successfully compete with its European counterparts. Obviously, in such a competition cast collections counted for little.

The Irreproducible

The new emphasis museums began to place on exhibiting originals was also connected with crucial changes in the wider artistic culture. The second half of the nineteenth century witnessed the decline of traditional history painting and consequently the erosion of the authority of the antique and Renaissance sculpture on which it had been based. Sculpture that had hitherto provided an undisputed grounding for artistic education and practice began to suffer ne-

glect as art schools accorded greater importance to life drawing and painting, and to spontaneous modes of execution. Academies in France and the United States shifted their emphasis from what Albert Boime calls "the executive" to "the generative" phase of composition, leading to the rise of a new "aesthetics of the sketch."[42] In the United States, landscape painting replaced history painting as the leading art form as early as the 1850s, and in the period following the Civil War, loosely handled, painterly landscapes increasingly appealed to collectors. Beginning in the 1870s, Albert Pinkham Ryder, master of loaded and often seemingly incoherent painterly surfaces, slowly gained an audience and a market for his often controversial art. During the same period, James McNeil Whistler deeply impressed American collectors and artists perhaps as much with his aestheticizing philosophy as with his understated, almost monochromatic paintings. In the 1880s French Barbizon landscapes became fashionable among wealthy American collectors, who also began to develop an interest in the work of the French impressionists. A group of painters following the lead of such French Barbizon painters as Corot and Daubigny, created an American Barbizon School. Childe Hassam, Theodore Robinson, and Julian Alden Weir, among others, pursued successful careers working in an impressionist style somewhat more subdued than that of their French counterparts. Tonalism, an art of blurred and softened forms, acquired a following. George Inness, master of hazy, warmly colored landscape compositions, achieved celebrity among collectors and critics who lauded him as a "modern among the moderns."[43] Thomas Wilmer Dewing, another tonalist, depicted idealized women posed in landscape settings so vaguely painted as to verge on abstraction.[44]

The widespread taste for genteel, painterly landscapes was symptomatic of the new value accorded artistic sensibility. The distinctive marks and touches an artist left on the surface of a work came to stand for the unique, irreproducible character of artistic genius. Unlike traditional academic art, which pursued an ideal of timeless, impersonal perfection, the landscapes of an Inness or a Whistler embodied a far more subjective and immediate sense of what a work of art might be. American museums may have been slow to embrace the productions of contemporary landscapists, but they nonetheless began to espouse the aesthetic values associated with advanced art. Consequently, the "battle of the casts" in Boston, and similar conflicts elsewhere, involved not only the question of whether museums should pursue traditional forms of popular education but the even more basic question of what ultimately defined a work of art.

Several factors thus combined to tilt the balance against casts. The interests of millionaire collectors, on the one hand, and those of intellectuals and artists, on the other, converged in the new policies of the Metropolitan Museum and the Museum of Fine Arts.[45] This is not to say that the concerns of affluent collectors were directly reflected in the ideas put forth by artists, critics, and aestheticians. The process was far more complex, far more mediated. Still, the aesthetic idealism of a Prichard or a Berenson served well enough the purposes of Morgan and his confreres. Faith in higher values, and the inspiration to be derived from authentic works of art, complemented, if at times perhaps a little too expediently, robber baron acquisitiveness and the penchant for ostentatious cultural display.

Therefore, it is perhaps no wonder that the Museum of Fine Arts and Metropolitan Museum reversed themselves so swiftly. In 1904, Prichard took up arms in the "battle of the casts" anticipating defeat but foreseeing eventual victory: "I shall lose," he wrote Mrs. Gardner, "but I shall have lit a great lamp—the lamp of real appreciation, of the first rate, of aesthetic conviction."[46] What he could not foresee was how quickly his "lamp of real appreciation" would triumph. Six years later the Museum of Fine Arts was exhibiting a greatly reduced number of casts and warning visitors that "the final perfection of style in the work of great masters cannot be reproduced in plaster."[47] At about the same time, the Metropolitan Museum appointed Edward Robinson as its new director. Robinson served until 1930, and there is no evidence that in his two decades in office he ever raised objections to the museum's policy of removing casts from its galleries to make room for "the masterpieces of different countries and times."[48]

In retrospect, the outcome of the history sketched here seems inevitable: casts and replicas were fated to give way to originals, to objects that were indisputably works of art. Yet until the reversals of the early 1900s the outcome of this history was always in doubt. Still, it was never simply a conflict over the aesthetic or educational merit of casts, but, rather, a question of the evolving needs of the elites who controlled museums and who ultimately determined their direction. By 1910 it had become apparent that cast collections no longer had a role to play in museums, that they could only depress elite aspirations. Henceforth, a major American art museum would be, by definition, a repository of rare and costly works of art: "the Education," as Henry James observed, "was to be exclusively that of the sense of beauty."[49]

CHAPTER FOUR
Samuel Parrish's Civilization

Essays devoted to museum founders tend to be celebratory. They praise the founders' vision, express gratitude for their benefactions, and dwell on their taste and character, often in fulsome terms. My purpose here is not to extol Samuel Parrish's foresight and taste, nor is it to pass retrospective judgment on a figure who flourished in the age of William McKinley and Theodore Roosevelt. Instead, I am interested in Parrish as a historical personage, and in his museum as an embodiment of the cultural values of his time.

Parrish opened his Southampton Art Gallery at precisely the moment when the United States was embarking upon its first large-scale imperial adventure: the Spanish-American War. Like the European powers it emulated and sought to surpass, the United States justified its imperialist impulses in terms of a "civilizing" mission. "Civilization" was a pervasive theme of the period.[1] In New York, Boston, Chicago, and a dozen smaller cities, newly erected art museums announced themselves centers of "civilization." They did this not in so many words but through their architecture and collections, which claimed for the United States the cultural legacy of Greece, Rome, Renaissance Italy, and the European Middle Ages. Parrish's museum was, in its modest way, also a monument to civilization. And although his ideal of civilization might today appear arbitrary or idiosyncratic, it coincided in important ways with the more grandiose claims that marked the beginning of his nation's imperial age.

Parrish was born in 1849 into a Philadelphia Quaker family of professionals, philanthropists, and reformers.[2] His father, a well-known eye surgeon, died when Parrish was three, but the family was fairly well off (there may have been substantial inherited money), and Parrish attended Philips-Exeter Academy and Harvard, from which he graduated in 1870. Two years later he was admitted to the Philadelphia bar. After a year spent in foreign travel and several years as an associate of law firms in Philadelphia and later in New York, he formed, in 1880, a partnership with Francis K. Pendleton, a Harvard classmate. The two specialized in corporate law, representing railway interests—the Norfolk and Western, and Denver and Pacific were among Parrish's clients—and foreign investors in American real estate.

Details of Parrish's rapid ascent to the upper ranks of Wall Street lawyers are scarce, but it is clear that within a few years of his move from Philadelphia he had become a fixture in the small New York world of Republican lawyers, politicians, and corporate managers who oversaw the nation's economy and largely determined its political life. Parrish's success can be measured in several ways. For one, in an age when club membership was a necessary adjunct to professional accomplishment in law, business, and politics, Parrish proved himself eminently "clubbable."[3] He was made a member of the Century Club, an elite meeting place for businessmen, politicians, artists, architects, and writers. He was also invited to join the prestigious University Club and, in the city of his birth, the Philadelphia Club. In the mid-1880s he began to summer in Southampton, then a newly fashionable resort; there he became a member of the Meadow Club and, in 1891, a founding member of the exclusive Shinnecock Hills Golf Club.[4]

Club membership brought with it profitable contacts. Among his circle of friends and acquaintances, Parrish counted politicians, businessmen, lawyers, and artists. George Wickersham—a prominent railroad lawyer and Attorney General under President William Howard Taft—was a close friend, as was William Laffan—journalist, publisher of the *New York Sun,* passionate art collector, and trustee of the Metropolitan Museum of Art.[5] Parrish knew such eminences as Henry Gurdon Marquand, a former associate of Jay Gould and a millionaire Wall Street banker, who helped found the Metropolitan Museum of Art and served as president of its board of trustees from 1889 until his death in 1902;[6] and Elihu Root—the foremost corporate lawyer of the period (the

"attorney for capitalism" as many remembered him), a leader of the reform Republicans during the 1890s, Secretary of War under McKinley, and Secretary of State under Theodore Roosevelt.[7] Parrish also numbered among his acquaintances figures prominent in the visual arts, such as the painter William Merritt Chase, the sculptors Daniel Chester French and Augustus Saint-Gaudens, and the architect Stanford White, who in 1887 built a summer house at Shinnecock for Parrish's law partner, Francis K. Pendleton, and a few years later designed the clubhouse for the Shinnecock Hills Golf Club. (In 1931, White's biographer, Charles C. Baldwin, recalled with horror that Pendleton allowed Parrish "to 'materially modify' White's designs" for his house.)[8]

The firm of Parrish and Pendleton prospered, but Parrish grew restive and in 1897, when he was forty-eight, he retired from active practice to pursue other interests. Eight years later, in an autobiographical essay written for his Harvard classmates, he uncharacteristically put aside his "natural reserve" and produced an "epitomized" autobiographical statement in which he described the interests that occupied him in his retirement. They were: involvement in "practical politics," which in Parrish's case meant chairing the Suffolk County Republican Committee; the study of United States "national development" and foreign policy; and the creation of "a small public art museum in the village of Southampton."[9] In a number of respects, the three interests were related. As a reforming Republican and adherent to the somewhat nebulous doctrines of Progressivism, Parrish believed that politics should not be left to professionals. "The perpetuation and reasonable and necessary improvement of our institutions," he wrote, required "the active participation of men of education," disinterested men without "expectation of political preferment," men like Theodore Roosevelt and Elihu Root—and Parrish himself.[10] This educated elite, with its enlarged vision of democracy and of the country's place in the world, could be a guiding force nationally as well as locally. Thus, while Parrish concerned himself with the mundane affairs of the Suffolk County Republicans, he also made known his views on United States foreign policy in speeches, pamphlets, and letters to the editor that were published in the *Sun* and the *New York Tribune*.

Like the progressive-conservatives who came to power with Roosevelt, Parrish believed that Britain and the United States were natural allies and that the Anglo-Saxon or "English-speaking race," as he sometimes called it, was destined, through a process of natural selection, to dominate the world.[11] In his writings Parrish resorted to a hodgepodge of pseudoscientific theories in

an attempt to establish that the inhabitants of the tropics and subtropics were intellectually and culturally inferior. Democracy, he maintained, was possible only for "certain highly favored sections of the Caucasian race," the British and the Americans.[12] By contrast, the peoples of Africa, south Asia and Latin America were utterly incapable of self-government. It was therefore up to the nations of the temperate zone to shoulder the burden of colonial rule and "civilization." Parrish thought that among the countries of the temperate zone, Britain and the United States had proved themselves the most fit to oversee tropical empires. The British, in his view, employed "beneficent methods" in ruling India and "the innumerable islands of the Tropic sea."[13] Thus he argued that the United States should emulate British policy in overseeing Latin America and in administering Puerto Rico, the Philippines, Guam, etc., countries it had wrested from Spain in the Spanish-American War.

Parrish's ideas were, for the most part, familiar rationalizations of the progressive-conservatives' imperialist ambitions. Today these ideas might seem deluded, yet in Parrish's time the discussion of the Spanish-American War and of the United States' future role in the world was often cast in portentous terms of national duty and the fate of civilization. "Nations," Parrish wrote in 1899, "are the trustees of civilization. If they fail to make proper use of their opportunities, others better qualified will take their place."[14] The outcome of the Spanish-American War demonstrated the truth of this assertion. To honor its historical responsibilities, the United States would have to make the most of its gains. "For the United States to falter or turn back now would be a crime against civilization."[15] Thus for Parrish, as for many of his influential contemporaries, the idea of civilization was inseparable from a national policy of imperial conquest and colonial domination.

2

While traveling in Italy in the fall of 1896, Parrish arrived at the idea of founding an art museum in Southampton. By January 1897, he had engaged Grosvenor Atterbury (1869–1956), a pupil of Stanford White, to design the museum building.[16] Work began almost immediately and proceeded with extraordinary speed. On 15 August 1898 Parrish opened the museum's Renaissance-revival structure to the public. The Southampton Art Gallery, as it was officially known, housed not only the modest collection of early Renaissance paintings that Parrish had purchased on trips to Italy, but also an extensive collection of

casts and replicas.[17] Among them were well-known examples of ancient Greek and Italian Renaissance sculpture: sections of the Parthenon frieze, the *Laocoön,* the *Winged Victory,* the *Caesar Augustus of Prima Porta,* the *Spinario* (or *Boy Pulling a Thorn*), and Madonnas by Luca della Robbia and Michelangelo (see figs. 4.1 and 4.2). In addition, Parrish furnished the museum with casts of "royal effigies"—copies of electrotype reproductions in the possession of the National Portrait Gallery in London, which were themselves taken from originals at Canterbury Cathedral and Westminster Abbey. These copies—testimonials to Parrish's Anglophilia—represented Plantagenet and Tudor kings and queens from Henry III to Elizabeth I along with "one or two affiliated royal personages."[18] The effigies figured prominently in the extensive *Historical, Biographical, and Descriptive Catalogue* of the museum's holdings that Parrish prepared in time for the museum's opening. Pride of place in the catalog was reserved for another work, a full-sized, hand-colored, photographic reproduction of the Bayeux Tapestry, which Parrish exhibited in four upright, glass-covered cases (visible in fig. 4.2).

In the years following the museum's opening, Parrish expanded the collection by adding reproductions of, among other works, the *Delphi Charioteer,* the *Venus de Milo,* busts of the first eighteen Roman emperors, Donatello's *St. George Tabernacle* from Or San Michele, Verrocchio's bronze *David,* and an eighteen-foot-high composite "altarpiece" made up of plaster and terra cotta copies of relief panels by Andrea della Robbia, Ghiberti, and Donatello (see figs. 4.3, 4.4.). To accommodate these acquisitions, Parrish had Atterbury design a wing to the north of the original structure. Completed in 1902, this extension doubled the size of the display space, but it proved insufficient, and in 1912 Parrish asked Atterbury to add a second wing consisting of three rooms attached to the southern side of the building. This final addition, which gave the museum the shape of a Latin Cross (fig. 4.5), not only permitted Parrish to exhibit his entire collection but also allowed space for a "Family Room" in which he displayed such heirlooms as a settee that had once belonged to William Penn, a dining table that had been the property of his great-grandfather, Miers Fisher, and an engraved portrait of Joseph Bonaparte, which the latter had presented to Parrish's grandfather, Dr. Joseph Parrish. The Family Room also contained a specially designed cabinet in which Parrish placed diplomas and certificates "of membership in various learned societies to which [his] father and grandfather belonged," along with medals and citations that he himself had been awarded (fig. 4.6).[19]

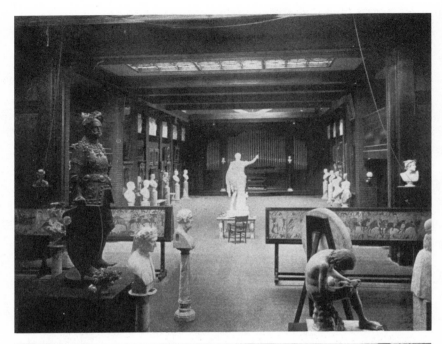

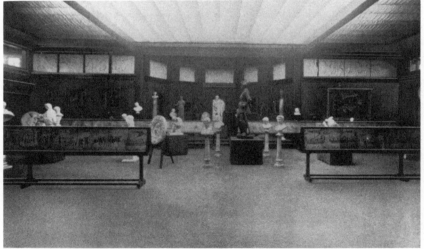

4.1 Interior of the Parrish Art Museum before 1912, looking toward the north hall.
Photo courtesy the Parrish Art Museum, Southampton, New York.
4.2 Interior of the Parrish Art Museum before 1912, looking toward the south alcove.
Photo courtesy the Parrish Art Museum, Southampton, New York.

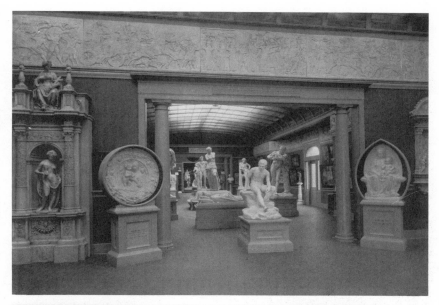

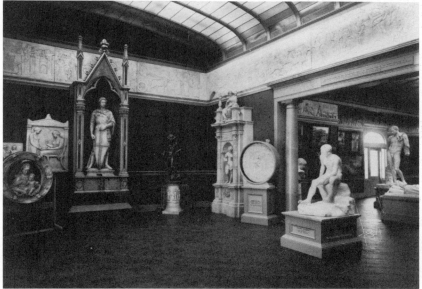

4.3 Interior of the Parrish Art Museum after 1913, looking north. Photo courtesy the
Parrish Art Museum, Southampton, New York.

4.4 Interior of the Parrish Art Museum after 1913, view of a corner of the "first
room." Photo courtesy the Parrish Art Museum, Southampton, New York.

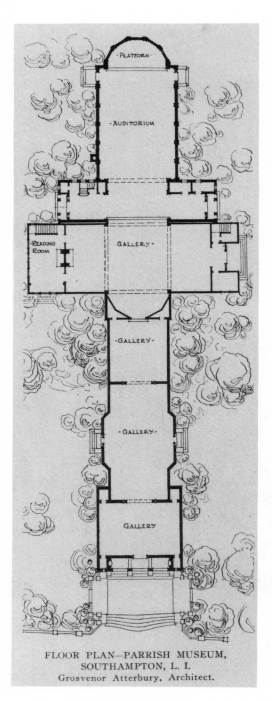

FLOOR PLAN—PARRISH MUSEUM,
SOUTHAMPTON, L. I.
Grosvenor Atterbury, Architect.

4.5 Ground Plan of the
Parrish Art Museum in its
completed state, 1913. Photo
courtesy the Parrish Art
Museum, Southampton,
New York.

Although Atterbury's design evolved in three stages, the final result seemed architecturally coherent and won praise from Charles C. May (a critic for the influential *Architectural Record*), who was familiar with Atterbury's oeuvre. From May's account and from surviving photographs, it is possible to reconstruct something of the experience of visitors to the museum between 1913 and 1932, when Parrish's and Atterbury's intentions were most fully realized. Atterbury's design emphasized the idea of the museum as a repository of the artistic heritage of both Greco-Roman antiquity and the Italian Renaissance, with particular emphasis on the latter. The architect lavished special attention on the entranceway (fig. 4.7), a loggia recalling Filippo Brunelleschi's designs for the Foundling Hospital and Pazzi Chapel in Florence. Here visitors encountered a complex decorative scheme in which the architect played off antique accents (marble columns, vases, portrait busts) against tapestry-like brick surfaces and glazed terra-cotta plaques imitative of the work of Luca and Andrea della Robbia. Passing through the loggia and the central doorway with its ornate iron grillwork, visitors found themselves in the first of the museum's five galleries. May applauded Atterbury's unobtrusive design, which allowed the interior to function as "merely the setting" for the works on display, and he noted that inside the museum the visitor "receives at once a grateful sense of freedom from supervision or necessity of viewing the collection in prescribed sequence. The single attendant, to be sure, invites registration, but there ends every suggestion of restraint, and one is free to enjoy the collection at leisure and, if there is still time, to wander through the gardens."[20]

Parrish acted as his own curator, and he did not hesitate to juxtapose original works with replicas in what now appears an entirely arbitrary manner (see figs. 4.1–4.4). Museum-goers of the 1990s might be disconcerted by the absence of chronological sequence in Parrish's installation, his mingling of replicas of works from fifteenth- and sixteenth-century Italy, Tudor England, ancient Rome, and fifth- and fourth-century Greece. But Parrish and his contemporaries were accustomed to late Victorian installations that featured galleries crammed with works of art from widely separate cultures. Parrish was familiar with the writings of art historians who divided the history of art into civilizations and periods, but like many other curators of his day, he was more concerned with the overall impact of the display, with balancing forms in a pleasing manner, than with a strictly art historical mode of presentation.[21] (Thus he even allowed the gothic tabernacle of Donatello's *St. George* to obscure a portion of the Parthenon frieze [see fig. 4.4].) Moreover, Parrish

4.6 The "Family Cabinet," n.d. Photo courtesy the Parrish Art
Museum, Southampton, New York.

probably assumed that visitors would readily comprehend the relation of parts
to whole in his museum since from his viewpoint the parts added up to the
heritage of civilization. "It will be noted," he wrote in his *Catalogue,* "that the
collection is confined almost exclusively to such objects as illustrate or repre-
sent the history, biography, and art of Greece, Italy, and England; the three
countries, above all others, to which we in America, directly or indirectly, owe
all that is most valuable in our intellectual and political life."[22]

3

Art collecting was a common practice in the circles in which Parrish moved,
and it is therefore not surprising that, as soon as he established his partnership
with Pendleton, he began to purchase examples of early Renaissance paint-
ing.[23] He could not compete with millionaire collectors for works by famous

masters, and he probably sensed that a collection of at best minor paintings would not justify founding a museum. He was thus obliged to consider other art forms and, in the end, made the somewhat unusual decision to build a collection consisting mainly of sculptural replicas.

Today a museum of copies and simulacra would be an art historical oddity; during the 1890s, however, few would have questioned Parrish's decision or argued that copies did not belong in museums. In the closing decades of the nineteenth century, the Louvre's Atelier de Moulage and similar workshops in Florence, Rome, and Naples did a thriving business supplying art museums with replicas of famous and not-so-famous statues. No serious museum was complete without copies of such well-known pieces as the *Venus de Milo,* the *Winged Victory,* and the *Laocoön.* When the United States' first art museum, the Corcoran Gallery of Washington, D.C., opened in 1874, it featured a vast collection of casts and replicas of works from Greco-Roman antiquity and the

4.7 The main entrance of the museum, after 1913. Photo courtesy the Parrish Art Museum, Southampton, New York.

Renaissance.[24] In 1879 Charles C. Perkins, one of the founders of the Boston Museum of Fine Arts, argued that the museum's goal should be the "education of the nation" and not "making collections of objects of art"; *The Boston Advertiser* hailed Perkins's ideas, saying, "our aim must be to bring these [masterworks] within the reach of our people by means of the best available copies."[25] In 1886 Henry G. Marquand gave the Metropolitan Museum $10,000 worth of casts, and during the 1890s, while president of its board of trustees, he headed a committee on casts, which counted among its members Augustus Saint-Gaudens, Louis C. Tiffany, Stanford White, and Professor Allan Marquand, his son and an expert on the art of Luca and Andrea della Robbia.[26] The committee raised the large sum of $80,000 to obtain, in its words, "a complete collection of casts, historically arranged, so as to illustrate the progress and development of plastic art in all epochs, and mainly in those that have influenced our civilization."[27] Indeed, the Metropolitan's Hall of Casts functioned as "the very center" of the original museum building, and for a time during the 1890s the museum operated a "moulding department" in emulation of the Louvre's Atelier de Moulage.[28]

Parrish was aware that replicas were not equivalent to originals, but unlike those who in the early 1900s were beginning to dismiss casts as "the pianola of the arts," he held fast to his belief that casts and replicas were invaluable aids to art education.[29] They were, he wrote, "the real treasures" of the great museums of New York, Boston, Chicago, and Washington. In Parrish's view, collections of "modern pictures," although "interesting and valuable," did not compare in educational worth with "plaster reproductions of the antique and Renaissance sculpture, those masterpieces of the genius of man at its highest period of development in the world of art."[30] Since Parrish did not possess the means to assemble a collection of first-rate originals, this statement might be considered self-serving, but he was in all likelihood sincere in his devotion to ancient and Renaissance art. His taste had been formed during the 1880s under the influence of such figures as Laffan, Saint-Gaudens, and Henry G. Marquand (to whom he dedicated his *Catalogue*) and, in the years that followed, he remained faithful to the artistic doctrines of that period, above all to its romantic and rather precious cult of the Quattrocento—the art of Brunelleschi, Ghiberti, Donatello, the della Robbias, Antonio Rossellino, Mino da Fiesole, and Benedetto da Maiano which, in the form of simulacra, he celebrated with such fervor in his museum (figs. 4.4, 4.5).[31]

The Southampton Art Gallery was very much a part of its historical moment—
the years around 1900 when men like Parrish could imagine a future in which
the United States, in alliance with England, would dominate the globe and
bring "civilization" to less fortunate "races." Parrish founded his museum on
this vision. Indeed the museum's opening, presided over by a Republican
judge, consisted of "an informal conference in regard to the future of the
United States in view of the questions which have arisen as the result of our
war with Spain."[32] (By chance, the opening occurred one day after the United
States proclaimed its military occupation of the Philippines.) Two years later,
Parrish obtained Saint-Gaudens's help in purchasing for the museum replicas
of busts of the first eighteen Roman emperors—as if to mark symbolically the
United States' new imperial role (fig. 4.8).[33]

 During its early years the museum achieved a certain degree of popularity.

4.8 Interior of The Parrish Art Museum, ca. 1912. Photo courtesy
the Parrish Art Museum, Southampton, New York.

In 1915 Charles May estimated that the museum attracted as many as six thousand visitors during the six months of the year it was open.[34] But this was in all likelihood the museum's high point. Belief in the educational value of casts and replicas was rapidly diminishing. In 1906 the Metropolitan Museum abolished the office of curator of casts, and about the same time casts disappeared from the galleries of the Boston Museum of Fine Arts.[35] As improved printing techniques made photographic reproductions readily available, the words "original" and "authentic" took on new importance. Visitors came to museums primed to see "originals"—works that could be viewed elsewhere only in reproduction.[36]

Thus the popularity of Parrish's museum was fated not to last. By the 1920s collections of casts were old-fashioned; by the 1930s they were obsolete. Parrish failed to anticipate these changes, or to recognize them when they occurred. Moreover, he made the mistake of assuming that the values he associated with the art of Greece, Rome, and Renaissance Italy were timeless and universal, and he surrounded himself with artistic conservatives who reinforced his error.[37] In 1924, in a letter to the museum's board of trustees, Parrish stipulated that the museum remain unaltered after his death, that "nothing so far as practicable be either added to or taken away from the collection," and that the Family Room be kept entirely intact.[38] In other words, he saw the museum as his memorial, a sort of museological tomb or house of the dead. Inevitably, this did not occur. Parrish died in 1932 and his museum quickly fell into disuse and disrepair. Its demise might be blamed on the depression, which drastically reduced the income from Parrish's bequest. Still, all but the most impoverished cultures manage to renew what they most highly value. By the 1930s, beliefs that Parrish had taken for granted had lost a good deal of their cultural force. The optimism of 1898 held few claims on the cold realities of depression America and, in the years following his death, his museum functioned, if it functioned at all, as a monument to an outmoded ideal of civilization.

PART II

CHAPTER FIVE

The Museum of Modern Art: The Past's Future

Introduction

Between 1980 and 1984 the Museum of Modern Art (MOMA) carried out a far-reaching renovation and expansion. Following a design developed by Cesar Pelli, then dean of the Yale School of Architecture, MOMA doubled its exhibition space, added a glassed-in atrium or "garden hall," upgraded its dining facilities, built a new theater-lecture hall, and vastly expanded its bookstore. To help finance the undertaking, the Museum, in an unprecedented move, sold air rights to a developer who erected a fifty-two-story residential condominium tower (also designed by Pelli) over the Museum's new west wing.[1] Initially, critics feared the condominium tower would mar MOMA's appearance; however, when the Museum reopened they were nearly unanimous in their praise of Pelli's design. The *New York Times,* in an editorial called "Marvelous MOMA," pronounced "the surgery . . . a success. A lot has been gained but the miracle is that nothing has been lost."[2] Robert Hughes, in an article in *Time* entitled "Revelation on 53rd Street," observed that "perhaps there are no second acts in American lives. But there are in American museums, and this one promises to be a triumphant success."[3] Even Hilton Kramer, editor of the neoconservative *New Criterion* and frequently a harsh critic of the Museum, concluded that despite the Museum's looming condominium tower, its mass audience more or less indifferent (according to Kramer) to art, and the "irksome sense of bustle and commotion" that made the garden hall a "ghastly experience"— despite all this, the renovation resulted in the best of all possible new MOMAs.[4]

Critical comment thus added up to a collective sigh of relief that "surgery" on MOMA (!) had not been too radical after all. Instead of lamenting the lack of a fresh start or new direction, it tended to laud MOMA's deepening attachment to tradition. Kramer, for example, noted in the course of a sometimes shrewd analysis that "the museum's primary function [now is] to exhibit as extensively as possible and as intelligently as possible the masterworks from its own permanent collection."[5] And he quoted with evident satisfaction the words of Alfred Barr, inscribed on a plaque newly installed at the entrance to the permanent collection of painting and sculpture, concerning the Museum's obligation to engage in "the conscientious, continuous and resolute distinction of quality from mediocrity."

Jo-Anne Berelowitz has observed that the term "museum," as an encompassing signifier, "must be granted the flexibility of a cloth that can be gathered here, stretched there to accommodate a form whose mutations are linked to the changing character of capital, the state and public culture."[6] The Pelli renovation was frequently explained in terms of the Museum's need for additional space, more efficient access, etc. Yet the renovation was also a "mutation" in the sense Berelowitz uses the word, enacted upon the fabric of an institution that was, and in many respects remains, the most influential of its type. Later in this article I shall argue that despite the opinions of the journalist-critics, their enthusiasm for *plus ça change*, the Pelli renovation marked a new stage in the Museum's history. To arrive at that argument I shall treat two fundamental aspects of what might be called "museum perception": first, the temporal relation between viewer and object, in the sense of the viewer's perception of the time of the object, of where the object stands in relation to the viewer's present; and second, the related issue of MOMA's representation of itself, in particular the way the Museum building has evolved or "mutated" as a signifier of the modern.

Utopia

MOMA's history can be divided into three periods. The first, beginning with the Museum's opening in 1929 and petering out in the late 1950s, might be called its utopian moment. During this period MOMA constituted its history of modernism. Drawing upon then current aesthetic discourses, it subjected a heterogeneous set of materials (paintings by El Lissitzky and Matisse, films by Dziga Vertov and the Marx Brothers, etc.) to the systematizing and taxonomical

procedures that characterize the museum as a cultural institution. This involved the division and classification of materials according to media (painting, sculpture, photography, film, etc.) and, through the application of aesthetic criteria, their further classification by style. At the beginning, these criteria were not altogether fixed. A study of MOMA during the 1930s would reveal a process of experimentation, of trial and error out of which emerged a complex modernist aesthetic construct based on Bauhaus architecture and design, fauvism (with an emphasis on Matisse), cubism (Picasso and Braque), and surrealism. In the process, MOMA produced a history of modernism that justified this aesthetic, that made it seem historically inevitable (fig. 5.1).

Writing on the cultural logic of late capitalism, Frederic Jameson has argued that an artist's resistance to one manifestation of capital can lead to an art of compensation.[7] Through a utopian gesture, the artist, in Jameson's words, "ends up producing a whole new Utopian realm of the senses."[8] Yet this utopian move, while it represents an imaginative escape from the oppressive conditions of the present, is also unavoidably grounded in those same conditions. What appears as an escape from a particular stage of capital often anticipates a later, more advanced stage. This utopian reflex may also apply to aesthetic constructs. It takes no special insight to see the MOMA of the 1930s projecting a modernist resolution onto the contradictions of its particular historical moment, or in seeing this resolution cast precisely in terms of capitalism's next stage of development—the unprecedented corporate expansion and modernization (through the application of advanced technology) of post-World War II America. Of course MOMA was far from alone in its anticipations of corporate modernization. The New York World's Fair of 1939, for example, represents a popular version of a similar utopian projection.

Probably the most revealing feature of MOMA's utopianism was the new museum building itself (fig. 5.2). Designed by Philip Goodwin in collaboration with Edward Durrell Stone, and opened in the spring of 1939, the building functioned, first of all, as a unifying element, one that diminished or obscured the heterogeneity of the collections and the diversity of experiences offered. The building was also MOMA's most representative artifact, not something it had collected but something it had deliberately created, the most potent signifier of its utopian aspirations. The building, with its clear, simple lines and polished surfaces (the facade's Thermolux windows contributed a great deal to its industrial or machine-made look) stood in direct contrast to the adjacent brownstones and other nineteenth-century structures on West 53rd Street.[9]

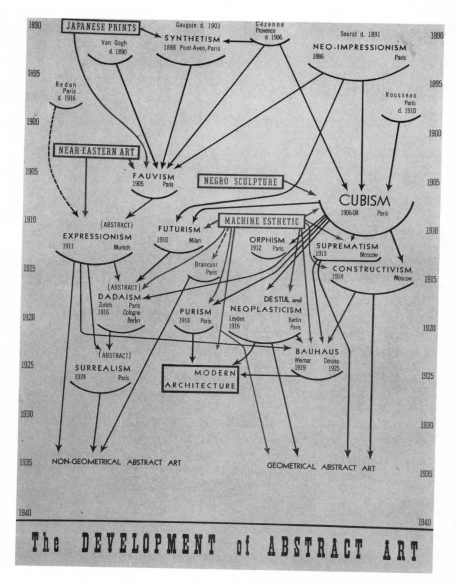

The DEVELOPMENT of ABSTRACT ART

5.1 Alfred Barr, cover design for exhibition catalogue: *Cubism and Abstract Art* (1936), Museum of Modern Art, New York. Photo courtesy the Museum of Modern Art, New York.

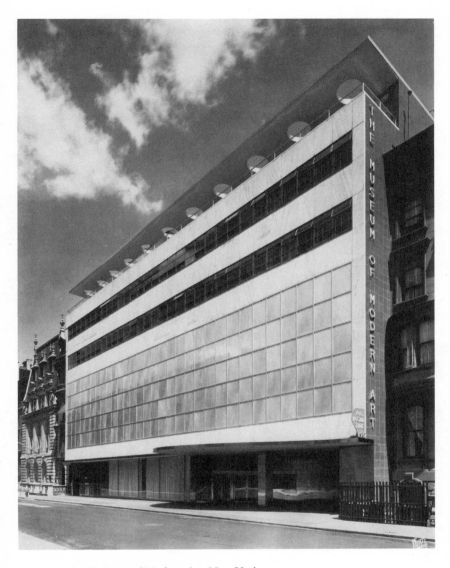

5.2 Facade, Museum of Modern Art, New York, 1939.
Photo courtesy the Museum of Modern Art, New York.

5.3 Interior, Museum of Modern Art, New York, 1939.
Photo courtesy the Museum of Modern Art, New York.

This type of contrast was crucial to MOMA's developing aesthetic. The building set up an opposition between a present still haunted by a backward, Victorian past and a future of clarity, rationality, efficiency, and functionality: an opposition that was obvious even to the most untutored observer, as I can vouch from my own experience. When I was four my father took me to the Museum for the first time and later that day we marched in the 1947 May Day Parade, which, as I recall, had as its slogan "Two, Four, Six, Eight, Henry Wallace '48." MOMA became inextricably bound up in my mind with other emblems of modernity I was aware of at the time: warplanes at Floyd Bennet Field; the Empire State Building; the streamlined IND subway train that brought us to Manhattan that day, so different from the World War I vintage trains we usually rode. I was thus made aware of a contrast between my Brooklyn neighborhood of shabby brownstones and rundown tenements, rapidly becoming slums— the "fallen city fabric"[10] of the present—and these glimpses of a promised future, which I indiscriminately associated with "progressive" politics and the 1947 May Day parade—a last gasp, as it turned out, of the Popular Front of the 1930s.

The crucial point is this: the Goodwin-Stone building represented a decisive break with conventional museum design.[11] It therefore implied a massive restructuring of the viewing subject. If the building's facade proclaimed a repudiation of the past and an exaltation of a technological future, the interior demonstrated the means by which such a future might be achieved. The Museum interior was transformed into antiseptic, laboratory-like spaces—enclosed, isolated, artificially illuminated, and apparently neutral environments—where viewers could study works of art which were displayed as so many isolated specimens (fig. 5.3). Much has been made of the "intimacy" of these gallery spaces.[12] Yet this "intimacy" also produced its own sense of distance. The museum space—the white cube which MOMA became famous for pioneering—contributed to a new aesthetic of reification, an aesthetic that redefined both the work of art and the viewer, who was prompted to gaze upon the work with something approaching scientific detachment. In this technologized space, the work acquired its utopian aura.

Nostalgia

The 1950s, the beginning of the second phase of MOMA's history, was the Museum's moment of vindication. Bauhaus-style architecture, which the Museum assiduously promoted, became a ubiquitous signifier of corporate modernity. The decade also witnessed the international "triumph of American painting," a triumph which MOMA did much to engineer. In a sense, it was possible to say that the future projected by MOMA during the 1930s and 1940s had come to pass—a future, as it turned out, that coincided with unprecedented economic expansion and the beginning of the "American century." Yet this future proved to be no utopia. Bauhaus modernism became Bauhaus monotony, standing for an impersonal corporate rationalism and the commodification of architectural form. The "new American painting," as it was frequently called, was transformed almost overnight into a modernist academy. We might at this point begin to conceive of MOMA as an undertaking of a powerful corporate elite—an elite that, as part of its claims to dominance, successfully projected its own aesthetic regime of modernity. Yet what is perhaps most remarkable about this history is the failure of vision that quickly followed. There were no convincing postwar utopias. The 1950s marked MOMA's highpoint as an institution, and the beginning of its transformation. For at this point, in accord with the cultural logic I have been tracing, MOMA

began to look increasingly to itself and its past. Utopian projection was replaced by nostalgia for an outmoded utopia—or rather, for the time when belief in a utopian future was still credible. This longing for the past's utopia came to dominate MOMA's practice as an institution. For a while the Museum attempted to maintain its influence on contemporary art—the Op Art Exhibition of 1967 was, arguably, a last pathetic gesture in that direction. Yet without a credible historical-aesthetic construct extending from past to future, MOMA's influence was bound to dwindle. Today MOMA has little direct impact on artistic practice.[13] Instead, the Museum's activities are generally divided between reporting recent art world developments and maintaining its permanent collection. The latter involves, among other things, blockbuster exhibitions (Picasso, primitivism, cubism, "Matisse in Morocco," "High and Low") focused on one or another aspect of the canonical history of modernism promulgated by the Museum more than half a century ago.

The history of the permanent collection underscores the retrospective mood that began to take hold during the 1950s. MOMA's founders initially conceived of it as a *Kunsthalle,* an institution primarily devoted to special exhibitions. Although the Museum began to build a collection during its early years, its collecting policy was deliberately limited. In effect, the Museum attempted to overcome the contradiction inherent in the idea of a museum of modern art by deaccessioning, or selling to other museums, works in its collection that were more than fifty years old. Indeed, as late as 1947 MOMA sold twenty-six paintings to the Metropolitan Museum, works that, in Alfred Barr's words, "the two museums agree[d had] passed from the category modern to that of 'classic.'" Among these "classics" were Cézanne's *Man in a Blue Cap* and Picasso's *Woman in White.*[14] Symptomatically, in the 1950s MOMA abandoned its original policy and focused more of its efforts on building and exhibiting a permanent collection. In 1953 it did away with the fifty year rule; three years later it officially declared its intention of exhibiting a "permanent collection of masterworks." This decision led directly to the expansion of the Goodwin-Stone building, which was carried out between 1962 and 1964 under the direction of architect-trustee Philip Johnson (fig. 5.4). The Johnson expansion in effect enshrined the permanent collection.[15] During the 1950s, MOMA had devoted at most 11,000 square feet to exhibiting its collection of painting and sculpture. This space was now expanded to 19,000 square feet. The Museum also added 6,700 square feet to house the prints and drawings, architecture and design, and photography collections. (The curators of these collec-

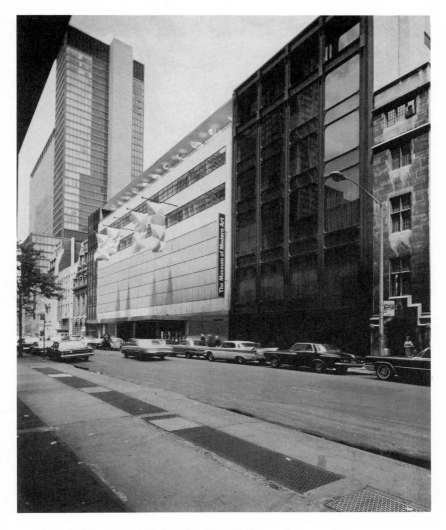

5.4 Facade, Museum of Modern Art, New York, c. 1964.
Photo courtesy the Museum of Modern Art, New York.

tions usually divided their gallery spaces between permanent and temporary displays. The Johnson expansion thus more than doubled the amount of space available for the permanent collection.[16]

Johnson's handling of the expansion provides further evidence of MOMA's growing attachment to its own past. Planning had begun in the early 1960s,

only a little more than twenty years after the completion of the Goodwin-Stone building. Yet in those two decades the building, and especially the facade, had acquired canonical status. The facade was now, in effect, MOMA's logo, an architectural emblem signaling the Museum's nostalgic attachment to the corporate utopianism of the 1930s. Although, in the course of the renovation, Johnson slightly modified the original building, moving the entrance to the left and eliminating the few art-deco curves Goodwin and Stone had allowed themselves, he deliberately maintained, through contrasts of color and structure, a clear distinction between the 1939 facade and his two Bauhaus-style wings.[17] Yet if Johnson strove to preserve something of the visual contrast between the Goodwin-Stone building and adjacent structures, the resulting historical contrast reversed the original temporal sequence. The 1939 facade now signified MOMA's past—a past made evident through its opposition to Johnson's representation of the Museum's present. This contrast was not without its ironies. MOMA's utopianism now appeared as a historical relic, as so much failed prophecy in the face of Johnson's no-nonsense steel and glass designs, and dozens of similar designs in the vicinity of the Museum: in effect, the futuristic hopes of the 1930s overwhelmed by the sleek, banal reality of postwar corporate capitalism. Johnson's tripartite design thus produced a set of meanings about MOMA's historical situation and the significance of its collections that precisely anticipated—but also helped to determine—all that viewers would encounter in the Museum itself.

Forever Modern

MOMA's choice of Cesar Pelli to carry out the 1980–84 renovation was far from fortuitous. In an interview given in 1981, just as work was getting under way, Pelli acknowledged that his role was above all that of custodian of MOMA's architectural heritage:

> when you are working on a building designed by Goodwin and Stone, that has already been changed and added to by Philip Johnson, the issue is very different; the functions, the ideas, the beliefs that shaped these buildings are still present today. Transformation is not possible.[18]

Like Johnson, Pelli insisted upon the inviolability of the Goodwin-Stone facade:

The primary reading of the new west wing will be a shiny dark wall, in the same relation to and contrast with the Goodwin-Stone facade as Johnson's east wing. The Goodwin-Stone building will continue being the symbol and entrance of the Museum of Modern Art and will maintain its now-historical relationship with the rest of the block as a white medallion on a dark ground.[19]

Yet contrary to Pelli's assertion, transformation was not only possible, it was inevitable. By now the Goodwin-Stone facade had been dwarfed by its neighbors on 53rd Street (fig. 5.5). It made a certain sense to preserve the facade or to create something on the same scale (it is the largest rectangular shape readily viewed from across the street). Still, the issue was not purely visual—how could it be?—but visual-ideological. The surrounding office buildings and especially the condominium tower, itself a part of the Museum's fabric, intensified the contrast between past and present, between utopian hopes frozen in the past, and the unfocused dynamism of the late capitalist present. Pelli was quite right to emphasize that "the functions, the ideas, the beliefs that shaped these buildings are still present today." What he failed to add, however, is that they are present in a form that puts them just beyond the viewer's grasp.

Johnson's 1964 renovation left the original lobby areas and the galleries on the second and third floors pretty much intact. Visitors still reached the second and third floors via Goodwin-Stone's modest staircase located in a corner of the lobby. Pelli demolished most of the staircase,[20] enlarged the lobby, and added his glassed-in atrium or garden hall, an entirely new structure placed against the main body of the building. Gaining access to the galleries is now a memorable experience. Visitors to the post-Pelli MOMA pass from the street into the lobby and, after paying admission, proceed to the garden hall. In other words, having first entered the old Museum (the facade), they again enter the Museum, but this second time they, in effect, enter the new Museum. Their progress through the building repeats this alternation between old and new, between the space of the present and the (nostalgic) space of MOMA's past. In other words, the experience of the building is now (literally) structured around a spatial dichotomy between the new Museum, of the atrium, and the old Museum, of the galleries housing the permanent collection and temporary displays.

MOMA's garden hall or atrium (fig. 5.6) is representative of an increasingly familiar form of public space, a space that is at once grandiose and overwhelm-

5.5 Facade, Museum of Modern Art, New York, c. 1984.
Photo courtesy the Museum of Modern Art, New York.

5.6 Garden Hall interior, Museum of Modern Art, New York, 1991. Photo: author.

5.7 Entrance to the permanent collection, Museum of Modern Art, New York, 1991. Photo: author.

ing, and yet barely legible. It is a space that tends to suppress older forms of subjectivity and to produce, in their place, an experience that is at once impersonal and fragmented, and yet tinged with a sense of euphoria.[21] Critics complained that MOMA's atrium, with its banks of elevators, polished marble floors, and all-consuming light, is unsuited to the exhibition of works of art. For example, Hilton Kramer, in his grumpy, moralizing fashion, observed that the atrium "is sheer spectacle and gives the visitor a lot to look at when he [sic] doesn't want to look at art."[22] But isn't this precisely the function of such a space—a space that has been deliberately spectacularized (more or less in the manner of a thousand "postmodern" shopping malls), a space that radiates a sort of free-floating intensity destined to overwhelm any object placed within it?

The museum's exhibition spaces might be read as so many "insides" to the atrium's "outside." Yet "inside" and "outside" do not entirely fit the situation: to cross the boundary from one to the other, to go, for example, from the atrium to the "intimate" spaces of the galleries housing MOMA's permanent collection of painting and sculpture, is to experience a profound disjunction (fig. 5.7). In effect, Pelli's design further distances MOMA's past—a past that thus acquires an aura of unreality, a sense of being sealed off as in a time capsule—since it is now experienced through the medium of the atrium's present.

Brief Conclusion

MOMA's inability to seriously come to grips with contemporary art has long been a matter of debate. Some critics have urged that a change of policy or a change of curators might remedy the problem. Others, for example Hilton Kramer, have maintained that MOMA's adherence to a "false orthodoxy," its attachment to a formalist art history, is the cause for its dilemma.[23] If I have been in any way successful in this chapter, such arguments will immediately ring false. The history of MOMA, as I have tried to show, is not simply a history of policies and persons but also a history of "mutation," a process of evolution and institutional change that has inscribed itself on the body of the Museum and on the works of art it displays. Such a history cannot be undone—and any effort, at this late date, to mitigate its impact has, in all probability, not the slightest chance of success.

CHAPTER SIX
Regionalism Redux

A study of the painter Thomas Hart Benton (1889–1975) ought to be called "The Work of Art in the Age of *Time* Magazine" since it was the cover story of *Time*'s 1934 Christmas issue that catapulted Benton and his fellow regionalists to national prominence. Employing a newly perfected process for illustrating inside stories in color, *Time* reproduced paintings by Benton, Grant Wood, and John Steuart Curry—regionalism's "big three"—along with works by Edward Hopper, Reginald Marsh, and Charles Burchfield. An accompanying text entitled "U.S. Scene" laid down what would soon become a familiar regionalist line: instead of depicting the life they knew, American artists had taken to producing "tricky, intellectual canvases which usually irritated or mystified the public." Under the spell of European modernism, American painting had become "so deliberately unintelligible that it was no longer news when a canvas was hung upside down." But *Time* was pleased to report that relief from "such outlandish art" was at hand. A new school of sturdy American realists had recently sprung up in the Middle West. Led by Benton, these "earthy" artists would banish artiness and foreign ideas, and restore American painting to intelligibility and national relevance. *Time* emphasized the feisty, down-home qualities that distinguished Benton's art and personality. "To critics who have complained that his murals were loud and disturbing, Artist Benton answers: 'They represent the U.S. which is also loud and not in "good taste."'" The artist's 1925 self-portrait with paint brushes and easel (fig. 6.1)—a painting that was in fact deeply indebted to French modernism, although *Time* ignored

6.1 Thomas Hart Benton, *Self-Portrait*, 1925. Oil on canvas, 30 x 24 in. (76.2 x 60.9 cm.). Collection of Jessie Benton Lyman. Photo courtesy The Nelson-Atkins Museum of Art, Kansas City, Missouri.

the connection—graced the magazine's cover along with a caption: "He knows an ass and the dust of its kicking."[1]

A little more than a month after *Time*'s tribute to the painters of the American scene, the Museum of Modern Art, in a related move, mounted an exhibition of the work of George Caleb Bingham (1811–79). Today MOMA seems an unlikely place to stage the revival of a nineteenth-century American genre painter. During the 1930s, however, the modernist canon was as yet barely formed and MOMA, like the fledgling Whitney Museum, was on the lookout for art historical precedents. As Alfred Barr, MOMA's first director, explained in a foreword to the exhibition catalog, the museum had already exhibited the work of Homer, Ryder, and Eakins; nineteenth-century American folk art; and early Chicago skyscraper architecture. Like the Bingham show, these exhibitions were not "planned as ventures in 19th century archaeology but because in different ways the work shown and the personalities behind the work are pertinent to our own times." Bingham, in particular, merited attention as an early painter of "the 'American scene,' making a visual record of life in the Mississippi Valley."[2] Barr thus accorded the artist the status of protoregionalist. Indeed, after the MOMA exhibition it became virtually impossible to see him in any other way. Like the regionalists, Bingham was said to paint "direct, simple records of his own day."[3] Moreover, the artist was closely identified with a particular part of the country. In his heyday Bingham had been known as "the Missouri artist," and in 1917 Helen Fern Rusk, the artist's first biographer, revived the label.[4] MOMA titled its exhibition catalog *George Caleb Bingham, The Missouri Artist,* and Albert Christ-Janer called his 1940 biography *George Caleb Bingham of Missouri.*

In his book Christ-Janer posited a "unique parallelism" between Bingham and Benton. The two artists, he wrote, shared "a kinship of spirit that is timeless." Both "honestly" depicted what they saw; both "grounded their roots deep in the soil of Missouri." Summing up the link between the two, Christ-Janer implied a history of artistic heroism: "the one was a pioneer; the other is a titanic developer."[5] Christ-Janer was himself a regionalist painter, and he naturally invited his friend Benton to write the book's preface. Benton, a fluent writer and the author of a popular autobiography, used the occasion to launch a salvo against modernism, and to proclaim, as he had done frequently, his regionalist faith. Benton's text suggests the ease with which Bingham could, by the late 1930s, be assimilated to regionalist myth:

Bingham lived in a day when it was the picture rather than the way it was made which occupied the amateur's attention. No elaborate pseudo-technical verbiage was erected between his pictures and his audience. If he painted a tree, it was a tree and not a sign pointing to some obscure world of special values with which this cult or that was trying to prove its superior sensibility. Painting was plainer and more matter of fact in Bingham's days. There were no painters' painters nor was one supposed to need some special training or some occult capacity to determine whether or not one liked an artist's work. A picture was not directed to coteries of precious experts but to ordinary people who might buy it and put it in their homes. This was healthy and as it should be and, though Bingham lived in a world that was still close to the wilderness and faced hard times now and then, he had a public and was a successful artist. He painted for a living world and painted what that world could understand—its own life.[6]

For Benton, Bingham inhabited an antimodernist utopia: a world without overt class or cultural divisions in which artists communicated directly with audiences made up of ordinary people. "American painting," Benton wrote thinking of the still-flourishing regionalist movement, "is again coming back to this simplicity."[7]

Since the 1930s, John Francis McDermott's biography (1959) and Maurice Bloch's biography (1967) and catalogues raisonnés (1967, 1986) have given Bingham scholarship a solid factual grounding.[8] Mathew Baigell, Karal Ann Marling, and Henry Adams have studied Benton's paintings and drawings, and produced extended accounts of the artist's life and work.[9] Yet, despite scholarly gains, critical understanding has for the most part been mired in the myths of the 1930s—in effect the age of Reagan-Bush looking back to the age of Roosevelt looking back to the age of Jackson. Reputable scholars continue to celebrate Bingham in nationalist terms as a maker of "democratic images,"[10] while Benton still inspires folkish prose and warmed-over regionalist hype— "Thomas Hart Benton painted America. For more than seventy years, he painted its cities and small towns, its farms and backwoods."[11] Clearly, a reassessment of both artists, is long overdue.

Yet it does not automatically follow that such a reassessment is bound to take place. Scholars may revise or contradict received ideas—and, at least when it comes to Bingham, a revisionist trend appears to be getting under way.[12] But

whether revisionist thinking attains general currency or is confined to professional conferences and specialist publications depends on a host of cultural and institutional factors, in particular the extent to which museums are willing to engage with, or pursue, newer approaches to American art. Their record so far has been dismal. Innovation in the field is exclusively the work of smaller institutions, as recent exhibition reviews attest.[13] Larger museums, such as the National Gallery and the Metropolitan Museum, take no chances with their corporate and government backers. With these institutions, caution long ago became a virtue and a way of life, and a critical or scholarly reassessment is usually the last reason for mounting a full-scale retrospective exhibition of an artist's oeuvre. Instead, retrospectives are frequently communal rites, occasions for reaffirming traditional beliefs about artists and the histories they represent. Unfortunately this was the case with the two exhibitions under review.

I

Henry Adams's exhibition at the Nelson-Atkins Museum in Kansas City was the centerpiece of an elaborate Benton centennial celebration which included VIP previews, members galas, concerts, special lectures, tours of the Benton home and studio, and the sixth annual "Thomas Hart Benton Birthday Bourbon & Branch Bash" at Kelly's Westport Inn. The "countdown" for the centennial began two years earlier with a symposium, also timed to coincide with the artist's birthday, called "Thomas Hart Benton: An American Original" (the same title Adams used for exhibition and book), and featuring critics Clement Greenberg and Hilton Kramer, Benton scholars Mathew Baigell and Karal Ann Marling, and art historian Edward Fry. The symposium was a carefully calculated replay of the old regionalist debate with charges of artistic self-betrayal (Greenberg) and failure of modernist nerve (Kramer), and countercharges of "Eastern geographical arrogance" (Marc F. Wilson, the Nelson-Atkins's director); much was made of the fact that Greenberg and Kramer were from New York.[14] In response to the symposium Donald Hoffmann, a local art critic, asked, "Why begin again to flail an old horse?"[15] Yet in the manner of Benton himself, the museum seemed determined to flail every old horse in sight. "If the show is going to produce controversy," curator Adams declared, "then let's have it."[16]

Even before the exhibition opened, director Wilson was calling Lynne

Breslin's postmodernist installation "provocative."[17] Breslin, a partner in a New York design firm, adumbrated the folkloric world of Benton's paintings through the use of bold colors, sudden lighting shifts, and stylized wooden assemblages: a prairie windmill, a row of corn stalks with copper leaves, a replica of the tower from *Boomtown,* farm-fence wainscotting placed against a wall painted to resemble a prairie sky, etc. (see fig. 6.2). These striking departures from standard installation practice in effect paid homage to Benton's hostility to museums and his well-known belief that his paintings belonged in outhouses, bars, bordellos and Kiwanis Clubs, places where ordinary people were likely to see them.[18] Breslin's installation also suggested a subtle contrast between postmodernism's ironic blend of high and popular art, and Benton's decidedly unironic attempts to fashion a popular style. The installation was probably meant to engender in the viewer what might be called a Bentonesque mood, a bittersweet mixture of folkishness and nostalgia. Yet the Bentonization of the museum environment resulted in few, if any, critical gains. The novelty of seeing a painting hanging on a mock corncrib or simulated church tower quickly wore off. The self-conscious theatricality of dark rooms and melodramatic spotlighting became, after a while, merely irritating. The use of a slatted wall running through the middle of the doorway from one gallery space to the next produced a sense of constriction. To what purpose? Had the exhibition pursued an overt thesis or argument, a well-designed installation might have helped to articulate it. But because the argument was implicit in the retrospective form itself, Breslin had nothing more to work with than a vaguely defined need to celebrate the artist as genius, and she was thus free to pursue her Benton theme-park concept.

In the exhibition the outsize Benton persona was the only historical context for the eighty-eight paintings on view. The prairie windmill and a rectangular object that vaguely resembled a barn door marked the entryway to a corridor where viewers queued up to be admitted to the exhibition proper. Breslin's cornstalks (to the right) and power pylons (to the left) lined the corridor, which was also decorated with an overhead frieze of blowups from the Benton family album: Benton drawing his wife Rita on a Martha's Vineyard beach in 1922, sketching Vineyard neighbor Henry Look ca. 1938, playing the harmonica accompanied by Rita and son T.P., sketching at a farm sale while an overalled farmer watches. Backed by an eye-catching teal blue curtain, Benton's 1925 self-portrait—the work that had appeared on the cover of *Time* in 1934—was hung on axis at the end of the corridor, providing a visual climax.

6.2 Installation view, "Thomas Hart Benton: An American Original," 1989. Photo by
E. G. Schempf, courtesy of The Nelson-Atkins Museum of Art, Kansas City, Missouri.

To gain entry to the first of the exhibition's five galleries, viewers filed down the corridor and made a left turn directly in front of the painting.

This ritual obeisance helped to establish Benton as an overwhelming presence in the exhibition. A lavishly printed checklist—with the by now inescapable 1925 self-portrait reproduced in color on its cover—reinforced the exhibition's cult-like atmosphere. The checklist was itself a good idea, eliminating the need for text blocks in the galleries and affording viewers direct access to information about the works on display. Yet for the most part the checklist's biographical snippets and thumbnail formal analyses abstracted the paintings from any context other than the artist's biography. Throughout, Benton's intentions provided both the meaning of, and context for, his paintings. Consider, for example, the introduction to the third section of the exhibition, "An American Vision (1927–1935)." (In the checklist this text is set adjacent to a color reproduction of Benton's sinuous *Ballad of the Jealous Lover of Lone Green Valley* of 1934.)

> By the late twenties Benton had experimented with most of the avant-garde styles, both European and American. He found them lacking. He wanted to express a uniquely American subject matter, and the only way he could derive the appropriate vocabulary was through direct experience. The only way to get that experience was to meet the people first-hand. He began a series of trips, mostly in the Southeast and South, that provided him with vibrant images of America and her people.[19]

The exhibition divided Benton's career into six periods—"Early Work: Finding A Voice (1910–1920)," "Chilmark (1921–1926)," etc.—beginning with examples of the experimental and mildly avant-garde works he executed in Paris before World War I, and ending with a group of ten paintings from the years 1951–1970.[20] Adams's selection was for the most part predictable, encompassing such well-known and frequently reproduced works as the 1919 portrait of the critic Thomas Craven (Benton's close friend and one of regionalism's most ardent champions), *Self-Portrait with Rita* (1922), *The Lord is My Shepherd* (1926), *The Engineer's Dream* (1931), *Persephone* (1938–39), *The Hailstorm* (1940, "Benton at his quintessentially regionalist best" according to the checklist), and *Wreck of the Ole '97* (1943). If the selection of works held no surprises, the treatment of Benton's murals did. Although these works were of considerable importance for American painting during the 1930s, the two sets in the exhibition—the unfinished *American Historical Epic* (1919–1927) and *The Arts of*

Life in America (1932)—were not segregated from the easel paintings, or given a separate space, but simply inserted in the chronological lineup of Benton's work.[21] Indeed, nothing was allowed to interrupt the chronological flow. Even Jackson Pollock's *Going West* of 1934–38, which Adams included in the exhibition to demonstrate Benton's powerful influence on his most famous pupil, was hung without fanfare (on the mock corncrib, as it happened) in chronological sequence, as if it were simply part of Benton's oeuvre—although this may have been Adams's point.

The insistence on strict chronology coupled with Breslin's overemphatic design produced a curiously uninflected account of Benton's art. Thus Benton's well-known nude *Persephone*—a work Craven pronounced "unsurpassed by anything [of its type] produced thus far in America,"[22] but which today begs for a feminist reading—was placed in a corner of the gallery dominated by the corncrib while the less well-known *July Hay* (1943) was for no apparent reason hung on one of the tower-like structures in the brightly lit prairie-sky room. Within the exhibition galleries, only Benton's 1970 self-portrait—the last work visitors saw before exiting the show—was accorded genuinely special treatment. This portrait of the artist as an old curmudgeon was set up in a gallery with a skewed ceiling baffle that reflected the tilted ceiling represented in the painting. Harshly illuminated with a raking spotlight mimicking the lighting in the painting, the self-portrait functioned as a mirror image. The effect was more disconcerting than a simple confrontation with Benton's late version of himself since it suggested an equation that all but collapsed any distance remaining between viewer and artist.

The 1970 self-portrait seemed a fitting conclusion to an exhibition celebrating the artist as "an American original." Yet Benton's apparent uniqueness obscured the host of questions his work continues to raise. The exhibition allowed for little reflection on the significance of the paintings apart from their relationship to the artist's biography, and it glossed over problematic as well as deplorable aspects of his art. Thus the checklist said nothing about the anti-Semitic, antihomosexual, and anti-intellectual imagery in *The Arts of Life in America,* and it was equally silent about Benton's frequent resort to caricature and racial stereotyping in other works. Part of the problem is that, with few exceptions, Benton scholarship has been in the hands of the artist's admirers who incline to a sectarian devotion that disarms critical thinking. This tendency has led to the polarization exemplified by the 1987 symposium in which one side argues on formalist grounds that Benton was a bad painter while the

other dismisses the argument as so much elitist presumptuousness. This impasse may be comfortable for Benton devotees since it accords with Benton's own version of the opposition to his painting, but it has resulted in a situation in which it still remains difficult to conceive of the artist as a historical figure. Instead, there has often been little, if any, distinction made between the study and the promotion of his art, and it was therefore probably to be expected that a major Benton retrospective would be an exercise in nostalgia for the man and for the populist-conservative values present in his work.

Adams's biography, which accompanied the exhibition, shared its premises.[23] Profusely illustrated and written in a sensationalizing, journalistic manner, the book tells the story of a colorful and pugnacious artist whose life, in the words of the dust jacket blurb, "was stormy and filled with drama, often of Benton's own making." From its size and appearance the book seems the definitive account of Benton's life and art. Yet the text embodies a curious merging of voices that frustrates a scholarly reading and makes it at times impossible to determine where Benton's version of things ends and Adams's begins.[24] As we might expect, Adams sets out to vindicate the artist and his work. But perhaps because of his overidentification with his subject, he frequently adopts the artist's polemical style, making exaggerated claims for Benton's painting and influence, and dismissing in summary fasion the artist's critics and opponents.[25] Benton emerges once more in the guise of Christ-Janer's "titanic developer," a heroic figure who "in his reckless compulsion to seize the whole of America . . . exploded the hermetic and tightly sealed world of the Cubists into something quite new—a form of pictorial organization that would reshape the destiny of American painting."[26] Well, not exactly. Yet Adams presses on. Employing tactics characteristic of an outmoded formalist art history, Adams repeatedly attempts to validate Benton as a formal innovator—in effect, striving to meet Greenberg and Kramer on their own turf. Adams's treatment of Benton's relation to Pollock is, in this respect, symptomatic and revealing: "It is not too much to say that every element of Pollock's mature work that was significant and original, that was more than a second-rate imitation of European modernism, can in some way be traced back to Benton's influence."[27] Not even Benton would have made such a breathtaking claim.

Adams's concept of influence is highly questionable. It can only be sustained when the history of art is stripped of any concern for the web of social and cultural circumstances in which art is produced and used. Yet a formalist

art history seems precisely calculated to avoid such concerns. Consequently, for all its wealth of biographical detail, Adams's book remains a commonplace hagiographic exercise in which art is divorced from any larger history, and history itself is reduced to anecdote and a series of dull apologetics for the artist and his beliefs.

2

As we have seen, in an exhibition the threshold or liminal experience is crucial for all that follows, for it is at the threshold that the visitor is initiated into the meanings inscribed in the exhibition space.[28] From this viewpoint, the Bingham exhibition really began in the St. Louis Art Museum's Great Hall where a sign with an enlarged reproduction of the exuberant figure of a dancing boatman from Bingham's *Jolly Flatboatmen in Port* (1857) marked the entrance. Once past the dancing boatman, visitors faced a reproduction of the central portion of the artist's *Fur Traders Descending the Missouri* (1845), literally a more reflective image than the dancer and consequently a (*sub*liminal) invitation to study an accompanying text block. Text blocks were placed throughout the exhibition, but this first, as I observed, was the one visitors were most likely to read from beginning to end. It provided a context, a set of references, for the two images the visitor had just seen:

> . . . during that twelve year period [1845–57] Bingham created a small body of paintings which sum up numerous aspects of the American experience: robust commercial progress, the democratic electoral process in action, and rural activities and games. His paintings of life along the Missouri and Mississippi Rivers comprise a sequence of elegiac representations of the American experience.

Thus, in the space of two or three minutes, visitors encountered the exhibition's encompassing themes: an upbeat version of the American past (dancing boatman) seen in elegiac retrospect (fur traders); a diverse history of persons, institutions, and cultural practices (commerce, democracy, rural life) brought into harmonious unity (the American experience).

The exhibition proper enlarged upon these themes. In the galleries, images (paintings, drawings, prints) and texts told and then retold a familiar American story of western emigration and settlement. The story was not spelled out in so many words but communicated through the organization of space, the

placement of works of art, the choice of lighting and color schemes, and through the strategic use of text blocks containing brief descriptions, bits of observation, fragments of a larger narrative. The story was, in other words, more subtext than text, an organizing principle that to the exhibition planners—curator Michael Edward Shapiro and his staff—may have seemed natural or inevitable. Of course a visitor could pause to study a painting or make comparisons between paintings and preparatory drawings (this was surely the curator's intent). Yet the exhibition was something more than a compilation of individual works of art, more than a set of discrete aesthetic experiences. To walk through the galleries was unavoidably to participate in, to enact a history, and thus in some way to absorb a partial and disputable account of the past as if it were nothing of the sort.

The exhibition began, in the words of the handout, with a "collective portrait of Bingham's world." The first gallery contained nineteen portraits of Missourians (along with a depiction of John Quincy Adams), in effect the dramatis personae of the history laid out in subsequent galleries. The portraits (all by Bingham) served to identify the artist with his home state and to ground history in fact. In the next gallery, visitors confronted Bingham's full-length portrait of Leonidas Wetmore, a dandy in an immaculate buckskin suit standing in front of a wilderness river. This painting functioned as a transition from portraits to landscapes and frontier scenes, a transition that was also marked by a shift in color from the dark blue of the portrait room to the soft green of the next two galleries. Here space seemed to open up and visitors saw, first, settled eastern landscapes, then wild and uninhabited (by implication western) landscapes, and finally images of a perilous westward migration (*Captured by Indians, The Emigration of Daniel Boone*), temporary settlement (*Squatters*), the creation of a frontier culture (*Shooting for the Beef*) and the establishment of middle-class households (*Family Life on the Frontier*). Text blocks described a history at once orderly and legitimate: "The families [in *The Emigration of Daniel Boone*] appear to be earnest, respectable Easterners heading west to create an agrarian community"; *Family Life on the Frontier* "shows the Western experience as one of building a community family by family."

This story continues. With the creation of permanent settlements, what was formerly the frontier becomes a setting for the pursuit of politics and commerce. The next gallery—light gray and mauve, with lower light levels than the preceding one, and producing a more concentrated focus on the works—featured Bingham's election series arranged in narrative sequence: *Stump Speaking*

6.3 Installation view, "George Caleb Bingham." Photo by Robert Pettus, courtesy of The Saint Louis Art Museum.

(1853–54), *The County Election* (1851–52), and *The Verdict of the People* (1854–55). Across from the series, the museum set up a structure meant to resemble the portico in *The County Election* (fig. 6.3). Here Bingham's second version of *The County Election* (1852) was flanked by twelve preparatory drawings and four states of John Sartain's engraving of the painting. Entering this structure, with its plank floor and simple bench, visitors in effect mimed the voter in the painting who steps up to the portico to cast his ballot. Text blocks emphasized the idea of a rough-and-tumble western democracy: "this painting [*The County Election*] functions both as a monument commemorating [*sic*] freedom of choice and as a rowdy festival"; and the importance of the democratic process to an expanding United States: "as his paintings imply, these men [figures in the preparatory drawings for *Stump Speaking*], their points of view, and their votes would play an essential role in the future of a nation constantly moving westward."

The careful staging of the election pictures brought the exhibition to a point

of maximum intensity, reinforcing a traditional interpretation of Bingham as a proponent of frontier democracy. The last two rooms, brightly lit and painted blue, eased the pace. Here the history of the West was rewritten as a history of western river traffic, beginning with the dugout in *Fur Traders Descending the Missouri* and ending with the modern waterfront, with its steamboats and warehouses, of *The Jolly Flatboatmen in Port*. History is now an idyll in which the river serves, in the words of a text block, as "a tranquil agent of change." This is a world without effort or conflict: rafts drift along with the current, and boatmen engage in forms of proletarian leisure—smoking, drinking, card playing, fiddling, dancing, fishing, or simply lounging. History resolves itself in these images, an altogether painless history in which workers are "benign and heroic," "humble," "powerful, kindly figures," comparable to "river gods, guarding the passage from civilization to untamed nature."

Immediately before exiting, visitors came face-to-face with *The Jolly Flatboatmen in Port,* a work which by then resonated with the exhibition's accumulated meanings. This last touch, with its reminder of the entrance (the dancing boatman), typified the expertise that went into the making of the show. Such expertise was no doubt admirable. Yet the seamlessness of presentation, the ease with which visitors moved from painting to painting and from space to space, the seeming absence of prompting or manipulation, tended to naturalize, to render all but invisible the historical outlook I have here been at pains to elucidate. In a sense the problem was the exhibition's very seamlessness. A sense of historical perspective requires breaks, pauses, interruptions in narrative flow. There is also such a thing as expertise in challenging museum audiences to think critically and historically.[29] But critical thinking was the least of the exhibition's concerns. Every now and then a word or phrase in a text block might hint at historical distance, as when, for example, the river paintings were called, somewhat oddly, "a series of utopian views." In general, however, there was a blending of discourses, a fusing of images and texts. Left hanging in all this were the fundamental questions the material raised—for example, why was it important for Bingham and his audience to see boatmen as smiling, dancing, cheerful, carefree? (This question prompts a related one: why did the exhibition keep insisting the boatmen were "benign," "kindly," etc.?) Such questions evoke a side of Bingham and his world that the exhibition did its best to suppress.[30]

Not much better can be said of the exhibition catalog, which, with the exception of Elizabeth Johns's essay, generally mirrors the exhibition's as-

sumptions.[31] The catalog consists of five essays: a biographical sketch by historian Paul C. Nagel; three studies of different portions of Bingham's oeuvre by Barbara Groseclose, Johns, and curator Shapiro; and a brief concluding essay by John Wilmerding. Absent, however, are studies of Bingham's drawings—which played a conspicuous role in the exhibition—and prints; nor is there any attempt to deal with the artist's portraits as a separate topic.

Nagel recapitulates the well-known facts of Bingham's career in an essay that reads like a bad novel (e.g., "The Binghams were cheerful for three months, although George had fewer patrons than he anticipated and no commission arrived from the Missouri legislature . . .").

Groseclose, in the first of the three essays that make up the heart of the catalog, considers "The 'Missouri Artist' as Historian." Groseclose is not interested in history paintings per se (and what it means for an artist to be a historian is never defined), but instead treats a large selection of works—mainly genre paintings—in chronological sequence, beginning with *The Concealed Enemy* (1845) and ending with *Order No. 11* (1865–70), Bingham's protest against measures taken in Missouri by the Union government during the Civil War. The author of a well-known study of Bingham's election paintings,[32] Groseclose is familiar with the Missouri context and with Bingham's involvement in Whig politics, and she begins her essay by asking how "Bingham's painting and politics intersect." Yet perhaps because she attempts to cover too much terrain, Groseclose does not with any clarity or consistency pursue this question. Moreover, in her discussion of the election paintings, which she sees reflecting a Whig ambivalence on Bingham's part toward frontier democracy, she simply recapitulates her earlier views, sidestepping an engagement with Gail Husch's recent article which calls those views into question.[33]

Johns was asked to write on Bingham's landscapes and frontier paintings (there is some overlap with Groseclose), and in her essay pays close attention to issues of context, race, and gender. She treats, in some detail, differences between eastern and western attitudes, and describes how Bingham negotiated between them with paintings that often held different meanings for different audiences. Johns is the first to undertake a systematic study of Bingham's landscapes, and her close readings are informed by a broad knowledge of the history of American landscape painting. In dealing with Bingham's frontier scenes, she carefully prepares the historical groundwork—there are, for example, discussions of the politics of captivity narratives and the Daniel Boone

myth—and this results in illuminating interpretations of *Captured by Indians, The Squatters, Shooting the Beef,* and *The Emigration of Daniel Boone.*

Shapiro writes on Bingham's river paintings in the pompous and condescending language of the text blocks: "by most accounts, nineteenth-century Missouri boatmen were a boisterous and vulgar lot; here, Bingham seems to consider them as ancient river gods, relaxed and confident guardians of commerce." This approach has the effect of distancing the subject and disposing of the historical questions it raises (the essay contains no original research), leaving Shapiro free to see Bingham's paintings as embodiments of the democratic spirit, celebrations of "the heroism of the common man," etc.

Wilmerding continues in a similar vein in his essay on "Bingham's Geometries and the Shape of America." This essay appears to be loosely based on a concept of zeitgeist once popular among art historians in which artistic form is seen reflecting or mirroring the spirit of the times. By manipulating the two terms (form and zeitgeist), a fit of sorts can be achieved, and thus Wilmerding maintains that "stylistically, Bingham's work of this critical period [the decade 1845–55] has a consistent clarity, structure, and solidity about it which [is] an expression of America's supreme moment of self-confident optimism and expansionism."

Shapiro's and Wilmerding's essays in effect negate Johns's and Groseclose's efforts to understand the relation between Bingham's art and specific cultural and historical contexts (Whig politics, the Eastern art market, the doctrine of Manifest Destiny). And, as we have seen, it was the Shapiro-Wilmerding version of Bingham that dominated the exhibition.[34]

3

Regionalism argued for the primacy of place. It was necessary, according to regionalist doctrine, for an artist to be deeply rooted in a particular locale. Yet to become known as, for example, "the Missouri artist," a painter had to acquire a national reputation, and this could occur only if the painter produced works in which apparently local qualities and traits took on a more than local significance. This contradiction has been noted before, but its implications for the study of Benton and Bingham have not been sufficiently stressed. The regionalist myth of plain painting for plain people has helped to obscure the real complexities of culture, context, class, and class-bound artistic traditions

(e.g., oil painting's way of picturing or figuring a social world) that regionalism embodied. Myth is obviously part of the regionalist phenomenon and it too requires critical examination. But art historical scholarship cannot base itself on myth or take as its intellectual foundation the very ideologies it proposes to study. Indeed, the first question that must be asked has to do with the historical viability or functionality of myth: why, for example, Bingham's representations of the lower classes held such appeal for middle-class audiences in the 1840s and 1850s; or why Benton's imagery of a down-home America enjoyed the popularity it did in the 1930s and early 1940s—not with the farmers, southern blacks, backwoods musicians, and other "ordinary people" the artist portrayed but with a largely middle-class public (e.g., readers of *Time*) to whom he sold prints and paintings (in 1940 Benton was asking $12,000 for *Persephone*), and with government bureaucrats and corporate patrons. The answers to these questions will no doubt be complex, involving among other issues the current state of criticism. For as the continued pairing of Bingham and Benton suggests, it is impossible summarily to detach the past from the present or to separate histories that have, for good historical reasons, been fused. To see Bingham without a 1930s regionalist gloss requires a thoroughgoing critique of regionalist premises.

Yet critical scholarship alone will not affect a larger public. And given the built-in resistance of the big museums, there is probably not a good deal to hope for in the current situation. But it can also be argued that without new scholarly approaches, there will be no basis in the future for exhibitions that challenge museum audiences to see Bingham and Benton as deeply embedded in the social and cultural complexities of their times.

CHAPTER SEVEN

The Battle over "The West as America"

Critical Exhibitions

Imagine an exhibition of classical Greek sculpture or Roman baroque painting but not in the usual manner: not an exhibition devoted to the contemplation of "masterpieces," not a demonstration of the evolution of a period style or a grouping around a familiar theme (Athenian democracy, the glories of papal patronage) but an exhibition that attempted to reveal the works under consideration as ideological. You might object that such an exhibition would be virtually impossible to mount. To begin with, a critical examination of ideologies would probably require more in the way of written materials than an art exhibition could easily bear. Moreover, the type of historical criticism that now routinely occurs in academic settings would very likely encounter grave difficulties in a museum. For example, puncturing the myth of Athenian democracy would no doubt arouse the ire of a public—or at least its self-appointed representatives in the press—habituated to celebrations of "The Greek Miracle." Finally, an exhibition that rigorously avoided the familiar affirmative discourses focusing on "treasures," "masterpieces," and "genius" and instead submitted its materials to critical scrutiny would almost inevitably run into opposition from institutional and corporate backers as well as from potential lenders. How likely is it, after all, that the Vatican would send paintings to an exhibition that linked baroque religious imagery to the seamier side of papal ambition, or dealt with religious faith as ideology *tout court?*

The critique of ideology strikes at the very heart of the museum's traditional

function, its capacity, in Walter Benjamin's words, to produce "an eternal image of the past."[1] Consequently, proposals for what might be called critical exhibitions more or less inevitably meet with institutional resistance since they pose the threat of undermining the museum's authority and thus adversely affecting the various elite, corporate, and government interests that that authority normally serves. Yet such exhibitions are at least becoming more imaginable. The rise of critical and revisionist art histories has resulted in withering criticism of traditional museological approaches and has thus made it more difficult for museums to ignore the nature and effects of their habitual practices. Still, critical exhibitions remain a rarity. With one crucial exception (which forms the subject of this essay), the few American examples that come readily to mind have occurred at experimental and nonmainstream institutions: "Art/Artifact" at the Center for African Art in New York City (1988); "Winslow Homer's Images of Blacks" at the Menil Collection in Houston, Texas (1988–89); "Mining the Museum" staged by the Baltimore Museum of Contemporary Art at the Maryland Historical Society (1992). Of course it might be argued that these exhibitions failed to realize very much in the way of a thoroughgoing critique of ideology and that in the case of the Menil Foundation's "Winslow Homer's Images of Blacks," what critique there was did little more than flatter that particular institution's liberal, upper-class pretensions. Still, these small exhibitions represented a deliberate break with past practices.

Rhetorical Inventions

The same may be said of "The West as America," a large-scale exhibition dedicated to "reinterpreting images of the frontier" (as the exhibition's subtitle proclaimed), which opened at the Smithsonian Institution's National Museum of American Art in Washington, D.C., on 15 March 1991. In the preface to the catalog, William H. Truettner, curator for "The West as America," asserted that ideology "is the embracing factor of our investigation,"[2] and in the exhibition itself he attempted to put this claim into practice. The exhibition contained 164 paintings, prints, sculptures, watercolors, and photographs, which Truettner divided among six thematic sections. The section titles underscored the idea that what was on display was a culturally constructed pictorial rhetoric: "Repainting the Past," "Picturing Progress," "Inventing the Indian," "Claiming the West" (a deliberate pun since painting claims its subject as surely as settlers claim the land), "The Kiss of Enterprise" (another pun), and "Doing the 'Old

America.'" Works in the exhibition ranged from long-neglected academic exercises such as Emanuel Leutze's *Departure of Columbus* of 1855—an elaborate costume picture featuring a heroically resolute Columbus bidding farewell to his son while melodramatically gesturing westward—to Henry Farny's, Frederic Remington's, Charles Russell's, and Charles Schreyvogel's retrospective evocations of a lost frontier world of troopers, cowboys, and Indians.

Yet this was not simply another line-up of western art. In the context of the exhibition, paintings, drawings, photographs, and sculpture began to shed something of their status as major or minor works of art and take on the qualities of historical artifacts: objects created to achieve particular aims. As Bryan J. Wolf observed, in a perceptive review, the central point of the exhibition was that, in conquering the West, palette and paintbrush were as much instruments of domination as Colt revolvers or the pony express.[3] "The West as America" thus attempted to instill in the viewer a sense of the works' utility, the way they addressed often pressing (ideological) needs. Consider, for example, the exhibition's presentation of Frederic Remington's well-known *Fight for the Water Hole* of 1903 (fig. 7.1), one of a number of "last stand" paintings executed around the turn of the century. Like other paintings by the artist, *Fight for the Water Hole* has long been considered a documentary work, an accurate or realistic representation of an event that occurred in the Texas Panhandle in 1874 when a band of Comanches and Kiowas attacked a group of soldiers. The wall text that accompanied the painting took a different position:

> Few scenes have come to represent nineteenth-century frontier America more than the "last stand" and other images of battle. Yet by 1900, newspapers in the industrialized eastern United States referred to immigrant laborers as "savages" or "redskins" and the "last stand" itself came to symbolize the plight of an embattled capitalist elite in an era of strikes, violence, and widespread immigration. Although their paintings were not deliberate allegories, artists represented the West as if it were an urban situation. In Remington's *Fight for the Water Hole,* an outnumbered group of cowboys fights desperately to preserve a dwindling commodity— literally even a way of life—from a ruthless enemy "strike."[4]

In sum, the exhibition did almost everything in its power to frustrate a reading of western art as simple reportage or as a reflection of the "real," and emphasized, instead, the role of constructed images within particular histories. Yet it may have done too much, since it overlaid its rhetorical subject matter

7.1 Frederic Remington, *Fight for the Water Hole*, 1903. Oil on canvas, 27 1/4 x
40 1/8 in. (69.2 x 101.9 cm.). The Museum of Fine Arts, Houston. The Hogg Brothers
Collection, gift of Miss Ima Hogg.

with a far too insistent rhetoric of its own. Much of the controversy over "The
West as America" revolved around the exhibition's wall texts which were
frequently condemned for talking down to a supposedly benighted audience.
The texts quite properly underlined the idea that "images are carefully staged
fictions," that they "are contrived views," that "seeing is not believing," and
emphasized the way in which an elaborate pictorial rhetoric of westward
expansion had helped sanctify Manifest Destiny. For example, a wall text
placed next to George Caleb Bingham's *Daniel Boone Escorting Settlers through the
Cumberland Gap* of 1851–52 (fig. 7.2)—a painting featuring Boone's wife on
horseback at the head of a line of settlers—read as follows: "Such images
persuaded Americans that migrating west was a peaceful mission, accom-
plished by 'Holy Families' who courageously settled new territory." Elsewhere
wall texts made worthwhile and even daring political points: "One of the most
insidious aspects of white privilege historically has been its unquestioned claim
to be standing at world center, measuring culture in terms of difference and

distance from itself." (Ten weeks after the opening, when several wall texts were revised, the words "white privilege," deemed offensive by a panicky museum staff, disappeared.) In several instances, wall texts assumed a politically aggressive stance: "doomed Indians" and "the white man's Indian" were subsumed under the heading "wishful thinking." Other texts belabored the more or less obvious: "these images teach us more about the feelings and ideas of those who paid for them and made them than they do about the Indians whose lives they represent." Or they adopted a self-righteous tone: "What's Wrong with the Language We Use?" one wall text asked and went on to spell out the "racial attitudes" of the "words we use" to describe Native Americans, perhaps a necessary point but made in a manner that could only inspire in the visitor powerful twinges of guilt—or as often happened angry rebellion. "A relentless sermon, phenomenally condescending to both the painters and the painted," the historian Simon Schama wrote of "The West as America" in the

7.2 George Caleb Bingham, *Daniel Boone Escorting Settlers through the Cumberland Gap,* 1851–52. Oil on canvas, 36 1/2 x 50 1/4 in. (92.7 x 127.6 cm.). Washington University Gallery of Art, St. Louis. Gift of Nathaniel Philips, Boston, 1890.

exhibition's comment book.[5] Other viewers, perhaps with less political animus, arrived at similar conclusions: "How nice!" wrote one visitor. "According to your commentaries the world is filled with racist white males and their hapless victims. Grow up!"

The West of the Neoconservative Imagination

The wall texts were a serious tactical miscalculation, and hostile commentators made the most of them. At the exhibition's opening, historian and retired librarian of Congress Daniel Boorstin wrote in the comment book: "a perverse, historically inaccurate, destructive exhibit. No credit to the Smithsonian."[6] Within days "The West as America" was engulfed in controversy. Taking a cue from Boorstin (a repentant 1940s leftist who made his reputation during the McCarthy period as a leader of the consensus school of American history), neoconservative reporters and columnists sprang to the attack. *The Wall Street Journal* published an editorial entitled "Pilgrims and Other Imperialists" in which it displayed its usual subtlety in defense of capitalist values: "Only in the land of the free, of course, is it possible to mount an entirely hostile ideological assault on the nation's founding and history, to recast that history in the most distorted terms—and have the taxpayers foot the bill."[7] Nationally syndicated columnist Charles Krauthammer labeled "The West as America" "the most politically correct exhibition in American history . . . tendentious, dishonest and, finally, puerile."[8] The controversy soon reached the halls of Congress where Republican Senator Ted Stevens of Alaska, incensed over "The West as America" and reports of "leftist" influence at the Smithsonian, publicly humiliated Smithsonian secretary Robert McC. Adams at an Appropriations Committee hearing—"You're in for a battle," Stevens rumbled ominously. "I'm going to get other people to help me make you make sense"—and threatened to cut the institution's funding.[9] (Loathe to make waves, three weeks later Adams humbled himself in front of the assembled editorial staff of the ultra-right-wing *Washington Times,* a newspaper owned by the Reverend Sun Myung Moon's Unification Church.)[10]

The controversy was in some respects very much a product of its historical moment. The exhibition opened during the period of official euphoria over the United States and its allies' "victory" in the Gulf War. In an atmosphere of super-charged patriotism, the exhibition's critical assessment of Manifest Destiny and related expansionist myths seemed downright subversive to those

celebrating the demise of the "Vietnam syndrome." In addition, "The West as America" coincided with the opening rounds in a far-reaching debate over "pc" or "political correctness," a term of leftist self-mockery co-opted by neoconservatives to disparage what they saw as plots and conspiracies hatched by left-leaning humanities professors to undermine the values of western civilization, do away with notions of truth and objectivity, and brainwash students with Marxist and feminist "propaganda."[11] To the ideologues of the Reagan right, who displayed a curious schadenfreude in piling up examples of "pc" outrages, "The West as America" looked like a ripe target. In a pamphlet entitled "Telling the Truth"—her parting shot as chairperson of the National Endowment for the Humanities—Lynne Cheney cited "The West as America" as proof that the "pc" contagion had spread from university campuses to cultural institutions, and she berated the exhibition for such crimes as its "aggressive lack of objectivity."[12] Cheney's argument, like so much of the "pc" debate, represented a shift of focus for the neoconservative right. With the end of the cold war and the crumbling of the "Evil Empire," a new demonology was needed, and conservatives and neoconservatives quickly settled for a domestic culture war which suddenly became "as critical to the kind of nation we will one day be [thus proclaimed the unspeakable Patrick Buchanan] as was the cold war itself."[13] Charles Krauthammer made explicit the connection between neoconservative cold war nostalgia and the new culture war agenda when he began his attack on "The West as America" by imagining "a party museum" thirty years ago, in Moscow, planning "an exhibit of American art depicting the Western frontier as a chronicle of racist capitalist rapacity and call[ing] it 'The American West: The Origins of Imperialism.' . . . Alas, they don't do it that way in Moscow any more," lamented Krauthammer, "but they do do it that way in Washington."[14] Krauthammer's inadvertent "alas" was, of course, the tipoff.

Yet for all their dark talk about political correctness and the politicization of cultural institutions, the neoconservative pundits failed to come to grips with the difficult issues the exhibition raised. For the most part, they resorted to familiar tactics, filling their columns with patriotic boilerplate and castigating revisionist historians for failing to appreciate the "tremendous adventure" of westward expansion.[15] An exception, however, was Richard Grenier, a writer for *The Washington Times,* who mounted an argument to the effect that "Indians came into dominance in their respective regions by methods far worse than any the white man ever used against them," and then went on to cite Alexis de

Tocqueville in defense of the idea that the destruction of "inferior" native cultures was perhaps tragic but nonetheless inevitable—an argument, he claimed, "most sane people" would agree with.[16]

To subtler ideologues, Grenier's argument would be embarrassing in its explicitness. Yet once you strip away the adventure tales, the cowboys-and-Indians myths that Remington and others did so much to propagate, the history of the American West becomes, from a variety of traditional viewpoints—e.g., Boorstin's consensus paradigm—deeply problematic. That history is, inescapably, a brutal story of expansion and conquest, of ruthless efforts to destroy Native American populations and cultures, of the merciless exploitation of industrial and agricultural labor—cowboys, railway workers, miners, itinerant farm hands—and of bloody labor strife. Not only neoconservative pundits, but more traditional scholars as well, have attempted to keep this nightmare aspect of Western history at bay. This probably accounts for the abusiveness, the rhetorical violence, and evident sense of panic that characterized the hit-and-run responses to "The West as America" from three well-known historians of the American West: William H. Goetzmann of the University of Texas, his son William N. Goetzmann, and Gerald D. Nash, Distinguished Professor of History at the University of New Mexico. Goetzmann *père* accused Truettner of failing to credit the two Goetzmanns' *West of the Imagination* as the basis for "The West as America" (a charge that seems a little odd given the irreconcilable differences between the two projects) and faulted the exhibition for adhering to a "conspiracy theory" and "an outmoded Marxist interpretation."[17] Nash, in a furious diatribe, maintained that revisionist historians along with the organizers of "The West as America" were simultaneously promoting fascism and Stalinism.[18] Goetzmann *fils* added the following to the exhibition comment book:

> If American whites were so bad, is it possible to picture Indians (Native Americans) paddling across the Atlantic to stop Hitler and other totalitarians. The curator [Truettner] should spend more time in what used to be the U.S.S.R. and learn what "political correctness" means and has meant. The trendy "screaming weenies" are at it again—but the pictures, all works of imaginative *art* (the definition of art) are wonderful.

A desire to steer clear of the painful contradictions of western history probably also explains the more cautious but still basically hostile response from traditional scholars of western art. These scholars remain deeply invested

in the notion that representations of the American West possess documentary as well as artistic value and they thus raised objections to interpretations of such works as Remington's *Fight for the Water Hole* as anything other than literal accounts of historical events. For example, B. Byron Price, executive director of the National Cowboy Hall of Fame in Oklahoma City, a major repository of western painting, informed a correspondent from the *Washington Post* that *Fight for the Water Hole* was in fact nothing more than "basic reportage": "Remington just painted the scene as he'd heard about it." (Price went on to assert that revisionist critics were "not like real people. They're uncomfortable with the sense of wonder that's in many of these paintings.")[19] In a similar vein, Ron Tyler, director of the Texas State Historical Association and a recognized authority on western art, maintained that Alex Nemerov's discussion of *Fight for the Water Hole* in the exhibition catalogue was based upon a misunderstanding of the reasons why Remington created such works. "Nemerov misses because he goes for what, in the revisionist canon, is the easy, politically correct conclusion." And the difficult conclusion? "Remington chose to paint the Old West and its characters because it was what he knew best." Thus "the cowboy in *Fight for the Water Hole* is not the embattled capitalist, as Nemerov suggests, but embattled mankind struggling against ultimate destiny."[20]

To their credit, a number of traditional art historians made efforts to come to terms with the implications of "The West as America," and revisionist western history in general. Yet their attempts remained inconclusive, reflecting the fundamental impossibility of reconciling traditional and revisionist approaches. For example, in a recently published essay, B. Byron Price worked out the following argument based on the "interpretive conclusions," as he put it, of "The West as America":

> If the art condemned in this exhibit is indeed flawed by racism, gender bias, and imperialism, then it follows that the museums exhibiting such works without caveats or as unbiased historical narrative, must also be guilty of promoting these concepts. Should these same institutions now don sack cloth and ashes, repent, and proclaim themselves museums of the western holocaust?[21]

Not a bad idea, especially in light of the opening in 1993 of the United States Holocaust Museum in Washington, D.C. But the vision of the National Cowboy Hall of Fame transformed into a memorial to Native American victims of genocide proved too much for Price who beat a quick retreat to the notion that

museums of western art should, in the future, take an "art history approach" that would "stress the universal and aesthetic qualities of the work rather than its transient and ideological traits."[22] Not for the first time, art history rides to the rescue.

"The Labor, Patience, and Suffering of the Negative"

For all their hysteria over "The West as America," the neoconservative opponents of the exhibition failed to develop a serious appreciation of its problems and shortcomings. Their myopia resulted from an inability to conceive of the exhibition as anything other than an art historical morality play, a "perverse" effort to force "works of imaginative *art*" into a procrustean bed of politically correct attitudes. But "The West as America" dared to aspire to achieving an overall historical critique of the art of the American West. That it fell far short of its goal resulted, in part, from its excessive reliance upon conventional art historical methods—from, in effect, attempting to do battle with the enemy on the enemy's turf. Thus in a pinch the exhibition fell back on traditional iconographical analysis, at times somewhat pointlessly finding crosses, Judas's kiss, and Last Supper imagery in scenes of western discovery and conquest. For example, in a wall text, Charles Russell's *Carson's Men* (1913) became a subliminal crucifixion:

> The three men, with their halo-like hats, are situated above a bison skeleton that recalls the skulls at Golgotha. Russell may also intend a play on Carson's first name, *Christ*opher, and on his crossing of the river, to convey the Christian meaning of the explorer's mission. . . .

The text brings to mind the ennui peculiar to a certain type of art history lecture, though this is not to say it is entirely wrongheaded. Indeed, this sort of analysis worked well enough in the wall text accompanying Bingham's *Daniel Boone Escorting Settlers Through the Cumberland* where the links to traditional Christian imagery were more readily apparent. But without providing a more developed critical framework, the discussion of *Carson's Men* could only strike most visitors as arbitrary and purely speculative.

These difficulties are symptomatic of the exhibition's inability to carry through, in any sort of developed or consistent way, its program of historical criticism. From the viewpoint of ideology critique, the exhibition's main flaws resulted from the organizers' failure to consider the problems inherent in the

museum context, their failure to develop a concept of ideology sufficient to the materials on display, and finally, their failure to prepare for the inevitable clash of viewpoints over a subject that for most Americans remains compelling and highly controversial.

As has often been observed, museum spaces are productive of what western culture recognizes as high art. In these spaces historical artifacts acquire an aura of timelessness and universality—Benjamin's "eternal image of the past." Of course, the authority of any given museum is relative. For example, the Washington National Gallery carries far more authority than the National Museum of American Art. But in the end that authority depends entirely upon the museum's capacity to produce timelessness and universality. Thus, already inscribed in a given museum space is a set of meanings that work against any sort of critical narrative. Consequently, while museums present sacralized histories of cultural and artistic triumph, they are, as if by design, conceived to frustrate the sort of dialectical engagement with history that is, as Benjamin wrote, "original to every new present."[23] Instead, visitors are virtually compelled to approach the museum with a sense of reverence, to anticipate that at the museum they will encounter once again The Vindication of Art.

Consequently, the first serious difficulty with "The West as America" was that it in no way attempted to undermine or contradict the museum's usual authority. Instead it tried to adapt to its own purposes the museum's traditional, hegemonic voice. But the ahistorical or anti-historical could not be so readily converted to the historical: the museum space could not, without massive intervention, lose its aura of timelessness. Although the exhibition's neoconservative critics objected to the injection of "politics" into the hypothetically neutral space of the museum, they failed to note that the "politics" on view were for the most part made to seem as authoritative and eternal as the "politics" that usually inhabit such a space. The difference in the end came down to very little: museum visitors long accustomed to being patronized by, as it were, a traditional museum voice (the artificial, self-consciously superior voices of Philippe de Montebello and Carter Brown come immediately to mind), objected to being patronized in a new way.

The second difficulty followed on the first, since the exhibition organizers' neglect of the ideological character of the museum space was symptomatic of their limited comprehension of ideology as a category of historical criticism. In the exhibition, and also to some extent in the catalog essays, ideology was something added to—or only occasionally present in—works of art, their

subject, perhaps their content, but almost never their form, never the way they shaped or represented or constructed a world. Ideology very often boiled down to a (usually erroneous) viewpoint, to a limited set of ideas or presuppositions. Thus there were few occasions in which visitors to "The West as America" encountered the force of ideology, its power over perception, its intimate relation to social practice. Nor was there much attention to the contradictory ways ideologies function, their ceaseless interplay and opposition. Instead, the exhibition often adopted a superior tone, as if what was wrong with the terrible things done to Native Americans or with the expropriation of Mexican-American territory was transparently self-evident, as if modern reason now triumphed over the partial and limited views of earlier Americans. But this was to miss the point entirely, to vastly underestimate the force of now-discredited ideologies and the power they once possessed to constitute, and at the same time naturalize, a set of assumptions so that those assumptions seemed to go without saying or vanish into the "real" (as was the case with so many paintings of the American west). In other words, the exhibition contained almost nothing to suggest what Hegel called "the labor, patience, and suffering of the negative," but rather too happily advanced to its enlightened conclusions. Thus, even sympathetic critics longed for a greater variety of materials in the exhibition, for examples of Native American and Mexican American artifacts, and for more attention to the question of high and low art forms. Such variety would at least have provided a greater sense of an interplay of rhetorics, of the clash of antagonistic discourses, and would have made it more difficult to subject everything in the exhibition to the same blandly normalizing viewpoint.

This brings us to the final difficulty. Because the exhibition was conceived in terms of a single, authoritative voice—a voice that drew upon the traditional, institutional authority of the museum—the organizers of "The West as America" proved unprepared for the uproar that followed the exhibition's opening. This lack of preparation was probably a result of a certain institutional insularity, an inability to recognize the historical and political context in which the exhibition would occur. But it also pointed to a failure to conceive of the exhibition in terms of a range of clashing or opposing viewpoints. Controversy is the lifeblood of democratic culture (and perhaps for this reason art museums avoid it like the plague); only through argument and debate can genuine historical engagement occur. "The West as America" took a step in the direction of this sort of engagement but because of its insistence upon a single,

controlling voice it did not go far enough. Instead it drew back from the implications of its own program. This was perhaps its worst shortcoming. To unfreeze "an eternal image of the past" requires more than simply pronouncing that image "ideological." Certain preconditions must be met since the ideological most fully reveals itself only when it encounters the diverse, living energies of the present.

CHAPTER EIGHT

Revisionism Has Transformed Art History
but Not Museums

As indicated in the previous chapter, the Smithsonian Institution's National Museum of American Art became embroiled in a bitter controversy over "The West as America" when it attempted a revisionist interpretation of images of the frontier. The show became a national issue when Senator Ted Stevens of Alaska, after accusing exhibition organizers of promoting a leftist political agenda, threatened to curtail Smithsonian funding. Neoconservative columnists spewed invective, calling the exhibition "Marxist," "perverse," "simplistic," "destructive," and, predictably, "politically correct." Publicity surrounding the controversy implied that art historical revisionism was on the verge of taking over the museum world.

Unfortunately, this is hardly the case. Indeed, "The West as America" represented one of the very few attempts in recent years to mount an exhibition along revisionist lines. Despite the prestige revisionist art history now enjoys in colleges and universities, museums have for the most part done everything in their power to ignore it.

"Revisionist" or "new" art history grew out of the crises of the 1960s. Younger scholars—many of whom were taking part in the civil rights, antiwar, and women's liberation movements—criticized the discipline's narrow focus on problems of connoisseurship and artistic "influence." In a field that prided itself on upholding standards of "civilization," the "new" art history seemed rough-edged and argumentative. It engaged in confrontational politics, took issue with built-in assumptions and biases, and exposed pervasive sexism and elitism. It also called for increased attention to the theories underlying the

practice of art history and for the recovery of the discipline's intellectual heritage—the focus on the historical and philosophical problems that had made the field central to the humanities in the early decades of the century.

I do not exaggerate when I say that "new" art history was responsible for the discipline's revitalization. Revisionist art historians insisted on discussion and debate in place of the usual numbing silence. Their probing and questioning opened the field to new areas of inquiry and to new theoretical perspectives.

Today revisionism generally dominates academic art history. Leading graduate programs vie for the services of Marxists, feminists, and semioticians. Theory has become a crucial part of the curriculum even at such strongholds of tradition as Columbia and New York Universities. Annual meetings of the College Art Association routinely feature sessions on such subjects as the construction of gender, the politics of representation, and the social history of art.

Thus revisionism has transformed academic art history; yet its impact on museum exhibitions remains slight.

In 1987 the Metropolitan Museum of Art put on a blockbuster exhibition, "American Paradise: The World of the Hudson River School Painters." The first large-scale retrospective since 1945 of Hudson River school landscapes, the exhibition brought together eighty-eight works, and featured rooms devoted to canvases by Thomas Cole, Frederic E. Church, and Asher B. Durand.

A few months later, the Hudson River Museum of Westchester (N.Y.)—an institution little known outside its immediate area and generally ignored by New York reviewers—staged its own Hudson River school exhibition, "The Catskills." Organized by Kenneth Myers, a young American studies professor at Middlebury College, "The Catskills" brought together more than 150 objects—landscape, genre and portrait paintings, prints, drawings, photographs, maps, postcards, books, china, railway timetables, hotel bills, and other artifacts relating to nineteenth-century Catskill tourism.

The Hudson River school is my particular area of specialization, and I visited the two exhibitions repeatedly. The contrast between them—one representative of old or traditional art history, the other of the "new"—could not have been more telling.

"American Paradise" was all glossy spectacle. The spacious galleries, the brilliant lighting, the lush setting combined to produce an experience in which visitors were overwhelmed by the beauty and power of the paintings. Yet something was missing. By viewing Hudson River School landscapes as so

many timeless masterpieces, viewers gained no sense of the paintings' history or historical role. Patronage, contemporary response to the works, the art market, tourism, religious beliefs, industrialization, Jacksonian politics, Manifest Destiny, slavery, the Civil War—all these topics were largely absent from, or rather absorbed by, the exhibition's pseudohistorical theme. Instead, the show promised visitors gleaming visions of a conflict-free American past—a "return to Paradise," in the words of the advertisement put out by Chrysler Corporation, the exhibition's sponsor.

"American Paradise" exemplified traditional art historical wisdom: Choose the best works, gather them together under a familiar if tendentious label ("Treasures," "Masterpieces," "Genius," "Paradise"), add wall texts with a smattering of background information, and, voilà, success is pretty much assured. But what if you depart from formula? What if you seriously want to explore the relationship between art and its historical context? This was the problem the Hudson River Museum set for itself.

The exhibition was laid out in the museum's large central gallery. Paintings hung on temporary walls facing cases with books, prints, and other artifacts related to the paintings. Wall texts set forth basic premises. Visitors followed a roughly chronological path. At almost every step one encountered fascinating juxtapositions—for example, stereoscopic images of the Catskill Mountain House, a rendering of it on Staffordshire china, Frederic Church's painting of the view from the Mountain House, and so forth. There was nothing forced or self-consciously didactic about the installation. Nor did the presence of objects in different media—traditionally a curatorial taboo—detract from the enjoyment of individual artifacts.

Still, as you worked your way through the exhibition, you became increasingly aware of how the materials on display derived from, and also helped to constitute, a touristic culture. Seen in this light, landscapes by Cole, Church, Durand, and others began to make greater artistic and historical sense. No longer reified masterpieces, objects of a disembodied aesthetic contemplation, they connected with a range of nineteenth-century cultural practices such as tourism, nature worship, and patriotic beliefs equating American nature with American identity.

"The Catskills" demonstrated one way in which museums can break out of the "masterpiece-treasure-genius-paradise" syndrome. There are others. A 1988 exhibition at New York's Center for African Art called "Art/Artifact" subjected the category "art" to a searching examination by re-creating the

different exhibition formats in which African works have been seen in the United States since the late nineteenth century. They included a "curiosity room"; a natural history museum display complete with diorama; an "atmospheric" big-museum type of installation; and a stark contemporary gallery. The center even included "authentic" period labels.

Another example was the Menil Collection's "Winslow Homer's Images of Blacks" in 1988. Visitors encountered a variety of works—oil paintings, watercolors, lithographs, wood engravings from *Harper's*—that allowed them to explore in detail the artist's complex response to the changing situation of blacks during the Civil War and Reconstruction.

These exhibitions provoked no heated controversies, no blowups over "Marxism" or "political correctness." Still, these and similar path-breaking shows usually turn up in smaller institutions, sites beneath the notice of the national news media. As a consequence they reach audiences limited to local museum patrons, students in the area, and art historians in the know.

Why don't larger national institutions like the Metropolitan, the Museum of Modern Art, and the National Gallery mount similar exhibitions? Why have they generally failed to take advantage of the large body of revisionist scholarship now available? Why are they so irrevocably attached to their formulaic blockbusters and treasure-house displays?

The usual response from such institutions—"we give the public what it wants"—begs the question. Indeed, it abdicates responsibility, since museums are supposed to be in the business of shaping, not reflecting, taste. A steady diet of commodified culture can only dull the public's critical capacities. Or is that really the point in an age when trustees from a leading museum travel to Disney World to study ways of improving exhibition techniques?

"Revisionist ideas about patronage or class or gender aren't exhibition ideas" is another frequent objection. On the contrary exhibitions can tell complex stories *spatially*. A successful exhibition is not a book on the wall, a narrative with objects as illustrations, but a carefully orchestrated deployment of objects, images, and texts that gives viewers opportunities to look, to reflect, and to work out meanings. Revisionists know this quite as well as traditionalists, as the three exhibitions cited demonstrate. What this objection usually boils down to is a fear that revisionists will neglect or ignore art's aesthetic dimension. This fear makes sense only if you believe the aesthetic is destroyed by the presence of anything else (historical artifacts, works of art in different media, information about patronage).

I believe that the real reason for museums' reluctance to draw upon revisionist scholarship has to do with their deep-seated fear of controversy and critical thought. Museums like the National Gallery thrive on the notoriety that comes with cheap stunts such as the exhibition of Andrew Wyeth's prurient "Helga Pictures." Genuine controversy is something else entirely: it raises basic questions, involves people in issues, makes them care passionately about ideas. In a society in which culture is ultimately controlled by corporate elites, controversy is too dangerous—it cuts too close to the nerve.

I am aware, of course, that museums have always been deeply conservative institutions. Dependent upon corporations, government agencies, and wealthy donors, and presided over by well-heeled trustees usually more interested in prestige and the fate of their personal art collections than in the public good, they have every reason to avoid anything that would bring down the wrath of their financial backers.

This built-in conservatism has been reinforced in the last few years by the appearance of dour, neoconservative culture guardians who have taken upon themselves the task of insulating the public from radical or even mildly dissenting views. Their wild-eyed assault on "The West as America"—whatever the exhibition's flaws, its historical premise was hardly novel—will no doubt inspire even greater caution on the part of curators and museum directors.

Thus, prospects for revisionist exhibitions are not especially bright. Still, this should not be cause for despair: revisionism is here to stay. And this means its specter will continue to haunt museum corridors.

CHAPTER NINE

Museums and Resistance to History

The stunning rise over the last decade of what is variously called new, revisionist, or critical art history has transformed the art historical landscape. Today revisionism dominates academic discussions and exerts an increasing influence on museums, as could be clearly seen at a recent annual meeting of the College Art Association, where a session on "Museums and the New American Art History" drew an audience of more than three hundred people. Even the cautious, tradition-bound Metropolitan Museum of Art is planning exhibitions that will address such issues as the representation of gender and class in works of art.

My own interest in such matters is far from theoretical. Some years ago William Truettner (best known for curating "The West as America") asked me to collaborate with him on an exhibition of the paintings of Thomas Cole (1801–1848), founder of the Hudson River school. In March 1994, after several postponements resulting from difficulties in obtaining key loans of art work, "Thomas Cole: Landscape into History" opened at the museum in which Mr. Truettner is curator of painting and sculpture. The largest showing of Cole's work since the memorial exhibition held shortly after the artist's death, the new show attempted to relate the artist's oeuvre to its social, cultural, and historical contexts.

What made Cole's art fascinating for us was the way it reflected his struggle to find symbolic resolutions to his deeply felt sense of a contemporary world in perpetual crisis. Bill Truettner and I sought to demonstrate in the exhibition that Cole's *Course of Empire* series—five paintings depicting the rise and fall of

an unnamed ancient civilization—was the artist's pessimistic allegory of Jacksonian America. The series made explicit the historical drama implicit in so many of his landscape paintings. Paralleling the first two paintings of *The Course of Empire,* Cole's American wilderness scenes and pastoral landscapes can be viewed as episodes in the early history of a New World empire doomed to suffer the fate of Old World empires.

It is this poignant and ultimately tragic sense of American history that renders Cole's landscapes unique, distinguishing them from the often blandly optimistic work of such contemporaries as Birch, Doughty, and Fisher—topographical landscapists who depicted contemporary tourist sites such as Niagara Falls. Cole's pessimism also set apart his paintings from the landscapes of artists belonging to the next generation of the Hudson River School—Albert Bierstadt, Frederic E. Church, and Asher B. Durand, for example, who, unlike Cole, celebrated the expansionist doctrine of Manifest Destiny and the desirability of material progress.

In the exhibition, we underscored the idea that Cole's conception of landscape reflected an intense awareness of history. Instead of mounting the paintings in the usual chronological sequence, we divided them into categories that corresponded to his mythic portrayals of New World history: wild nature (America before white settlement); nature in transition (pioneers and early settlers); pastoral or arcadian landscapes (the ideal of the virtuous republic); and Old World landscapes—often including ruins and implying decline and decay—contrasted with New World scenes of a young, developing nation. We also included religious allegories—the ahistorical antidote, as it were, to the tragedy of a secular New World that had lost its moral bearings.

We ended up with a powerful installation in which the five paintings of the *Course of Empire* series functioned as the exhibition's centerpiece, with the stages of the empire's rise and decline corresponding to the different landscape categories seen in the adjoining galleries (figs. 9.1, 9.2).

Although we were pleased with the way the exhibition worked visually and conceptually, we were far less happy with the audience response. Judging from remarks in the book we provided for visitors' comments on the exhibition, most viewers found the works beautiful and even fascinating, but few seemed to grasp the exhibition's underlying purpose. In some respects, I attribute this failure to a certain reticence on our part. If "The West as America" had overstated its case by insisting too stridently on particular interpretations of the works on display, we had understated ours. Wall texts, which introduced

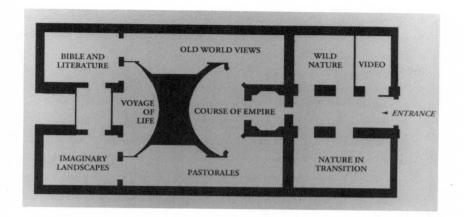

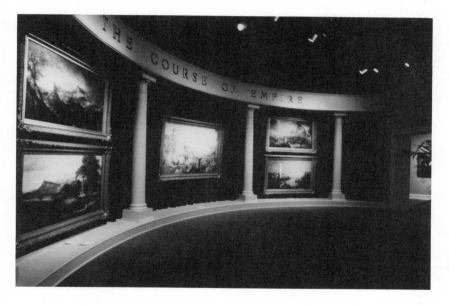

9.1 *Thomas Cole Exhibition Plan.* Photo courtesy of the National Museum
of American Art, Washington, D.C.
9.2 Installation view, "Thomas Cole: Landscape into History." Photo courtesy
of the National Museum of American Art, Washington, D.C.

the exhibition's different categories, were few and far between, and interpretations of individual works, which would have strengthened our argument immeasurably, were almost entirely lacking.

Yet I am reluctant to conclude that this failure can be explained solely by an insufficient number of wall texts or interpretations of individual works. At a deeper level, the public's response may be a result of its unfamiliarity with, and in some instances active resistance to, our approach.

Art in our culture stands for the transcendent, the timeless, and the universal. Museums are temples of art and, as a host of commentators have observed, art has become the secular religion of the middle class—the repository of society's highest values.

But if art is transcendent, timeless, and universal, then—as a category—it stands in polar opposition to history, which is worldly, time-bound, and usually focused on factual evidence. For that reason, efforts to understand works of art in relation to their social, political, or cultural contexts often run into a wall of resistance from critics, and traditional curators and art historians. In the academic world and, to an even greater degree, in the world of museums and art galleries, studies of the social history of art, of art and political power, of art and questions of race, class, and gender are still routinely criticized or dismissed as somehow not about art—indeed as if such studies tainted or contaminated art.

For some people, relating art to its historical contexts threatens belief in transcendence. Consequently, interpretations by revisionist art historians are often met with a dreary litany of accusations—that people who focus on art's social, historical, or political dimensions do not really like or care about art, are willfully ignoring its aesthetic qualities, or are not really discussing art at all.

This was the claim made by Paul Richard, art critic for the *Washington Post,* who asserted in the course of a lengthy review that Bill Truettner and I had offered no proof, in either the exhibition or the accompanying book, that we found Cole's paintings "stirring, even beautiful." Without a shred of historical data to back his argument and in the face of a mountain of evidence to the contrary, Mr. Richard went on to dispute our historical and political reading of *The Course of Empire* series. He maintained that the series could best be understood as the work of a dreamy, apolitical romantic inspired by "an old familiar thought" about the rise and fall of empires, and untouched by the crises of the Jacksonian era.

Mr. Richard's deep-seated hostility to historical interpretation epitomizes a

familiar cultural reflex. Not surprisingly, his views were echoed by a number of visitors to the show. Thus, one wrote in the exhibition comment book: "I think it's problematic to impose the spirit of the age on paintings; it discounts the importance of understanding the artist as a creative genius who somehow transcends the spirit of his or her age." A similar point was made by the curator of a well-known collection of eighteenth- and nineteenth-century American paintings: "The written [wall] text is interesting but the paintings speak for themselves. They stand alone and thus have broader appeal than any meaning imposed on them."

The widespread opposition to the historical understanding of art points to a deepening dilemma. As the panel at the College Art Association meeting demonstrated, curators increasingly are attracted to critical and revisionist approaches. Yet the question arises: will there be an audience for their efforts? It will take years of patient labor by curators, as well as zealous support from museum administrators, to win over a public long accustomed to believing that art is the work of transcendent genius and thus "speaks for itself." The public will have to get used to the idea that, whatever else they may be, works of art are historical artifacts—an idea that flies in the face of all that art museums have hitherto stood for.

NOTES

Introduction

1 See Alan Wallach, "Trouble in Paradise," *Artforum* 15, no. 5 (January 1977): 28–35.

2 Carol Duncan and Alan Wallach, "The Museum of Modern Art as Late Capitalist Ritual: An Iconographic Analysis," *Marxist Perspectives* 1, no. 4 (Winter 1978): 28–51.

3 Carol Duncan and Alan Wallach, "The Universal Survey Museum," *Art History* 3, no. 4 (December 1980): 448–469. Professor Duncan has elaborated the analysis of the museum as ritual structure in *Civilizing Rituals: Inside Public Art Museums* (London and New York: Routledge, 1995).

4 At that time the most interesting critical writing on museums was being done by thinkers from outside the discipline, e.g., Pierre Bourdieu and Alain Darbel (sociologists), Daniel Buren (artist), Philip Fisher (professor of literature), César Graña (sociologist). See Bourdieu and Darbel, *The Love of Art*, trans. Caroline Beattie and Nick Merriman (Stanford: Stanford University Press, 1990; originally published in French, 1969); Buren, "Function of the Museum," *Artforum* 12, no. 1 (September 1973): 69; Fisher, "The Future's Past," *New Literary History* 6, no. 3 (Spring 1975): 587–606; Graña, "The Private Lives of Public Art Museums," *Trans-Action* 4, no. 5 (April 1967): 20–25. Mention should be made, however, of the essays by art historians Linda Nochlin, Edward Fry, and Max Kozloff in *Museums in Crisis*, ed. Brian O'Doherty (New York: Braziller, 1972).

5 A selected bibliography of recent critical studies would include: Tony Bennett, *The Birth of the Museum* (London and New York: Routledge, 1995); Lisa G. Corrin, ed., *Mining the Museum: An Installation by Fred Wilson* (Baltimore: The Contemporary in Cooperation with the New Press, 1994); Reesa Greenberg, Bruce W. Ferguson, and Sandy Nairne, eds., *Thinking About Exhibitions* (New York: Routledge, 1995); Eilean Hooper-Greenhill, *Museums and the Shaping of Knowledge* (London and New York: Routledge, 1992); Ivan Karp and Steven D. Lavine, eds., *Exhibiting Cultures* (Washington, D.C., and London: Smithsonian Institution Press, 1991); Joy Kenseth, ed., *The Age of the Marvelous* (Hanover, N.H.: Hood Museum of Art, Dartmouth College, 1991); Andrew McClellan, *Inventing the Louvre: Art, Politics and the Origins of the Modern Museum in 18th Century Paris* (Cambridge: Cambridge University Press, 1994); Marcia Pointon, ed., *Art Apart: Art Institutions and Ideology Across England and North America* (Manchester and New York: Manchester University Press, 1994); Irit Rogoff and Daniel J. Sherman, eds., *Museum Culture* (Minneapolis: University of Minnesota Press, 1994); and Ralph Rugoff, *Circus Americanus* (London and New York: Verso, 1995).

6 Lynne V. Cheney, *Telling the Truth* (Washington, D.C.: The National Endowment for the Humanities, 1992), 37–38.

7 Angela Miller, "'Sermons in Paint,'" *Oxford Art Journal* 18, no. 2 (1995), 95.

8 Robert Hughes, "America's Prodigy," *Time* (11 July 1994): 54.

1 Long-Term Visions, Short-Term Failures

This chapter first appeared in A. Hemingway and W. Vaughan, eds., *Art in Bourgeois Society, 1790–1850* (Cambridge: Cambridge University Press, 1997), and is reprinted by permission of Cambridge University Press.

1 William C. Dowling, *Jameson, Althusser, Marx: An Introduction to the Political Unconscious* (Ithaca: Cornell University Press, 1984), 117.

2 The Smithsonian Institution is the one exception. Founded in 1846 under the terms of a bequest from James Smithson, a British subject who had never set foot in the United States, the Smithsonian was in effect forced upon a very divided American government.

3 See Frederic Cople Jaher, *The Urban Establishment: Upper Strata in Boston, New York, Charleston, Chicago, and Los Angeles* (Urbana: University of Illinois Press, 1982); Edward Pessen, *Riches, Class, and Power Before the Civil War* (Lexington, Mass.: Heath, 1973); E. Digby Baltzell, *Philadelphia Gentlemen: The Making of a National Upper Class* (1958; reprint, New Brunswick, N.J.: Transaction Publishers, 1989); Peter Dobkin Hall, *The Organization of American Culture, 1700–1900: Private Institutions, Elites, and the Origins of American Nationality* (New York: New York University Press, 1984).

4 Ronald Story, "Class and Culture in Boston: The Athenaeum, 1807–1860," *American Quarterly* 27, no. 2 (May 1975): 178. See also Ronald Story, *The Forging of an Aristocracy: Harvard and the Boston Upper Class, 1800–1870* (Middletown, Conn.: Wesleyan University Press, 1980), especially 160–182, in which he argues for Boston's preeminent role in the formation of a national upper class after the Civil War.

5 See Baltzell, *Philadelphia Gentlemen,* and Story, *The Forging of an Aristocracy;* Hall, *The Organization of American Culture,* 220–270, analyzes in some detail the corporate and organizational bases for the emergence of a "national elite."

6 See Paul DiMaggio, "Cultural Entrepreneurship in Nineteenth-Century Boston: The Creation of an Organizational Base for High Culture in America," in *Media, Culture and Society: A Critical Reader,* ed. Richard Collins et al. (London and Beverly Hills: SAGE, 1986), 194–211.

7 See William Dunlap, *A History of the Rise and Progress of the Arts of Design in the United States,* 2 vols. (1834; reprint, New York: Dover, 1969); Lillian B. Miller, *Patriots and Patriotism* (Chicago: University of Chicago Press, 1966); Neil Harris, *The Artist in American Society: The Formative Years, 1790–1860* (New York: George Braziller, 1966).

8 See Carrie Rebora et al., *John Singleton Copley in America* (New York: M. H. Abrams in association with the Metropolitan Museum of Art, 1995); and Elizabeth Johns, *American Genre Painting* (New Haven: Yale University Press, 1991), 1–23, and passim.

9 See Howard S. Merritt, "*A Wild Scene,* Genesis of a Painting," [Appendix I: Correspondence between Thomas Cole and Robert Gilmor Jr.], *Baltimore Annual* 2 (1967): 41–81; and Alan Wallach, "'This is the Reward of Patronising the Arts,'" *American Art Journal* 21, no. 4 (1989): 76–77.

10 See Kevin J. Avery and Peter L. Fodera, *John Vanderlyn's Panoramic Views of the Palace and*

Gardens of Versailles (New York: Metropolitan Museum of Art, 1988); and Carrie Rebora, "John Vanderlyn's Panorama" (master's thesis, University of California, Los Angeles, 1983).

11 Information and quotation from Maybelle Mann, The American Art-Union (Jupiter, Fla.: ALM Associates, 1987), 14–15.

12 Ibid., 15.

13 See Lawrence Levine, Highbrow/Lowbrow: The Emergence of Cultural Hierarchy in America (Cambridge: Harvard University Press, 1988).

14 Bruce McConachie's study of the theater in the antebellum period can be read, in part, as a critical response to Highbrow/Lowbrow. Where Levine makes a case for democracy in American culture before the Civil War, McConachie shows that early in the century the theater was usually under the control of paternalistic elites and that in the 1830s, 1840s, and 1850s, different types of theaters catered to different types of audiences (working class, "business-class," etc.). See McConachie, Melodramatic Formations: American Theatre and Society, 1820–1870 (Iowa City: University of Iowa Press, 1992).

15 For the National Academy of Design, see Eliot Clark, History of the National Academy of Design, 1825–1953 (New York: Columbia University Press, 1954), and Thomas Seir Cummings, Historic Annals of the National Academy of Design (1865; reprint, New York: Kennedy Galleries, 1969). See also Paul Staiti, Samuel F. B. Morse (Cambridge and New York: Cambridge University Press, 1991), 149–174. For the Pennsylvania Academy of the Fine Arts, see Lee Schreiber, "The Philadelphia Elite in the Development of the Pennsylvania Academy of the Fine Arts" (Ph.D. diss., Temple University, 1977). For the Boston Athenaeum, see Pamela Hoyle, "Introduction: The Making of an Art Museum," in A Climate for Art: The History of the Boston Athenaeum Gallery, 1827–1873 (Boston: Boston Athenaeum, 1980), 1–8.

16 The most comprehensive study of the American Academy is Carrie Rebora, "The American Academy of the Fine Arts, New York 1802–1842" (Ph.D. diss., City University of New York, 1989). For the National Academy of Design, see the previous note.

17 See Ella Foshay, Mr. Luman Reed's Picture Gallery: A Pioneer Collection of American Art (New York: Harry N. Abrams, in association with the New-York Historical Society, 1990). Reed was a shrewd operator but Foshay overestimates his understanding of art and underestimates the role of Thomas Cole and Asher B. Durand who advised Reed in the building of his gallery. The snobbish Robert Gilmor (cited above) was more to the point when he asserted that Reed had known nothing about the art of painting.

18 In addition to works of art, his gallery contained a small natural history collection as well as portraits by Asher B. Durand of all seven presidents, thus making it among other things a patriotic shrine.

19 According to "The New-York Gallery of Fine Arts," Broadway Journal 1 (1 March 1845): 135, "Most of the grocers too, of Front street, out of respect to the memory of Mr. Reed, who held an eminent position among them, have subscribed liberally" to the gallery.

20 Cited in Winifred E. Howe, A History of the Metropolitan Museum of Art, with a Chapter on the Early Art Institutions of New York, 2 vols. (vol. 1: New York: The Metropolitan Museum of Art, 1913; vol. 2: New York: Columbia University Press, 1946), 1:64f. For information about the gallery, see Maybelle Mann, "The New-York Gallery of Fine Arts: 'A Source of Refinement,'" American Art Journal 11, no. 1 (January 1979): 76–86; and Abigail Booth Gerdts, "Newly Discovered Records of the New-York Gallery of Fine Arts," Archives of American Art Journal 21, no. 4 (1981): 2–9.

21 Catalogue of the New-York Gallery of Fine Arts (New York: James Van Norden & Co., 1844), 2, 4.

22 Information in Mann, "The New-York Gallery," 82.

23 Cited in Howe, *A History of the Metropolitan Museum of Art,* 1: 64.

24 For the American Art-Union, see Mann, *The American Art-Union;* Rachel N. Klein, "Art and Authority in Antebellum New York City: The Rise and Fall of the American Art-Union," *Journal of American History* 81, no. 4 (March 1995): 1534–1561; and Patricia Hills, "The American Art-Union as Patron for Expansionist Ideology in the 1840s," in *Art in Bourgeois Society, 1790–1850,* ed. Andrew Hemingway and Will Vaughn (Cambridge: Cambridge University Press, 1997).

25 Klein, "Art and Authority," 1540.

26 Ibid., 1539f.

27 Ibid., 1548–1560. The *Herald,* one of the first penny papers in New York, appealed to a white working-class audience which it fed a poisonous diet of jingoism, "negrophobia," and outrage at some forms of corruption and injustice. In these respects it faithfully reflected the views of its proprietor, a "Hunker" or conservative Democrat with an insatiable appetite for sensationalism. Bennett not only mocked the New-York Gallery of Fine Arts but personally directed his newspaper's vendetta against the Art-Union. See James L. Crouthamel, *Bennett's New York Herald and the Rise of the Popular Press* (Syracuse: Syracuse University Press, 1989), 40–41, and passim.

28 See Janice Simon, "*The Crayon* 1855–1861: The Voice of Nature in Criticism, Poetry, and the Fine Arts" (Ph.D. diss., University of Michigan, 1990). For an earlier discussion, see Roger B. Stein, *John Ruskin and Aesthetic Thought in America, 1840–1900* (Cambridge: Harvard University Press, 1967). See also William James Stillman, *The Autobiography of A Journalist,* 2 vols. (Boston and New York: Houghton, Mifflin and Company, 1901), 1: 222–231.

29 See Simon, "*The Crayon* 1855–1861," 338–358.

30 "Allegory in Art," *The Crayon* 3 (April 1856): 113–114. Either Stillman or his coeditor, John Durand, wrote the review.

31 For a pioneering study of the criticism and reception of Ryder's art, see Eric Rosenberg, "Intricate Channels of Resemblance: Albert Pinkham Ryder and the Politics of Colorism" (Ph.D. diss., Harvard University, 1992). For a social-historical analysis of the New York art world during the 1870s, see Saul E. Zalesch, "Competition and Conflict in the New York Art World, 1874–1879," *Winterthur Portfolio* 29, nos. 2–3 (Autumn 1994): 103–120. Although the literature on Whistler continues to grow by leaps and bounds, there is, to my knowledge, no serious study of the reception of Whistler's work in the United States.

32 DiMaggio, "Cultural Entrepreneurship," 209.

2 *William Wilson Corcoran's Failed National Gallery*

This chapter first appeared as "On the Difficulty of Forming a National Art Collection in the United States: William Wilson Corcoran's Failed National Gallery," in Gwendolyn Wright, ed., *The Formation of National Collections of Art and Archaeology,* Studies in the History of Art, vol. 47. Copyright © 1996 Trustees of the National Gallery of Art, Washington, D.C., and is reprinted by permission.

1 Benedict Anderson, *Imagined Communities,* rev. ed. (London and New York: Verso, 1990).

2 Bertram Wyatt-Brown, "The South against Itself," review of William W. Freehling, *The Road to Disunion:* vol. 1: *Secessionists at Bay, 1776–1854* (New York: Oxford University Press, 1991), in *New York Review of Books* 38 (10 October 1991): 35.

3 Richard F. Bensel, *Yankee Leviathan: The Origins of Central State Authority in America, 1859–1877* (New York: Cambridge University Press, 1990), ix.

4 Richard Rathbun, *The National Gallery of Art, Department of the Fine Arts of the National Museum* Smithsonian Institution United States National Museum, Bulletin 70 (Washington, D.C.: Smithsonian Institution, 1909), 10.

5 See the correspondence between Thomas Jefferson and Charles Willson Peale in Lillian B. Miller, ed., *The Selected Papers of Charles Willson Peale and His Family*, 2 vols. (New Haven and London: Yale University Press, 1988), 2: 974–975, 990–993. The standard text for this subject is Charles Coleman Sellers, *Mr. Peale's Museum* (New York: Norton, 1980).

6 Joshua C. Taylor, *National Collection of Fine Arts, Smithsonian Institution* (Washington, D.C.: Smithsonian Institution Press, 1978), 5–12, gives a brief account of these institutions. For additional detail, see Rathbun, *The National Gallery of Art*, 9–75.

7 Taylor, *National Collection of Fine Arts*, 12–13; Rathbun *The National Gallery of Art*, 25–70; also see Wilcomb E. Washburn, "The Influence of the Smithsonian Institution on the Intellectual Life in Mid-Nineteenth Century Washington," in Francis Coleman Rosenberger, ed., *The Records of the Columbia Historical Society, 1963–1965* 66 (1966), 96–121; and Wilcomb E. Washburn, "Joseph Henry's Conception of the Purpose of the Smithsonian Institution," in *A Cabinet of Curiosities: Five Episodes in the Evolution of American Museums* (Charlottesville: University Press of Virginia, 1967), 106–166. It should be noted that not all of the paintings owned by the National Institution ended up in the Smithsonian's collection.

8 See Robert M. and Gale S. McClung, "Tammany's Remarkable Gardiner Baker, New York's First Museum Proprietor, Menagerie Keeper, and Promoter Extraordinary," *New-York Historical Society Quarterly* 42 (April 1958): 142–169; Lloyd Haberly, "The American Museum from Baker to Barnum," *New-York Historical Society Quarterly* 43 (July 1959): 272–287.

9 See Sellers, *Mr. Peale's Museum*, 276–307.

10 Paul DiMaggio, "Cultural Entrepreneurship in Nineteenth-Century Boston: The Creation of an Organizational Base for High Culture in America," in *Media, Culture and Society: A Critical Reader*, ed. Richard Collins et al. (London and Beverly Hills: SAGE, 1986), 196. In what follows I am indebted to DiMaggio's analysis and to arguments set forth in Pierre Bourdieu and Alain Darbel, *The Love of Art*, trans. Caroline Beattie and Nick Merriman (Stanford: Stanford University Press, 1990; originally published in French, 1969).

11 DiMaggio, "Cultural Entrepreneurship," 196.

12 Matthew Josephson, *The Robber Barons* (1934; reprint, New York: Harcourt Brace Jovanovich, 1962), 332.

13 See DiMaggio, "Cultural Entrepreneurship," for an account of how Boston's Brahmin elite built high cultural institutions in the period under consideration. For a study that reveals much about the ways in which local circumstances conditioned elite behavior, see Frederic Cople Jaher's monumental *The Urban Establishment: Upper Strata in Boston, New York, Charleston, Chicago, and Los Angeles* (Urbana: University of Illinois Press, 1982).

14 For biographical information about Corcoran, see Roland T. Carr's anecdotal *32 President's Square* (Washington, D.C.: Acropolis Books, 1980); Henry Cohen's excellent business biography, *Business and Politics in America from the Age of Jackson to the Civil War: The Career Biography of W. W. Corcoran* (Westport, Conn.: Greenwood, 1971); William Wilson Corcoran, *A Grandfather's Legacy, Containing a Sketch of His Life and Obituary Notices of Some Members of His Family, Together with Letters from His Friends* (Washington, D.C., 1879); and Davira Spiro Taragin, *Corcoran* (Washington, D.C.: The Corcoran Gallery of Art, 1976).

15 Cohen, *Business and Politics,* 228, graphically describes how Corcoran practiced the sort of casual corruption and chicanery typical of the period:

Corcoran ramified his political influence by loans, bribes, employment of agents, investments, and campaign contributions. Sometimes a specific quid pro quo was the important consideration; always there was the banking of good will. Out of the logrolling over scores of particular issues were improvised informal overlapping alliances that endured through successive controversies and influenced presidential politics. Most far-reaching was the chain opportunistically forged by Corcoran, Bright, and others through claims, Texas debt, [Lake] Superior speculation, railroad land grants, and other collaborations, leading in 1856 to the frustration of [Stephen A.] Douglas' presidential ambition, the election of the disastrous Buchanan, and the advancement of [John C.] Breckinridge.

16 Ibid., 225.

17 Ibid., 98–99.

18 Ibid., 99.

19 Letter of 13 January 1854, cited in Carr, *Presidents,* 155–156.

20 Unattributed quotation in Taragin, *Corcoran,* 14.

21 Ibid., 13–14. I have here relied on Jean Fagan Yellin's incisive study of Power's statue. See Yellin, *Women & Sisters* (New Haven: Yale University Press, 1989), 99–124.

22 Taragin, *Corcoran,* 14, paraphrasing a comment made about Corcoran in response to dismay over the figure's nudity.

23 William MacLeod, "Some Incidents in the Life of the Late Wm. Wilson Corcoran" (essay in MacLeod Papers, Columbia Historical Society, Washington, D.C.), 1.

24 Mary J. Windle, *Life in Washington, and Life Here and There* (Philadelphia: J. B. Lippincott, 1859), 147.

25 In a letter of 5 October 1860, J. Goldsborough Bruff, "Recording Secretary," informed Corcoran that "at the first annual meeting of the 'NATIONAL GALLERY AND SCHOOLS OF ARTS,' held at Willard's Hotel, on the 2nd instant, you were unanimously elected President of said institution" (William Wilson Corcoran Papers, Library of Congress, container 9). This new grouping was probably meant to supplant the Washington Art Association as the Gallery's organizational base; however, Bruff's letter is the only record of its existence I have come across; presumably the group dispersed with the beginning of the Civil War.

Corcoran made no secret of his ambitions, and in letters to him numerous casual correspondents as well as friends and business associates refer to his gallery as the "National Gallery" or "National Art Gallery" or "National Gallery of Great Painting." For example, in a letter from London of 16 June 1869, George Peabody thanked Corcoran for his "kind note dated 11th inst., covering cuttings from the newspapers giving an interesting account of your magnificent donations to establish a national gallery of painting and sculpture in the city of Washington, connected there with a Widow's Home" (in Corcoran, *A Grandfather's Legacy,* 297–298).

By the late 1870s, Corcoran's reputation as the founder of a United States museum equivalent to a national gallery was fairly widespread. Thus Edward Strahan, author of a lavish series of volumes describing United States art collections, listed Corcoran as first among American collectors and observed that "The name of Mr. Corcoran . . . is on the most prosaic construction fit to go down with that of Mr. Vernon, who presented his picture-collection to England, and may be said to have founded the National Gallery; and

with those of Augustine Sheepshanks, and Sir George Beaumont, who made equally generous dedications of their private hoards of pictures." See Edward Strahan (pseud. Earl Shinn), *The Art Treasures of America,* 3 vols. (Philadelphia: G. Barrie, 1879–1882), 1: 4.

26 In what follows, I have relied mainly on Taragin, *Corcoran,* passim, for information about Corcoran's activities during the 1860s.

27 For example, more than fifty years later the formidable Mary Smith Lockwood, Historian General as well as founder of the Daughters of the American Revolution, recalled the stratagem Corcoran employed in 1862 to prevent the government from confiscating his house, and then made the following observation: "Those are days we would gladly forget. We never want to think of a man turning his back on his country when she is in distress— especially one whom fortune had so kindly favored in his motherland." See Mary Smith Lockwood, *Yesterday in Washington.* 2 vols. (Rosslyn, Va.: The Commonwealth Company, 1916), 2: 99.

28 Taragin, *Corcoran,* 19–21.

29 Corcoran's letter to his board of trustees, the trustees' response, and the deed itself were immediately published. See the *National Intelligencer* (19 May 1869). These documents are preserved as part of the Corcoran Gallery's *Journal of the Official Proceedings of the Trustees of the Corcoran Gallery of Art,* Corcoran Gallery Archives.

30 *Daily Patriot* (21 February 1871).

31 *National Intelligencer* (May 1896).

32 A series of eleven-foot statues on the building's facade complemented this program. Produced during the 1870s by the Richmond sculptor Moses Ezekiel, the statues represented Phidias, Michelangelo, Raphael, Da Vinci, Titian, Dürer, Rubens, Rembrandt, Murillo, Canova, and Thomas Crawford, not coincidentally Ezekiel's teacher and today best remembered for the figure of *Armed Freedom* which surmounts the Capitol dome.

33 Information about the Corcoran's contents is derived from William MacLeod, *Catalogue of the Paintings, Statuary, Casts, Bronzes, &c. of the Corcoran Gallery of Art* (Washington, D.C.: The Corcoran Gallery, 1877).

34 Taragin, *Corcoran,* 25.

35 Ibid., 23.

36 See Bourdieu and Darbel, *The Love of Art,* 109–113; and Pierre Bourdieu, *Distinction: A Social Critique of the Judgment of Taste,* trans. Richard Nice (Cambridge: Harvard University Press, 1984; originally published in French, 1979).

3 The American Cast Museum

1 A number of authors have touched on the history of casts in American art museums, but so far there is no full-scale history or critical study. The only scholarly article on the subject is Betsy Fahlman, "A Plaster of Paris Antiquity: Nineteenth-Century Cast Collections," *Southeastern College Art Conference Review* 12, no. 1 (1991): 1–9, which focuses on the cast collection at Yale's School of Fine Arts and provides useful bibliographical information but fails to fulfill the promise of its title.

2 Samuel L. Parrish, *Historical, Biographical, and Descriptive Catalogue of the Objects Exhibited at the Southampton Art Museum,* third illustrated edition (1898; reprint, New York: Benjamin H. Tyrrel, 1926), ix–x. For more about Parrish and his museum, see chapter 4.

3 Information about the Corcoran's contents is derived from William MacLeod, *Catalogue of the Paintings, Statuary, Casts, Bronzes, &c. of the Corcoran Gallery of Art* (Washington, D.C.: The Corcoran Gallery, 1877). See also chapter two.

4 Ibid.

5 Walter Muir Whitehill, *Museum of Fine Arts, Boston: A Centennial History*, 2 vols. (Cambridge: Harvard University Press, 1970), 1: 22.

6 Ibid., 30f., 34, 36, 45, 76. The Museum of Fine Arts also exhibited electrotype reproductions of arms and armor, as well as a series of Braun photographs of old master drawings.

7 For a discussion of the application of the concept of an iconographic program to museums, see Carol Duncan and Alan Wallach, "The Universal Survey Museum," *Art History* 3, no. 4 (December 1980): 448–469.

8 In addition to these works from the western tradition, the second floor housed a superb collection of Japanese art acquired through "the workings of serendipity." See Whitehill, *Museum of Fine Arts*, 1: 82.

9 Henry Watson Kent, *What I Am Pleased to Call My Education* (New York: The Grolier Club, 1949), 39.

10 According to Kent, among those in attendance at the opening were Charles Eliot, president of Harvard; Martin Brimmer, president of the Boston Museum of Fine Arts; General Francis A. Walker, president of M.I.T.; Isabella Stewart Gardner; Mrs. Henry Whitman; Miss Helen Shafer, president of Wellesley College; and professors from Harvard, Yale, and Columbia. Daniel Coit Gilman, president of Johns Hopkins University and an alumnus of the Norwich Free Academy, spoke, after Norton, on "Greek Art in a Manufacturing Town" (ibid., 43). Gilman's remarks were published in *The Studio* 3, no. 12 (November 1888): 185–188.

11 Kent, *My Education*, 98f.

12 Calvin Tomkins, "The Art World: Gods and Heroes," *New Yorker* (15 September 1986): 82.

13 Kent, *My Education*, 100.

14 Ibid., 101–105.

15 For college and university collections see E. Baldwin Smith, "The Study of the History of Art in the Colleges and Universities of the United States," a pamphlet originally published by Princeton University Press in 1912 and reproduced in Craig Hugh-Smyth and Peter M. Lukehart, *The Early Years of Art History in the United States* (Princeton: Department of Art History and Archaeology, Princeton University, 1993), 12–36; for the Valentine Museum's cast collection, see *Description of Casts in The Valentine Museum* (Richmond, Va.: Valentine Museum, 1898); for the Southampton Art Gallery, see chapter 4.

16 "Museums as a Means of Instruction," *Appleton's Journal* 3 (15 January 1870): 80.

17 [Edward Robinson], "The Cost of a Small Museum," *Nation* 29, no. 1273 (21 November 1889): 405.

18 Francis Haskell and Nicholas Penny, *Taste and the Antique* (New Haven and London: Yale University Press, 1981), xiii.

19 Cited in Kent, *My Education*, 108–109.

20 See Edward Robinson, *Museum of Fine Arts Boston, Catalogue of Casts Part III* (Boston and New York: Houghton, Mifflin and Company, 1896).

21 Cited in Winifred E. Howe, *A History of the Metropolitan Museum of Art, with a Chapter on the Early Art Institutions of New York*, 2 vols. (vol. 1: New York: The Metropolitan Museum of Art, 1913; vol. 2 New York: Columbia University Press, 1946), 1: 252.

22 Ibid., 1: 268; 2: 1–2, 29. Tomkins, "The Art World," 84.

23 For Prichard, see David Sox, *Bachelors of Art: Edward Perry Warren & the Lewes House Brotherhood* (London: Fourth Estate, 1991), 167–208. For the fullest account of the "battle," see Whitehill, *Museum of Fine Arts,* 1: 173–220, but see also Sox, *Bachelors of Art,* 180–185. For an account of the divisions within the museum, see Martin Green, *The Mount Vernon Street Warrens: A Boston Story, 1860–1910* (New York: Charles Scribner's Sons, 1989), 167–173.

24 *Handbook of the Museum of Fine Arts, Boston* (Boston: Museum of Fine Arts, 1910), 315.

25 For Perry Warren, see Sox, *Bachelors of Art,* passim, and Osbert Burdett and E. H. Goddard, eds., *Edward Perry Warren: The Biography of a Connoisseur* (London: Christopher, 1941). For Warren's activities, see also Whitehill, *Museum of Fine Arts,* 1: 142–171. After the Museum of Fine Arts decided to focus its efforts on building the Huntington Avenue complex, Warren shifted his allegiance as purchasing agent to the Metropolitan Museum.

26 See Whitehill, *Museum of Fine Arts,* 1: 176–178, and Sox, *Bachelors of Art,* 178–185, for Prichard and Mrs. Gardner.

27 For Morgan as a collector see Aline Saarinen, "The Grandiose Gesture, J. P. Morgan," in Saarinen, *The Proud Possessors* (New York: Random House, 1958), 56–91; Louis Auchincloss, *J. P. Morgan, The Financier as Collector* (New York: Harry N. Abrams, 1990); and Neil Harris's superb essay, "Collective Possession: J. Pierpont Morgan and the American Imagination," in Neil Harris, *Cultural Excursions* (Chicago: University of Chicago Press, 1990), 250–277.

28 Cited in Calvin Tomkins, *Merchants and Masterpieces* (New York: E. P. Dutton & Co., Inc., 1973), 99.

29 Cited in Leo Lerman, *The Museum: One Hundred Years and the Metropolitan Museum of Art* (New York: Viking Press, 1969), 122.

30 Henry James, *The American Scene* (1907; reprint, New York: St. Martin's Press, 1987), 138. The entire passage is worth citing:

> There was money in the air, ever so much money—that was, grossly expressed, the sense of the whole intimation. And the money was to be all for the most exquisite things—for *all* the most exquisite except creation, which was to be off the scene altogether; for art, selection, criticism, for knowledge, piety, taste. The intimation,—which was somehow, after all, so pointed—would have been detestable if interests other, and smaller, than these had been in question. The Education, however, was to be exclusively that of the sense of beauty; this defined, romantically, for my evoked drama, the central situation. What left me wondering a little, all the same, was the contradiction involved in one's not thinking of some of its prospective passages as harsh. Here it is, no doubt, that one catches the charm of rigors that take place all in the aesthetic and the critical world. They would be invidious, would be cruel, if applied to personal interests, but they take on a high benignity as soon as the values concentrated become values mainly for the mind. (If they happen to have also a trade-value this is pure superfluity and excess.) The thought of the acres of canvas and the tons of marble to be turned out into the cold world as the penalty of old error and the warrant for a clean slate ought to have drawn tears from the eyes. But these impending incidents affected me, in fact, on the spot, as quite radiant demonstrations. The Museum, in short, was going to be great, and in the geniality of the life to come such sacrifices, though resembling those of the funeral pile of Sardanapalus, dwindled to nothing.

31 Cited in Whitehill, *Museum of Fine Arts,* 1: 183.

32 Letter to the president, cited in ibid., 201–203.

33 Sox, *Bachelors of Art,* passim, provides a sense of the context in which Prichard developed his aesthetic philosophy, which in many respects coincided with the aesthetic doctrines being formulated about the same time by Roger Fry and Clive Bell. Oscar Wilde's writings and the

doctrine of "l'art pour l'art" no doubt also contributed to Prichard's philosophy and were generally important for the thinking that sustained this new phase of the cult of the original.

34 In Whitehill, *Museum of Fine Arts,* 1: 201–202.

35 Ibid., 203.

36 Eileen Hooper-Greenhill, "The Museum in the Disciplinary Society," in *Museum Studies in Material Culture,* ed. Susan M. Pearce (Leicester and London: Leicester University Press; Washington, D.C.: Smithsonian University Press, 1989), 63.

37 Kent, *My Education,* 104. Dana, a champion of lower-class uplift, went on to become director of the Newark Museum where he instituted a policy of industrial arts education on the model of the South Kensington (later the Victoria and Albert) Museum. He polemicized against traditional art museums in *The Gloom of the Museum* (Woodstock, Vt.: Elm Tree Press, 1917). Kent, who no doubt was aware of Dana's subsequent career, astutely noted that the invitation to the street railway men at Springfield was "a characteristic Dana touch."

38 Haskell and Penny, *Taste and the Antique,* xiii. Unfortunately, Haskell and Penny do not analyze the evolution of European attitudes toward ancient art, claiming that such an analysis would require a study of "the history of European culture as a whole."

39 Cited in Lloyd Goodrich, *Thomas Eakins* (Washington, D.C.: National Gallery of Art; Cambridge: Harvard University Press, 1982), 27. Eakins was referring to the cast collection at the Pennsylvania Academy of the Fine Arts.

40 Metropolitan Museum of Art archives, cited by Jeannine Falino in her unpublished essay, "'As if I were a grand duke': The Use of Plaster Casts in Boston 1817–1939," 35.

41 See Tomkins, *Merchants and Masterpieces,* 81–82.

42 Albert Boime, *The Academy and French Painting in the Nineteenth Century* (London: Phaidon, 1971), 185, and passim. Boime notes that "the aesthetics of the sketch" developed within the academy and that it unintentionally contributed "to the evolution of independent tendencies." See also Lois Marie Fink and Joshua C. Taylor, *Academy: The Academic Tradition in American Art* (Washington, D.C.: National Collection of Fine Arts and the Smithsonian Institution Press, 1975), 58–60. By 1878, the curriculum at the National Academy of Design was, in the words of David Huntington, the academy's president, meant to balance "extreme care and perfection on the one hand, alternating with a rapid, resolute dash at the result." Fink and Taylor also describe the tendency of groups of more experimental artists to break away from the Academy (94–96). For the situation in Philadelphia, see Ronald J. Onorato, "The Pennsylvania Academy of the Fine Arts and the Development of an Academic Curriculum in the Nineteenth Century" (Ph.D. diss., Brown University, 1977). Thomas Eakins was responsible for a shift away from a conservative curriculum that emphasized the prolonged study of casts. He took as his motto, "if you are going to be a painter work with paint," and emphasized the rendering of "real objects from everyday life," but had no interest in the "spontaneous, impressionistic recapitulation of light and color onto his canvas." See Onorato, 111–112.

43 Cited in Nicolai Cikovsky, Jr., "The Civilized Landscape," in Cikovsky and Michael Quick, *George Inness* (Los Angeles: Los Angeles County Museum of Art, 1985), 41.

44 This description of artists and styles telescopes a complex history. In *Art and the Higher Life: Painting and Evolutionary Thought in Late Nineteenth-Century America* (Austin: University of Texas Press, 1996), Kathleen Pyne attempts "to study late nineteenth-century American visual culture as a response to the problematic conditions of American life." Pyne's book is the most important study published so far on the significance of "the genteel tradition." For

individual artists mentioned here, see Eric Mark Rosenberg, "Intricate Channels of Resemblance: Albert Pinkham Ryder and the Politics of Colorism" (Ph.D. diss., Harvard University, 1992), a far-reaching investigation of the reception and contemporary significance of Ryder's art; Elizabeth Broun, *Albert Pinkham Ryder* (Washington, D.C.: National Museum of American Art and the Smithsonian Institution Press, 1989); Richard Dorment and Margaret MacDonald, eds., *James McNeil Whistler* (Washington, D.C.: National Gallery of Art and Tate Publications, 1994); Nicolai Cikovsky and Michael Quick, *George Inness;* Susan A. Hobbs, *The Art of Thomas Wilmer Dewing: Beauty Reconfigured* (Brooklyn: Brooklyn Museum in Association with the Smithsonian Institution Press, 1996). See Peter Bermingham, *American Art in the Barbizon Mood* (Washington, D.C.: Smithsonian Institution Press, 1975), for the popularity of Barbizon painting among American collectors, and the American artists who took their inspiration from Millet, Diaz, Dupré et al. For American collectors of French Impressionist painting, see Anne Distel, *Impressionism: The First Collectors* (New York: Harry N. Abrams, 1990), 233–244, and Frances Weitzenhoffer, *The Havemeyers: Impressionism Comes to America* (New York: M. H. Abrams, 1986). For American impressionism and tonalism, see William H. Gerdts, *American Impressionism* (New York: Abbeville Press, 1984); and Wanda Corn, *The Color of Mood: American Tonalism, 1880–1910* (San Francisco: M. H. De Young Memorial Museum and the California Palace of the Legion of Honor, 1972).

45 Pyne, *Art and the Higher Life,* 5, suggests something of the complexity of the situation I am describing when early in her study she distinguishes between the roles played by "the mythical merchant princes and robber barons or new-money capitalists" and "a group of middle-class intellectuals, academicians, writers, editors, and artists who controlled the social and educational institutions responsible for shaping discourses and reproducing social hierarchies."

46 Letter to Helen Gardner, 2 November 1904, cited in Whitehill, *Museum of Fine Arts,* 1: 203.

47 *Handbook of the Museum of Fine Arts, Boston* (Boston: Museum of Fine Arts, 1910), 315.

48 Tomkins, *Merchants and Masterpieces,* 99.

49 James, *American Scene,* 138.

4 Samuel Parrish's Civilization

This chapter first appeared in Donna De Salvo, ed., *A Museum Looks at Itself* (New York: The New Press, and Southampton: The Parrish Art Museum, 1994), 53–61, and is reprinted by permission of the Parrish Art Museum.

1 For a valuable discussion of the word "civilization," see Raymond Williams, *Keywords* (New York: Oxford University Press, 1976), 48–50.

2 Biographical information and information about the Parrish family comes from *Autobiography of 1905 and Biographies of 1925 and 1927 of Samuel L. Parrish* (privately printed, c. 1928); Samuel L. Parrish, *Early Reminiscences* (New York: privately printed, 1927); Helen Lee Peabody, "An Art Lover and His Country Museum," typescript inscribed "Causeries de Lundi," 10 April 1961 (collection The Parrish Art Museum; "Causeries de Lundi," or "Monday Chats," was probably a women's club), and "Samuel Longstreth Parrish," in *The Story of the Parrish Art Museum* (Southampton, N.Y.: Parrish Art Museum, 1961), 13–30; Dillwyn Parrish, *The Parrish Family Including the Related Families of Cox, Dillwyn, Roberts, Chandler, Mitchell, Painter, Pusey,* ed. Susanna Parrish Wharton (Philadelphia: George H. Buchanan Co., 1925).

3 For information about Parrish's club memberships, see *Autobiography of 1905,* especially the biographical text reprinted there from *The National Cyclopaedia of American Biography* (New York: James T. White and Co., 1927), vol. B, 371–372.

4 Parrish wrote a history of the Shinnecock Hills Golf Club, which he published at his own expense and gave out to friends and business contacts. See his *Some Facts, Reflections and Personal Reminiscences Connected with the Introduction of the Game of Golf into the United States More Especially as Associated with the Formation of the Shinnecock Hills Golf Club* (c. 1923), and a handwritten list headed "Golf Pamphlets sent September" (both in the collection of the Parrish Art Museum).

5 See "George Wickersham," *The National Cyclopaedia of American Biography* (New York: James T. White and Co., 1930), vol. C, 16–18; "William MacKay Laffan," *The National Cyclopaedia of American Biography* (New York: James T. White and Co., 1943), 30: 249.

6 For Marquand, see K. S. E. [Katharine S. Eisenhart], "Henry Gurdon Marquand," *Dictionary of American Biography,* ed. Dumas Malone (New York: Charles Scribner's Sons, 1933), 6: 292–293; Winifred E. Howe, *A History of the Metropolitan Museum of Art,* 2 vols. (vol. 1: New York: The Metropolitan Museum of Art, 1913; vol. 2: New York: Columbia University Press, 1946), 1: 211; and Calvin Tomkins, *Merchants and Masterpieces* (New York: E. P. Dutton, 1973), 73–75.

7 See Richard W. Leopold, *Elihu Root and the Conservative Tradition* (Boston: Little, Brown and Co., 1954), passim, and 197; and "Elihu Root," *The National Cyclopaedia of American Biography* (New York: James T. White and Co., 1937), 26: 1–5. For Root's connection to the Century Club, see *Elihu Root, President of the Century Association, 1918–1927: Addresses Made in His Honor* (New York: Century Club, 1937). Both Parrish and Root were members of the Century, and Root was among the original forty-four members of the Shinnecock Hills Golf Club (see Parrish, *Some Facts, Reflections, and Personal Reminiscences,* 9).

8 Charles C. Baldwin, *Stanford White* (New York: Dodd, Mead & Co., 1931), 317. Peabody, "Samuel Longstreth Parrish," 16–17, claimed that in the 1880s, "the Parrish family had begun to spend summers at Southampton, in a house on First Neck Lane built by Stanford White," but there is no evidence that the house, which Parrish apparently owned, was White's work.

9 Samuel L. Parrish, letter to Thomas B. Ticknor, Esq. (Secretary of the Harvard Class of 1870), 7 July 1905, in *Autobiography of 1905.* Parrish printed this text in *Early Reminiscences.*

10 Samuel Parrish, *Autobiography of 1905.*

11 See Robert H. Wiebe, *The Search for Order* (New York: Hill and Wang, 1967), especially 258–260, for an account of the Theodore Roosevelt administration's Anglophile position. For an incisive treatment of United States foreign policy during this period, see Gabriel Kolko, "The Foundations of the United States as a World Power," in Kolko's *Main Currents in Modern American History* (New York: Pantheon Books, 1984), 34–66.

12 Samuel L. Parrish, "Colonization and Civil Government in the Tropics," Address to the Annual Meeting of the Suffolk County Historical Society, 17 February 1903, 3. Parrish published increasingly elaborate versions of this text between 1903 and 1916, when it appeared as *Self-Government in the Tropics* (Washington, D.C.: Government Printing Office, 1916).

13 Samuel L. Parrish, *Self-Government in the Tropics,* 8.

14 Samuel L. Parrish, *American Expansion Considered as an Historical Evolution.* Paper read before the American Social Science Association, 6 September 1899, 7.

15 Ibid., 12.

16 Samuel L. Parrish, *Early Reminiscences,* section on the history of the museum. For informa-

tion about Grosvenor Atterbury and the design for the museum, see Charles C. May, "The Parrish Museum, Southampton, Long Island," *Architectural Record* 38, no. 5 (November 1915): 524–539.

17 Parrish concentrated on Italian painting of the fifteenth and early sixteenth centuries but he also bought at least one seventeenth-century Dutch painting. *The Samuel Parrish Collection of Renaissance Paintings at the Parrish Art Museum* (Southampton, N.Y.: Parrish Art Museum, c. 1970) illustrates most but not all of the works that Parrish bought.

18 Samuel L. Parrish, *Historical, Biographical, and Descriptive Catalogue of the Objects Exhibited at the Southampton Art Museum,* 3d ed. (New York: Benjamin H. Tyrrel, 1898 [1926]), 46. Parrish published illustrated editions of the catalogue in 1912, 1916, and 1926. These contained a number of small additions: a preface (1912), a note on illustrations of works later added to the collection (1916), and the dedication of the third illustrated edition to Atterbury (1926). The original text was, however, published each time without alteration. Parrish added photographs of four new works to the 1912 edition, eight to the 1926 edition. Otherwise, additions to the collection went unremarked though a number are visible in the photographs of the museum's galleries that appear in these editions. References here are to the third illustrated edition which comprehends all previous editions (hereafter Parrish, *Catalogue*).

19 Samuel L. Parrish, "The Family Room of the Art Museum," *Early Reminiscences.*

20 May, "The Parrish Museum," 530.

21 In his *Catalogue,* 134, Parrish refers to "Lübke's 'History of Art.'" Wilhelm Lübke (1826–1893) was the H. W. Janson of his day, and his massive *Grundrisse der Kunstgeschichte* (Outline of the history of art), first published in 1868, went through numerous editions in German and English.

22 Parrish, *Catalogue,* xiv.

23 It was often said that Parrish had a precocious taste for Italian "primitive" painting, but there was in fact nothing particularly exceptional during the 1880s and 1890s about an interest in the work of Trecento and Quattrocento artists.

24 See Parrish, *Catalogue,* chapter 2.

25 Cited in Lawrence W. Levine, *Highbrow / Lowbrow: The Emergence of Cultural Hierarchy in America* (Cambridge: Harvard University Press, 1988), 151.

26 See Howe, *A History of the Metropolitan Museum,* 1: 211, 252–253; and F. J. M., Jr. [Frank Jewett Mather, Jr.], "Allan Marquand," *Dictionary of American Biography,* ed. Dumas Malone (New York: Charles Scribner's Sons, 1933), 6: 291–292.

27 Cited in Howe, *A History of the Metropolitan Museum,* 1: 252.

28 Ibid., p. 268; and 2: 1–2, 29.

29 Matthew Stewart Prichard, assistant director of the Boston Museum of Fine Arts, cited in Levine, *Highbrow / Lowbrow,* 152–153.

30 Parrish, *Catalogue,* pp. ix–x.

31 In 1882 Henry Marquand gave the Metropolitan Museum a large altarpiece by Andrea della Robbia representing the assumption of the Virgin. (See Allan Marquand, *Andrea della Robbia and his Atelier,* 2 vols. [Princeton: Princeton University Press, 1922], 2: 125.) Parrish, whose own collecting had focused on fifteenth-century Italian painting, had multiple connections with the group of artists and collectors involved in the Quattrocento revival, and he was doubtless familiar with Henry Marquand's gift. The composite altarpiece that Parrish designed for his own museum was very likely an attempt to fashion a work that would produce a comparable impact.

32 Invitation to the opening of the Southampton Art Gallery (archive of the Parrish Museum).

The judge was Henry E. Howland who summered in Southampton and belonged to the same clubs as Parrish. See "Henry Elias Howland," *The National Cyclopaedia of American Biography* (New York: James T. White and Co., 1907), 7: 472.

33 Parrish describes the business of purchasing the busts in a letter to the museum's trustees dated 12 November 1924, which he published in *Early Reminiscences.*

34 May, "The Parrish Museum," 525.

35 Howe, *History of the Metropolitan Museum,* 1: 211; and Nathaniel Burt, *Palaces for the People* (Boston: Little Brown, 1977), 222–224.

36 This brief analysis is indebted to, but also takes issue with, Walter Benjamin's celebrated essay, "The Work of Art in the Age of Mechanical Reproduction," in *Illuminations,* ed. Hannah Arendt, trans. Harry Zohn (London: Collins/Fontana, 1973), 219–254.

37 In the mid-1920s, Parrish's board of trustees included the conservative art critic Royal Cortissoz and the sculptor Hermon A. MacNeil. In 1925, Parrish set up a sculpture fellow-ship at the tradition-bound American Academy in Rome: Cortissoz and MacNeil were trustees of the Academy and thus facilitated the link between the two institutions. See prefatory note dated 1 February 1926, in Parrish, *Catalogue.*

38 Letter to the trustees dated 12 November 1924, in Parrish, *Early Reminiscences.*

5 The Museum of Modern Art

This chapter first appeared in *Journal of Design History* 5, no. 3 (1992): 207–215, and is reprinted by permission of Oxford University Press.

1 The story of MOMA's tower deal is a fable of its time. In this tale of megabuck real estate speculation and high-powered political manipulation, art, or rather the glamour and prestige associated with art, functions as a catalyst. In a three-way agreement between MOMA, the City of New York, and a real estate developer, the Museum sold its air rights to the Museum Tower Corporation for $17,000,000 with the proviso that tax income from the Tower would go to the Museum via a specially created New York City Trust for Cultural Resources. In addition to funneling tax money to the Museum, the Trust was responsible for the $40,000,000 bond issue that financed MOMA's expansion. (The Museum's endowment and the $17 million payment for air rights were used as collateral.) For brief and curiously deadpan accounts of these matters, see "MOMA," *Architectural Record* 169, no. 4 (March 1981): 94; Lee Rosenbaum, "A New Foundation for MOMA's Tower," *Art News* 79 (February 1980): 64–69.

2 "Marvelous MOMA," *New York Times* (13 May 1984): section 4, 22.

3 *Time* (14 May 1984): 80.

4 See Hilton Kramer, "MOMA Reopened: The Museum of Modern Art in the Postmodern Era," *New Criterion* 2 (Summer 1984): 1–44.

5 Ibid., 12.

6 Jo-Anne Berelowitz, "From the Body of the Prince to Mickey Mouse," *Oxford Art Journal* 13, no. 2 (1990): 82.

7 See Frederic Jameson, "Postmodernism, or the Cultural Logic of Late Capitalism," *New Left Review* 146 (July–August 1984): 53–93; see also Rosalind Krauss, "The Cultural Logic of the Late Capitalist Museum," *October* 54 (1990): 3–17.

8 Jameson, "Postmodernism," 59.

9 For the history of the building campaign and a discussion of the decisions affecting the

choice of architects see Dominic Ricciotti, "The 1939 Building of the Museum of Modern Art: The Goodwin-Stone Collaboration," *American Art Journal* 17, no. 3 (Summer 1985): 50–76; and Rona Roob, "1936: The Museum Selects an Architect, Excerpts from the Barr Papers of the Museum of Modern Art," *Archives of American Art Journal* 23, no. 1 (1983): 22–30.

10 The phrase is from Krauss, "The Cultural Logic of Late Capitalism," 11.

11 In saying this, I do not in any way mean to endorse the sort of ecstatic self-congratulation engaged in by MOMA and its publicists, who market MOMA in a debased language of "revolution," "miracles," and "revelations."

12 The Museum's director, Richard Oldenberg, wrote that Pelli's design would preserve "the special qualities for which the museum has been appreciated in the past: . . . a sense of intimacy with works on view because its galleries have been neither daunting in scale nor exhausting in number." See Richard Oldenberg, "Director's Statement," in Helen Searing, *New American Art Museum* (New York: Whitney Museum of American Art in Association with the University of California Press, 1982), 80–81. "Intimacy" has been a frequent refrain in commentaries on the Museum. For example, the *New York Times* observed the following in an editorial marking MOMA's reopening in 1984: "There was always a curious intimacy about MOMA. For all that its collections were formidable, its ambience was almost familial, and that intimacy remains." See "Marvelous MOMA," *New York Times* (13 May 1984): section 4, 22. William Rubin, director of the Museum's department of painting and sculpture from 1967 to 1988, has made "intimacy" an axiom of modern museum architecture. See his "When Museums Overpower Their Own Art," *New York Times* (12 April 1987): section 2, 31f.

13 Photography seems to be the one field where the Museum still exerts some authority. See Christopher Phillips, "The Judgment Seat of Photography," *October* 22 (Fall 1982): 27–63; and Abigail Solomon-Godeau, "Canon Fodder: Authoring Eugene Atget," *Photography at the Dock* (Minneapolis: University of Minnesota Press, 1991; article originally published in 1986), 28–51.

14 Alfred Barr, "Chronicle of the Collection," *Painting and Sculpture in the Museum of Modern Art, 1929–1967* (New York: Museum of Modern Art, 1967), 635.

15 In 1973 William Rubin, who had succeeded Barr as chief curator of painting and sculpture, rehung the permanent collection. This has been described as the first rehanging in fifteen years, which would mean that the arrangement of the permanent collection after the Johnson renovation in 1964 remained pretty much as it had been earlier. It should also be noted, however, that the 1973 rehanging did not substantially change the arrangement of the permanent collection. (Information from Russell Lynes, "Museum Maker—Alfred H. Barr, Jr.," *Vogue* 161, no. 5 [May 1973]: 144–146, 196; and comparison of ground plans from Barr, "Chronicle of the Collection," 646f., and a 1978 museum handout in the author's possession.)

16 For the information given here, see Barr, "Chronicle of the Collection," 637f., 641, 644; Gerald Marzaroti, "Is a Bigger MOMA a Better MOMA?," *Art News* (October 1987): 64f. It should be noted that well into the 1950s the curators frequently cleared the entire Museum to allow space for special exhibitions. Thus in the two years after the Goodwin-Stone building opened, the permanent collection was on view for only eighteen weeks. (See Barr, 633.) I would also note that as early as 1941 an Advisory Committee was complaining about the lack of space for the collection (Barr, 633f). It is significant, however, that the Museum only began to take action on this problem during the 1950s.

17 The west wing predated the east wing by fourteen years. In 1950 the Museum commissioned

Johnson to design an annex to house offices. Johnson complied by furnishing an orthodox Bauhaus design. The east wing facade of Johnson's museum was simply a refined version of the west wing. Thus, from 1964 to 1980, visitors confronted two almost identical wings framing the original facade.

18 Interview with Cesar Pelli, "The Museum of Modern Art Project," *Perspecta: The Yale Architectural Journal* 16 (1981): 107.

19 Ibid.

20 A portion survives as an internal link between the second and third floor galleries; it is in effect preserved (like the facade) as a relic of the original Goodwin-Stone design.

21 I follow here Jameson's and Krauss's discussions of "hyperspace": see especially Jameson, "Postmodernism," 61; Krauss, "Cultural Logic," 12f.

22 Kramer, "MOMA Reopened," 5.

23 Ibid., 2.

6 *Regionalism Redux*

This chapter first appeared in *American Quarterly* 43, no. 2 (June 1991): 259–278, © The Johns Hopkins University Press, and is reprinted with permission.

"Thomas Hart Benton: An American Original," Henry Adams, Curator; Ellen R. Goheen, Organizer; Lynne Breslin, Designer. The Nelson-Atkins Museum of Art, Kansas City, 16 April–18 June 1989; the Detroit Institute of Arts, 4 August–15 October; the Whitney Museum of American Art, New York, 17 November–11 February 1990; the Los Angeles County Museum of Art, 29 April–22 July 1990. Catalogue/biography of the same name by Henry Adams (New York, Alfred A. Knopf, 1989). Exhibition supported by grants from the United Missouri Bank of Kansas City, the Enid and Crosby Kemper Foundation, and the National Endowment for the Arts.

"George Caleb Bingham," Michael Edward Shapiro, Curator. The Saint Louis Art Museum, 24 February–13 May 1990; genre and history paintings at the National Gallery of Art, Washington, D.C., 15 July–30 September, coordinated by Nicolai Cikovsky Jr.; drawings at the National Museum of American Art, Washington, D.C., 8 June–19 August. Catalogue of the same title with essays by Barbara Groseclose, Elizabeth Johns, Paul C. Nagel, Michael Edward Shapiro, and John Wilmerding (New York: Harry N. Abrams, Inc., in association with the Saint Louis Art Museum, 1990). Exhibition supported by the National Endowment for the Arts and the Missouri Arts Council; research for exhibition and catalogue funded by the Henry Luce Foundation, Inc.; St. Louis venue sponsored by Boatmen's National Bank of St. Louis; Washington venue sponsored by Hecht's, a division of The May Department Stores Company, and Monsanto Company.

1 "U.S. Scene," *Time* (24 December 1934): 24–27. See also Henry Adams, *Thomas Hart Benton: An American Original* (New York: Alfred A. Knopf, 1989), 219–220.

2 Alfred Barr, "Foreword and Acknowledgment," in *George Caleb Bingham, The Missouri Artist, 1811–1879,* exhibition catalogue (1935; reprint, New York: Arno Press, 1969), 5 (hereafter Bingham-MOMA). In 1934, Meyric B. Rogers organized a Bingham exhibition which was shown at the City Art Museum in St. Louis and at the William Rockhill Nelson Gallery in Kansas City. A special number of the *Bulletin of the City Art Museum of St. Louis* 19 (April 1934) stood in for a catalogue, with a biographical essay by Rogers, and a checklist of works in the

exhibition. For the most part this checklist coincided with the checklist for the 1935 MOMA exhibition, indicating that MOMA relied heavily on Rogers's efforts.

3 Meyric B. Rogers in *Bingham*-MOMA, 12.

4 Helen Fern Rusk, *George Caleb Bingham: The Missouri Artist* (Jefferson County, Mo.: Hugh Stephens, 1917).

5 Albert Christ-Janer, *George Caleb Bingham of Missouri: The Story of An Artist* (New York: Dodd, Mead, 1940), 136.

6 Benton cited in ibid., viii. More than thirty years later, Christ-Janer published another study of Bingham, again with a preface by Benton. See Albert Christ-Janer, *George Caleb Bingham, Frontier Painter of Missouri* (New York: Abrams, 1975).

7 Benton cited in Christ-Janer, *George Caleb Bingham of Missouri*, viii.

8 See John Francis McDermott, *George Caleb Bingham, River Portraitist* (Norman: University of Oklahoma Press, 1959); Maurice Bloch, *George Caleb Bingham, The Evolution of an Artist* (Berkeley: University of California Press, 1967); idem., *George Caleb Bingham: A Catalogue Raisonné* (Berkeley: University of California Press, 1967); and idem., *The Paintings of George Caleb Bingham: A Catalogue Raisonné* (Columbia: University of Missouri Press, 1986).

9 See Mathew Baigell, *Thomas Hart Benton* (New York: Abrams, 1974); Karal Ann Marling, *Tom Benton and His Drawings* (Columbia: University of Missouri Press, 1985), and idem., "Thomas Hart Benton's Boomtown: Regionalism Redefined," *Prospects* 6 (1981): 73–137; Adams, *Thomas Hart Benton: An American Original* and idem., *Thomas Hart Benton: Drawing from Life* (Seattle: University of Washington Press, 1990). See also Emily Braun and Thomas Branchick, *Thomas Hart Benton, The America Today Murals* (Williamstown, Mass.: Williams College Museum of Art, 1985).

10 John Wilmerding, "Bingham's Geometries and the Shape of America," in Michael Edward Shapiro et al., *George Caleb Bingham* (New York: Harry N. Abrams, in association with the Saint Louis Art Museum, 1990), 175.

11 Adams, *Thomas Hart Benton: An American Original*, x.

12 See Gail Husch, "George Caleb Bingham's *The County Election*: Whig Tribute to the Will of the People," *American Art Journal* 19, no. 4 (1987): 4–22; Nancy Rash, "George Caleb Bingham's *Lighter Relieving a Steamboat Aground*," *Smithsonian Studies in American Art* 2 (Spring 1988): 17–32; Elizabeth Johns, "The 'Missouri Artist' as Artist," in Shapiro et al., *George Caleb Bingham*, 93–139. Rash and Johns have book-length studies on Bingham and on mid-nineteenth-century American genre painting. (See Nancy Rash, *The Painting and Politics of George Caleb Bingham* [New Haven: Yale University Press, 1991]; Elizabeth Johns, *American Genre Painting* [New Haven: Yale University Press, 1991].)

13 See Elizabeth Johns, "Art, History and Curatorial Responsibility," *American Quarterly* 41 (March 1989): 143–155; and Roger B. Stein, "Winslow Homer in Context," *American Quarterly* 42 (March 1990): 74–92.

14 William Robbins, "Admirers Toast Works of Thomas Hart Benton," *New York Times* (14 April 1987).

15 Donald Hoffmann, "Benton Event of Questionable Value," *Kansas City Star* (19 April 1987).

16 Quoted in Robert Sanford, "Fans of Thomas Hart Benton Hear Some Disparaging Words," *St. Louis Post-Dispatch* (19 April 1987). Adams continued: "by having the symposium early we have these critical views on record. Some of the things said here today will appear in a book of essays to be available at the time of the show." The book never materialized but essays by Kramer and Marling along with a previously unpublished Benton memoir appeared in *Forum: Visual Arts/Mid-America* 14 (June/July 1989).

17 "Foreword," *Thomas Hart Benton: An American Original,* exhibition checklist (Kansas City, 1989), p. 3 (hereafter, "Checklist"). Breslin designed only the Kansas City installation.

18 See, for example, the interview in the *New York World Telegram* (5 or 6 April 1941), Museum of Modern Art, Benton clipping file.

19 "Checklist," p. 10. The title page credits Ellen R. Goheen with having prepared the checklist and organized the exhibition, but it is not clear whether she is the sole author of the text.

20 The checklist had a seventh section devoted to the two sets of murals in the exhibition although in Kansas City the murals were displayed as part of the overall chronological sequence (see below).

21 Breslin placed a walkway under the central panels of *The Arts of Life in America,* but the walkway brought viewers too close to the paintings to experience their effect and was not used by most exhibition-goers. With the walkway Breslin may have intended to give the murals a special emphasis, but the walkway could not compete with the corncrib in the same gallery, or with other props and special effects.

22 Thomas Craven, *A Treasury of Art Masterpieces* (New York: Simon and Schuster, 1939), 294.

23 Ken Burns's ninety-minute film biography was a related project. Shown frequently during the exhibition's run at the Nelson-Atkins and aired on public television in November 1989, the film combines a biographical account with commentaries by Benton's family, friends, and art world figures including a number of the participants in the 1987 symposium (Hilton Kramer is cast in the role of "chief detractor"). Predictably, the film sensationalizes its subject ("Benton loved America but hated the Establishment"), but it contains genuinely interesting footage drawn from newsreels, a Reader's Digest film, and Benton's 1959 appearance on Edward R. Murrow's "Person to Person."

24 In a bibliographic note Adams, *Thomas Hart Benton: An American Original,* 344–345, states that he has "drawn so extensively on Benton's memoirs and interviews that he might be considered a coauthor. In fact, in many instances, particularly in the first three chapters, I have used Benton's own words and phrases without quotation marks. All full-sentence quotations, however, are indicated by quotation marks." Later, in the same note, he assures the reader, "I have not made up any of the dialogue in this book," but then goes on to describe how he has relied on Benton's "reconstructions of conversations," even though Benton "confessed . . . that his memories of these conversations was not perfectly exact." This is not the only problem researchers will encounter. Perhaps believing it would add to the book's appeal to a general audience, Adams eliminated footnotes, relying instead on cumbersome lists of references for each chapter. However, two typescript versions—one of the book as it was published, the other a considerably longer draft—are available, with footnotes, at the Nelson-Atkins Museum "for the benefit of scholars."

25 Consider, for example, the fate of art historian Meyer Schapiro's review of Benton's autobiography, *An Artist in America* (1937; reprint, Columbia: University of Missouri Press, 1983). Although written in the heat of art world polemics, Schapiro's brief essay remains the most illuminating analysis of the historical and political implications of Benton's "populist realist" style. Benton enthusiasts have yet to meet the challenge represented by Schapiro's text, which Adams, *Thomas Hart Benton: An American Original,* 279, crudely rejects as the work of "a champion hairsplitter." See Meyer Schapiro, "Populist Realism," *Partisan Review* 4, no. 2 (January 1938): 53–57.

26 Adams, *Thomas Hart Benton: An American Original,* 173.

27 Ibid., 331. By comparison, Stephen Polcari is far more cautious in his (still formalist) "Jackson Pollock and Thomas Hart Benton," *Arts Magazine* 53 (March 1979): 120–124. For a

treatment of the Benton-Pollock question that places it in a wider historical perspective, see Erika Doss, "The Art of Cultural Politics: From Regionalism to Abstract Expressionism," in *Recasting American Culture and Politics in the Age of the Cold War,* ed. Lary May (Chicago: University of Chicago Press, 1989), 195–220. For a look at the art historical issues Pollock's art raises, see Timothy J. Clark, "Jackson Pollock's Abstraction," in *Reconstructing Modernism,* ed. Serge Guilbaut (Cambridge: MIT Press, 1990), 172–238.

28 Here and elsewhere I use such words as "liminal" (a term borrowed from anthropology), "threshold," "initiate," and "enact" to draw attention to the ritual and often subliminal elements of the visitor's experience. For a fuller, if now somewhat problematic treatment of these issues, see Carol Duncan and Alan Wallach, "The Museum of Modern Art as Late Capitalist Ritual: An Iconographic Analysis," *Marxist Perspectives* 1, no. 4 (Winter 1978): 28–51.

29 Examples are discussed in the reviews by Johns and Stein cited in n. 13.

30 In Washington, the National Gallery presented an abbreviated version of the exhibition, eliminating the drawings and displaying only one portrait and one print, the final version of *The County Election,* which was shown at the exhibition's entrance alongside the second version of the painting. Bingham was once again presented, in the words of the National Gallery handout, as the painter of "the features and spirit of American democracy," but the exhibition stressed more the idea of Bingham's paintings as pure masterpieces. The luxurious installation, typical for the National Gallery, made the point. The National Museum of American Art mounted an exhibition of the drawings that had been shown in St. Louis, grouping them around photographs of the paintings.

31 Like Adams's book, the catalogue for the Bingham exhibition was conceived as a freestanding publication with references to the exhibition only in the foreword and acknowledgments. The catalogue does not contain a listing of works in the exhibition and, perhaps because the contents of the exhibition changed so radically between St. Louis and Washington (see previous note), no checklist was published. The only permanent record of the exhibition is an unbound "Object List" distributed as part of the Saint Louis Museum of Art's exhibition press kit.

32 See Barbara Groseclose, "Painting, Politics and George Caleb Bingham," *American Art Journal* 10, no. 2 (1978): 7–19.

33 See Gail E. Husch, "George Caleb Bingham's *The County Election,*" 4–22.

34 This is not the place to begin an inquiry into the persistence of the myth of Bingham as the artist of American optimism, American democracy, and the heroism of the common man, although one obvious reason for its continuing currency lies in its blatant appeal to patriotic sentiment. For example, in a public lecture marking the opening of the Bingham exhibition at the National Gallery, Shapiro argued for Bingham's continuing relevance in light of recent events in Eastern Europe and elsewhere. Suffice it to observe that the myth severely limits both scholarly investigation and the museum-going public's potential for understanding Bingham's art.

7 *The Battle over "The West as America"*

This chapter first appeared as "The Battle Over 'The West As America,' 1991," in Marcia Pointon, ed., *Art Apart: Artifacts, Institutions and Ideology in England and North America from 1800 to the Present* (Manchester: Manchester University Press, 1994), 89–101, and is reprinted by permission of Manchester University Press.

1 Walter Benjamin, "Eduard Fuchs, Collector and Historian," in *One Way Street and Other Writings,* trans. Edmund Jephcott and Kingsley Shorter (London: Verso, 1985), 352.

2 William H. Truettner, "Preface," *The West as America: Reinterpreting Images of the Frontier, 1820–1920,* ed. William H. Truettner (Washington, D.C., and London: Smithsonian Institution Press, 1991), 40. The catalogue contains essays by Truettner, Nancy K. Anderson, Patricia Hills, Elizabeth Johns, Joni Kinsey, Howard R. Lamar, Alex Nemerov, and Julie Schimmel.

3 Bryan J. Wolf, "How the West Was Hung, Or, *When I Hear the Word 'Culture' I Take Out My Checkbook," American Quarterly* 44, no. 3 (September 1992): 418–438.

4 Wall text copy on file in "The West as America" archive at the National Museum of American Art. This abbreviated analysis of *Fight for the Water Hole* derived from a more extended discussion in the exhibition catalogue. See Alex Nemerov, " 'Doing the "Old America," ' The Image of the American West, 1880–1920," in Truettner, *The West as America,* 285–343.

5 All citations are from the exhibition comment books, now in the National Museum of American Art's "West as America" archive. Selections from the comment books appear in "Showdown at 'The West as America,' " *American Art* 5, no. 3 (Summer 1991): 1–11.

6 Cited in Ken Ringle, "Political Correctness: Art's New Frontier," *Washington Post* (31 March 1991).

7 "Pilgrims and Other Imperialists," *Wall Street Journal* (17 May 1991). A later report in the *Journal* stated otherwise. See James M. Perry, "Washington Art Exhibit Is Criticized for Stance Taken on Western Frontier," *Wall Street Journal* (31 May 1991). The exhibition was in fact financed with private funds.

8 "Westward Hokum," *Washington Post* (31 May 1991). Krauthammer's column appears in over seventy newspapers in the United States and "Westward Hokum" surfaced elsewhere under such inventive headlines as "If this is the American West, Sioux me" (*New York Daily News* [2 June 1991]).

9 Kim Masters, "Senators Blast Smithsonian for 'Political Agenda,' " *Washington Post* (16 May 1991).

10 Alan McConagha, "Smithsonian Chief Admits Exhibit Error," *Washington Times* (6 June 1991).

11 For an overview, see Paul Berman, "Introduction: The Debate and Its Origins," in *Debating P.C.,* ed. Berman (New York: Laurel, 1992), 1–26; see also Pat Aufderheide, ed., *Beyond P.C.* (Saint Paul, Minn.: Graywolf Press, 1992).

12 Lynne V. Cheney, *Telling the Truth* (Washington, D.C.: National Endowment for the Humanities, 1992), 37–38.

13 Cited in Norman Mailer, "Republican Convention Revisited: By Heaven Inspired," *New Republic* (12 October 1992): 26.

14 Krauthammer, "Westward Hokum."

15 See, for example, Ringle, "Political Correctness."

16 Richard Grenier, "Sentimental Frenzy Posing as History," *Washington Times* (29 May 1991). Grenier seems to have become the neoconservatives' specialist on the Indian question. See his "Indian Love Call," *Commentary* 91, no. 3 (March 1991): 46–50.

17 William H. Goetzmann, review of "The West as America," *Southwestern Historical Quarterly* 96, no. 1 (July 1992): 130.

18 Gerald Nash, "Point of View: One Hundred Years of Western History," *Journal of the West* 32, no. 1 (January 1933): 3–4.

19 Cited in Ringle, "Political Correctness."

20 Ron Tyler, "Western Art and the Historian, *The West as America,* A Review Essay," *Arizona History* (Summer 1992): 220; see also William H. Truettner and Alexander Nemerov, "More Bark Than Bite: Thoughts on the Traditional—and Not Very Historical—Approach to Western Art," *Arizona History* (Fall 1992): 311–324.

21 " 'Cutting for Sign': Museums and Western Revisionism," *Western Historical Quarterly* 24, no. 2 (May 1993): 232.

22 Ibid. For another example of this sort of tortuous and ultimately failed struggle with the implications of "The West as America," see the essay by James Ballinger, "Frederic Remington's Southwest," *American Art Review* 5, no. 1 (Summer 1992): 90–95, 164. Ballinger is the director of the Phoenix Art Museum.

23 Benjamin, "Eduard Fuchs," 352.

8 Revisionism Has Transformed Art History but Not Museums

This chapter first appeared in *The Chronicle of Higher Education* 38, no. 20 (22 January 1992): B2–B3.

9 Museums and Resistance to History

This chapter first appeared in *The Chronicle of Higher Education* 41, no. 4 (21 September 1994): B3–B5.

INDEX

UNIVERSITY OF MASSACHUSETTS PRESS AMHERST

Exhibiting Contradiction